# Harry Potter™

## The CREATURE Vault

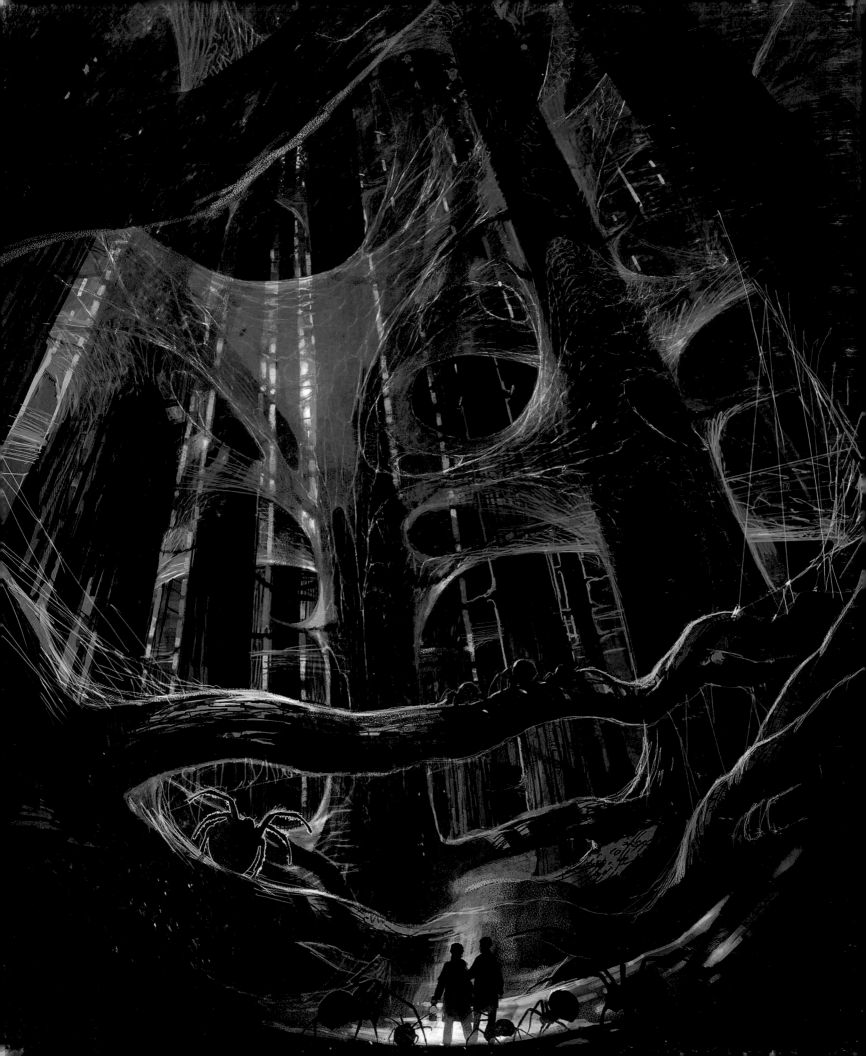

# Harry Potter™

# The CREATURE Vault

## The Creatures and Plants of the Harry Potter Films

By Jody Revenson

HARPER DESIGN
An Imprint of HarperCollins Publishers

An Insight Editions Book

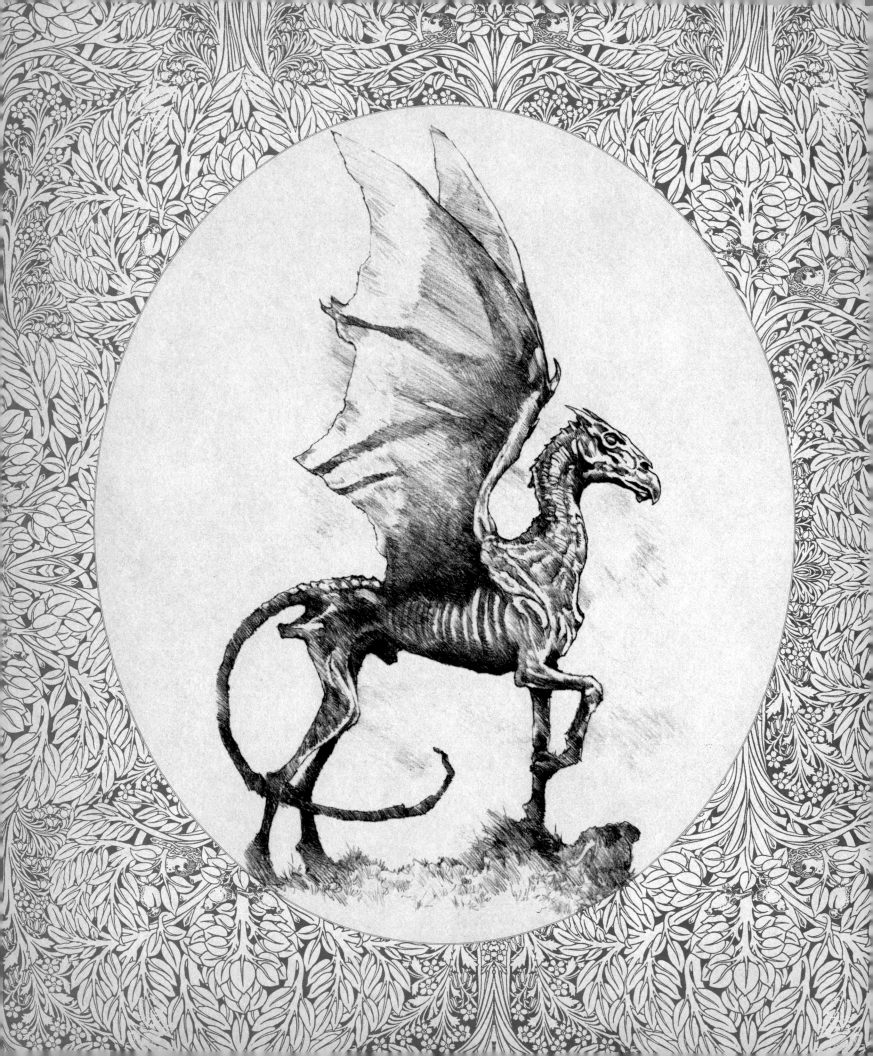

# CONTENTS

# Introduction

The creatures and beasts that populate the Harry Potter films are funny, majestic, chilling, and loving. They are as diverse a group of characters as the students who attend Hogwarts School of Witchcraft and Wizardry. The visual artists and production designers who worked on the series over the course of eight films brought these unique and beloved magical beings to such convincing life that we would not be surprised to see goblins working at our local bank. We can envision how an encounter might go with Grindylows during a swim, and wish our Muggle schools would offer a Care of Magical Creatures class where we could ride a Hippogriff like Buckbeak.

Unlike creatures in many other films, the creatures of the Harry Potter films "are very important to the story," says producer David Heyman. Harry Potter's story could not be told without them. They provide lessons and challenges to our hero that ultimately help him gain the skills and confidence needed for his battle with Lord Voldemort and the Dark Forces.

Bringing the film's creatures to life started with Stuart Craig, production designer for all eight Harry Potter movies. Working with producers David Heyman and David Barron; directors Chris Columbus, Alfonso Cuarón, Mike Newell, and David Yates; and the source—J.K. Rowling—Craig and his team of artists, designers, animators, and fabricators used time-honored techniques and invented new practical and digital methods to place the creatures on-screen.

Above all, the creatures had personality and individuality, first imbued by concept artists Dermot Power, Adam Brockbank, Wayne Barlow, Rob Bliss, Paul Catling, Andrew Williamson, Julian Caldow, and others. "What is the character of this creature?" visual development artist Rob Bliss would ask himself. "Is it good or bad,

intelligent or stupid?" Their artwork would provide inspiration and direction for teams of sculptors, modelers, makeup artists, painters, animatronic designers, and digital artists, most of whom worked together throughout the entire film series.

Starting from the first film of the Harry Potter series, the directive for any creature's design was that its anatomy and movement should be based on naturalism. This was especially important for creatures that had no real-life counterpart. The visual development artists studied birds and horses that provided practical, working anatomies for Hippogriffs and Thestrals, rooting them in reality. Aragog the Acromantula evolved from the wolf spider. All three of guard dog Fluffy's heads are based on a specific breed of dog, the Staffordshire Bull Terrier.

The Harry Potter films also featured mythological creatures that were human hybrids—centaurs, merpeople, and werewolves. Diverging from traditional approaches, the designers' reinterpretations produced logical, organic forms. Centaurs were no longer half man, half horse. By animalizing their human features, the centaurs were

unlike any seen before on-screen. The merpeople were recognizable as purely underwater-evolved creatures. Fenrir Greyback, a werewolf perpetually caught between his human and wolf states, had a physiognomy to reflect a seamless blend of both states.

There is no doubt regarding the technical advantage of using computers to create the incredible. Computer animation, says visual effects producer Emma Norton, "allowed us to put a dragon on top of Hogwarts and fly it around." Frequently, even though a creature would be wholly CGI, the effects department or creature shop would create a maquette, a model that would often be life-size, and painted or "haired" in its entirety for the digital artists to cyberscan. And the producers and the creature effects crew always explored the possibility of having a Hippogriff or a troll be constructed and animated practically. Having an actual-size, moving being was a significant advantage for the cinematographers and lighting designers, and especially for the actors. To be able to battle a fully realized Basilisk head or know what it feels like to hold a dying Dobby in your arms could do nothing but benefit Daniel Radcliffe's (Harry Potter) performance. Nick Dudman, creature effects supervisor and special makeup effects artist, stated that he felt "there was nothing that couldn't be done for real. And so you build a fire-breathing dragon,"

which he and his crew did, although he admits doing so was also because he always wanted to build a fire-breathing dragon.

In addition to the magical and the mythical, there were real-life animal actors in the Harry Potter films that portrayed a variety of roles from an Animagus form to a beloved pet. These real-life animal actors were trained and cared for by a team headed by animals supervisor Gary Gero and head animal trainer Jules Tottman, who ensured that a cat's paws were always kept warm, a toad found its way back to its terrarium quickly, and each owl, rat, or cat got a treat after their action or stunt.

The creature shop and props department also took special care in creating the creature-like plants featured in the Harry Potter films. The talented crewmembers of these departments harvested Mandrakes, captured the essence of the entangling Devil's Snare, and made a willow tree that could whomp a full-size car.

The following is a compilation of inspirational artwork, memorable screen captures, and fascinating behind-the-scenes information about the magical, unforgettable creatures and plants that we encounter on-screen in the Harry Potter films.

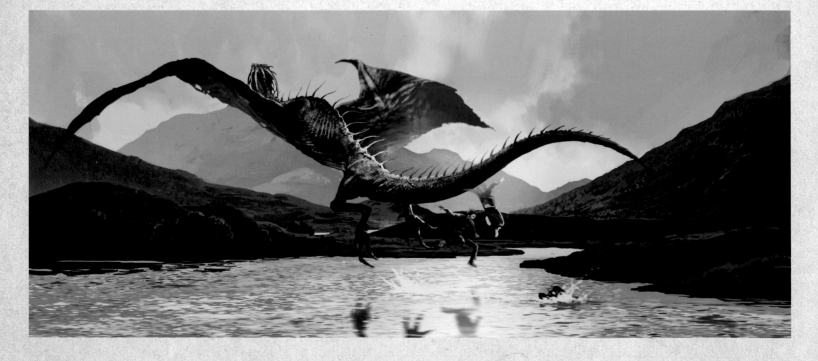

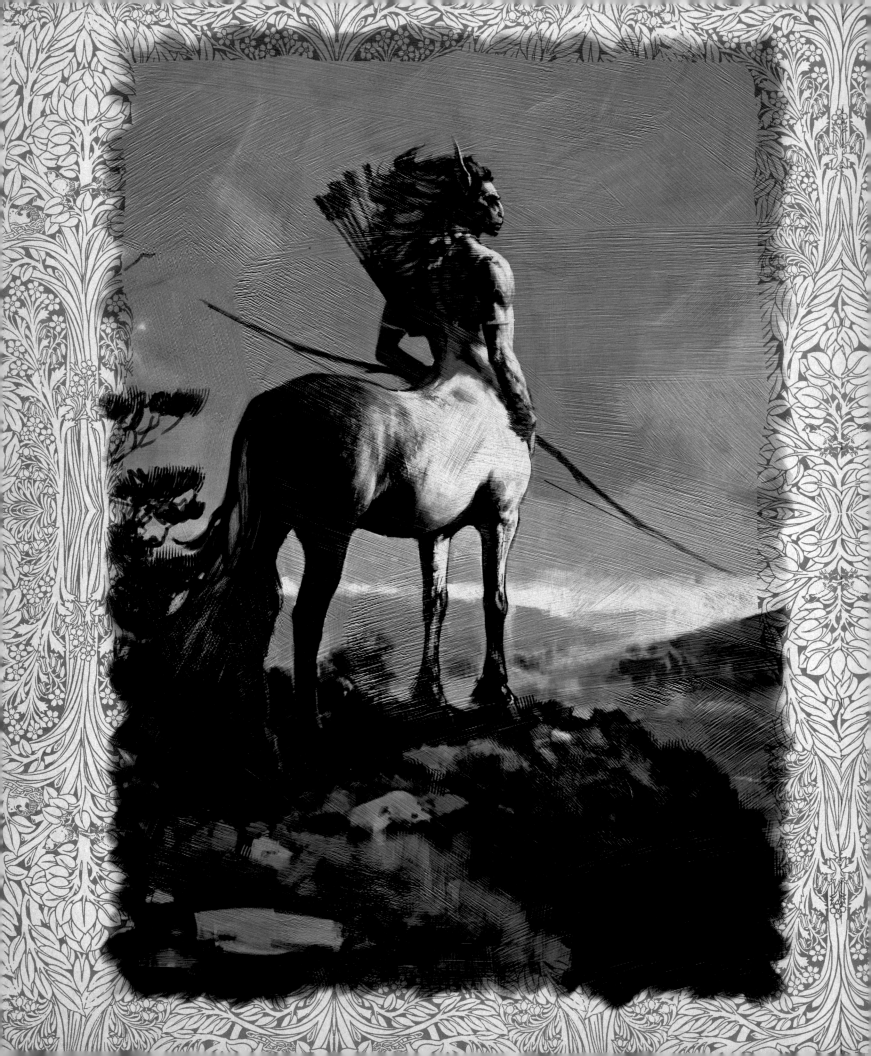

# FOREST DWELLERS

*I*n the Harry Potter films, the Forbidden Forest lies on the outskirts of the grounds of Hogwarts School of Witchcraft and Wizardry. Home to an abundance of creatures, the forest offers shelter and protection to herds of centaurs, unicorns, Thestrals and Acromantula. Adjacent to the forest is the paddock used for the Care of Magical Creatures classes.

# Centaur.

**C**entaurs are a species of creature that unites human and equine aspects. Harry Potter meets the centaur Firenze in <u>Harry Potter and the Sorcerer's Stone</u>, while he is serving detention in the Forbidden Forest. When Harry encounters Voldemort feeding from a unicorn, Firenze saves him from the Dark Lord's attack.

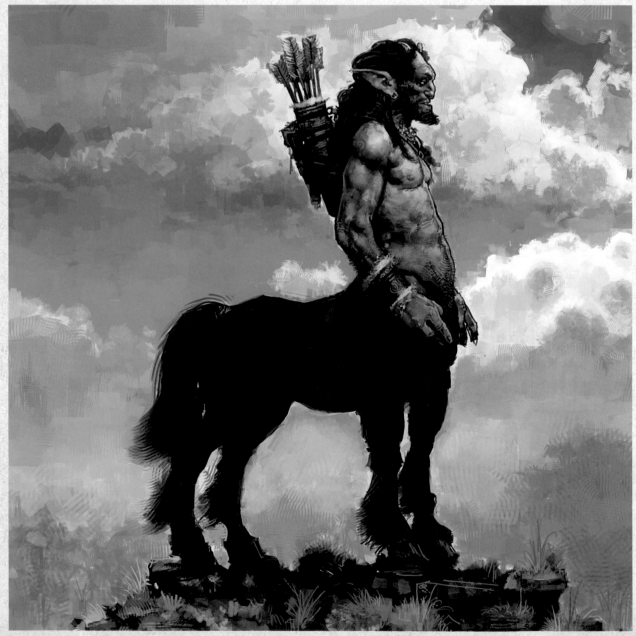

Fig 1.

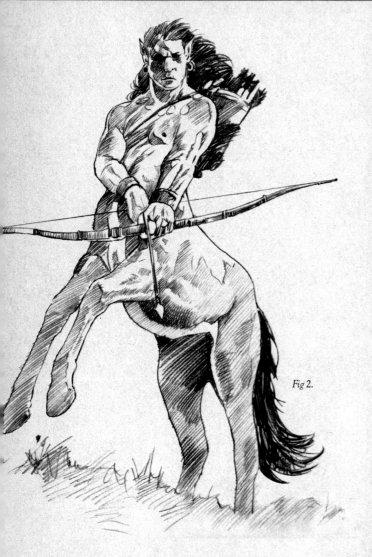

Fig 2.

Previous: The centaur Bane painted by Adam Brockbank; Centaur concepts by Rob Bliss (Fig. 1) and Adam Brockbank (Fig. 2) for *Harry Potter and the Order of the Phoenix*; Fig 3. Centaur concept art by Paul Catling for *Harry Potter and the Sorcerer's Stone*.

Fig 3.

Centaurs also play a key role in the comeuppance of Dolores Umbridge in *Harry Potter and the Order of the Phoenix*. When Harry and Hermione Granger tell Umbridge to follow them into the forest to see Dumbledore's Army's "secret weapon," they encounter a herd of centaurs, led by Bane. Umbridge's prejudice against the creatures leads to a heated exchange, and the centaurs drag her away into the depths of the forest.

The creature designers never considered centaurs to be half-breeds (as Dolores Umbridge did). In their early research of the mythological beings, they noted that ancient Greek and Roman artists had essentially stacked the top half of a man onto the body of a horse when portraying the creature. In a reverse of this traditional rendering, the designers conceived

the centaurs not as a humanized horse, but as an animalized human. The centaurs' faces in the films are long, with a broader forehead, flatter cheeks, nose, and jawline, and eyes set farther apart than a human's. Instead of skin, the horse's pelt and coloration envelop the entire creature, not just the bottom half. Pointed ears are set high up on the head.

Firenze in *Harry Potter and the Sorcerer's Stone* was computer-generated, but the process changed for *Harry Potter and the Order of the Phoenix*. To depict Bane and Magorian, the creature shop created two full-size models—called maquettes—of the centaurs that were used for cyberscanning into the computer. The maquettes were also placed in the forest set for lighting reference and to give the actors an "eyeline" to follow to the creatures.

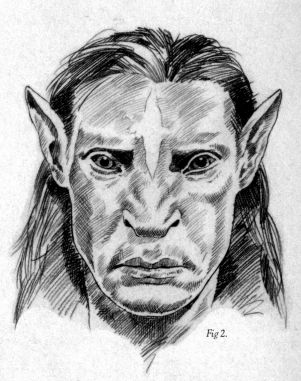

"*Hello there, Firenze. I see you've met our young Mr. Potter.*"

—RUBEUS HAGRID

*Harry Potter and the Sorcerer's Stone* film

Fig 1.

Fig 2.

Centaur head and face studies by Paul Catling (Figs 1. & 3.) for *Harry Potter and the Sorcerer's Stone*, and Adam Brockbank (Fig 2.) for *Harry Potter and the Order of the Phoenix*; Fig 4. The centaur Magorian dressed in weaponry and jewelry for *Order of the Phoenix*, illustrated by Adam Brockbank; Fig 5. Sketch of Centaur jewelry by Adam Brockbank; Figs 6. & 7. Centaur head studies by Adam Brockbank for *Order of the Phoenix*, paying special attention to blending their human and equine characteristics.

Fig 3.

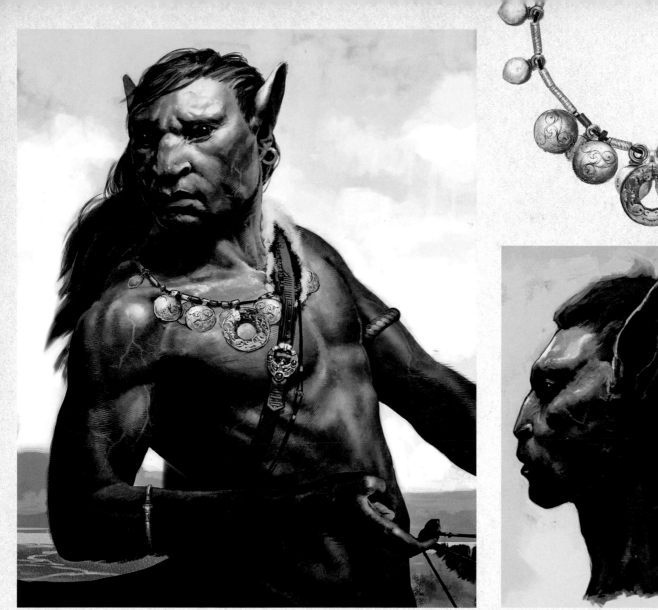

Fig 4.

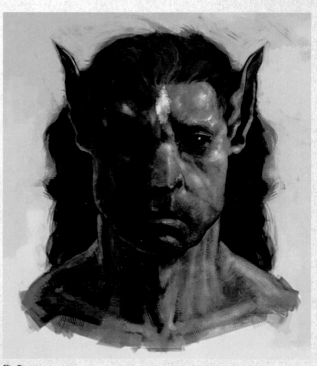

Fig 5.

Fig 6.

Fig 7.

To create their pelts, the centaur models were "flocked," a laborious process that involves wetting down the entire model with glue, sending an electrical charge through it, and then firing oppositely charged hairs at the model. This process causes the hairs to stick and stand on end. These hairs must be combed into their desired direction before the glue dries, which is a matter of only forty minutes. If the procedure is not accomplished within this time period, it has to start again from scratch. It took a team of six people and many rehearsals to insure that the correct combinations of hair colors and hair lengths bonded to their assigned areas. Then, longer hairs were punched into the models one at a time, followed by air-brushed artwork. It took the costume and prop departments eight months and a crew of more than forty people to get from the initial sculpt of the centaurs to their final fittings with handcrafted weapons and jewelry.

During their skirmish in the forest, Dolores Umbridge casts the *Incarcerous* spell on Bane, which causes a rope to wrap around the centaur's neck, choking him. For this scene, the creature designers researched how a stallion would react to this situation. They learned that a human would respond differently than a horse if lassoed and restrained. Whereas a horse would move downward, a man would react by jumping up and straightening his back. Bane's physical responses as an animalized human were thus a blend of these two physical reactions.

# FAST FACTS

## CENTAUR

✴

I. FIRST FILM APPEARANCE: *Harry Potter and the Sorcerer's Stone*

II. ADDITIONAL FILM APPEARANCE: *Harry Potter and the Order of the Phoenix*

III. LOCATION: Forbidden Forest

IV. DESIGN NOTE: The designers wanted the centaurs to have the sweaty, glistening coats associated with thoroughbred racehorses.

V. DESCRIPTION FROM *HARRY POTTER AND THE SORCERER'S STONE* BOOK, CHAPTER FIFTEEN:

*"And into the clearing came—was it a man, or a horse? To the waist, a man, with red hair and beard, but below that was a horse's gleaming chestnut body with a long, reddish tail."*

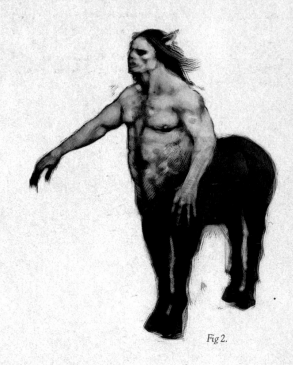

Fig 2.

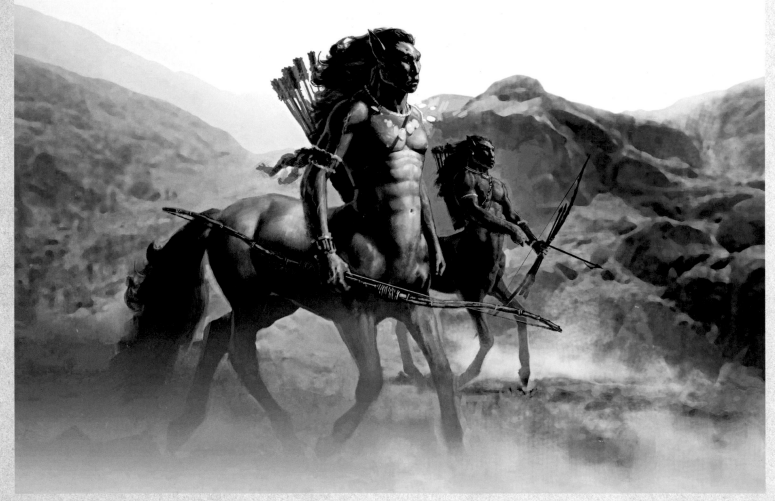

Fig 1. (above) Centaurs on patrol by Adam Brockbank for *Harry Potter and the Order of the Phoenix*; Fig 2. Early centaur study by Paul Catling for *Harry Potter and the Sorcerer's Stone*.

Figs 3. & 4. Maquettes for *Order of the Phoenix* of Magorian (top) and Bane (bottom); Fig 5. Harry Potter (Daniel Radcliffe) meets Firenze in a scene from *Sorcerer's Stone*; Fig 6. Centaur in the Forbidden Forest by Adam Brockbank for *Order of the Phoenix*. The visual development art often explored the character or creature within their environment's light conditions.

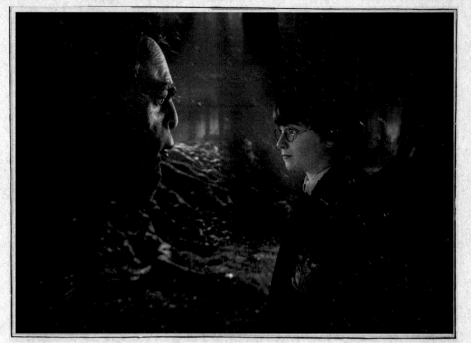

*Fig 5.*

*Fig 3.*

*Fig 4.*

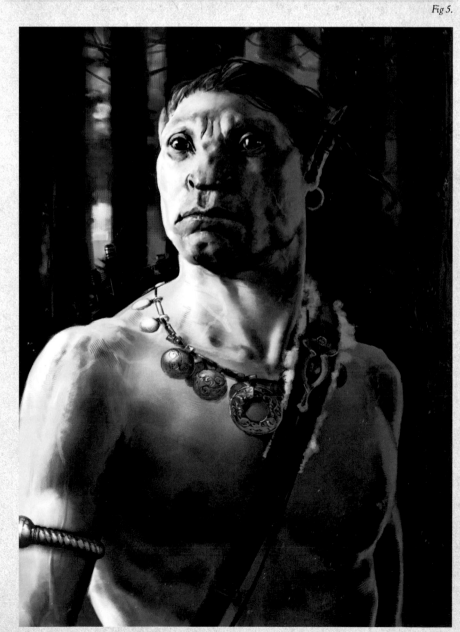

*Fig 6.*

# Unicorn.

In *Harry Potter and the Sorcerer's Stone*, it is discovered that unicorns are being attacked in the Forbidden Forest. Unicorns are peaceful magical creatures that resemble white horses, with a single spiraling horn projecting from their forehead.

Fig 2.

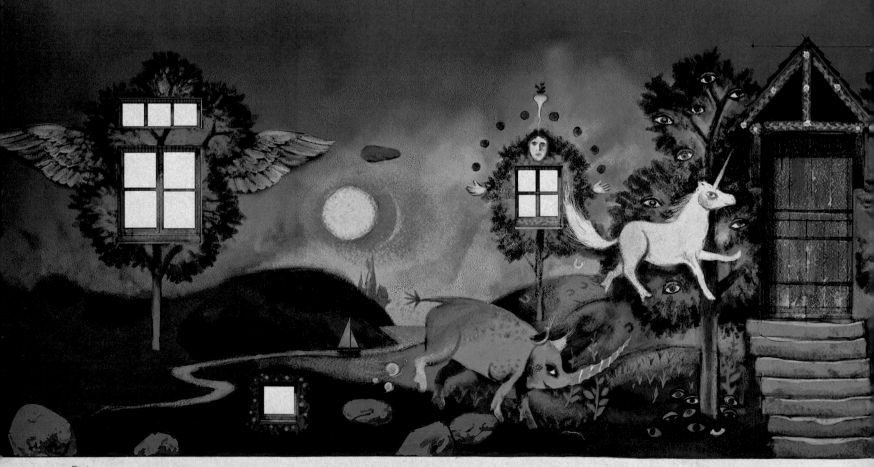

Fig 1.

While serving a late-night detention in the Forbidden Forest, Harry Potter and Draco Malfoy find an injured unicorn in the process of having its blood drained from its neck by a cloaked figure. Unknown to them, it is Voldemort in a strange form, who has been drinking unicorn blood to keep himself alive.

Although the injured unicorn in *Harry Potter and the Sorcerer's Stone* did not need to move, it was constructed with a fully articulated steel skeleton. The unicorn's pelt was flocked in the same manner as the centaurs. The creature makers based the physiognomy of the unicorn's body on a horse named Fado. The design of the horn was, of course, based on mythological inspirations.

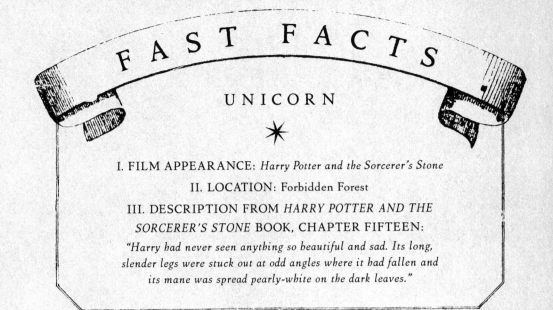

# FAST FACTS

## UNICORN

✳

I. FILM APPEARANCE: *Harry Potter and the Sorcerer's Stone*

II. LOCATION: Forbidden Forest

III. DESCRIPTION FROM *HARRY POTTER AND THE SORCERER'S STONE* BOOK, CHAPTER FIFTEEN:

*"Harry had never seen anything so beautiful and sad. Its long, slender legs were stuck out at odd angles where it had fallen and its mane was spread pearly-white on the dark leaves."*

# Acromantula.

**A**cromantula are a species of spider found in the world of *Harry Potter* that can grow to the size of an elephant. One of their unique features is their ability to converse with humans.

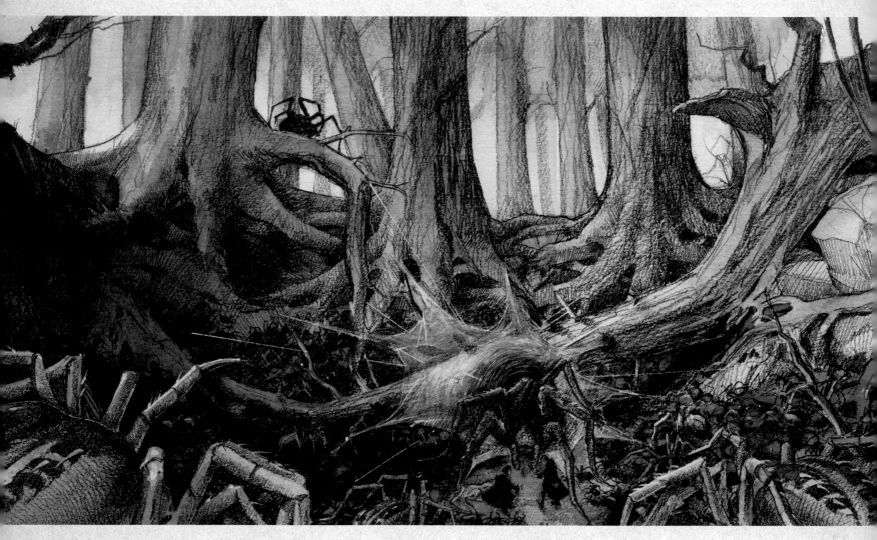

Fig 1. (above) Andrew Williamson portrays Harry and Ron's entrance into Aragog's hollow for *Harry Potter and the Chamber of Secrets*; Fig 2. A frightening perspective of the Acromantula by artist Dermot Power; Fig 3. Colored sketch of Aragog by Adam Brockbank; Fig 4. Crewmembers dress the set of the Forbidden Forest with young Acromantula for the filming of *Chamber of Secrets*.

"*You heard what Hagrid said. Follow the spiders.*"
— HARRY POTTER
*Harry Potter and the Chamber of Secrets* film

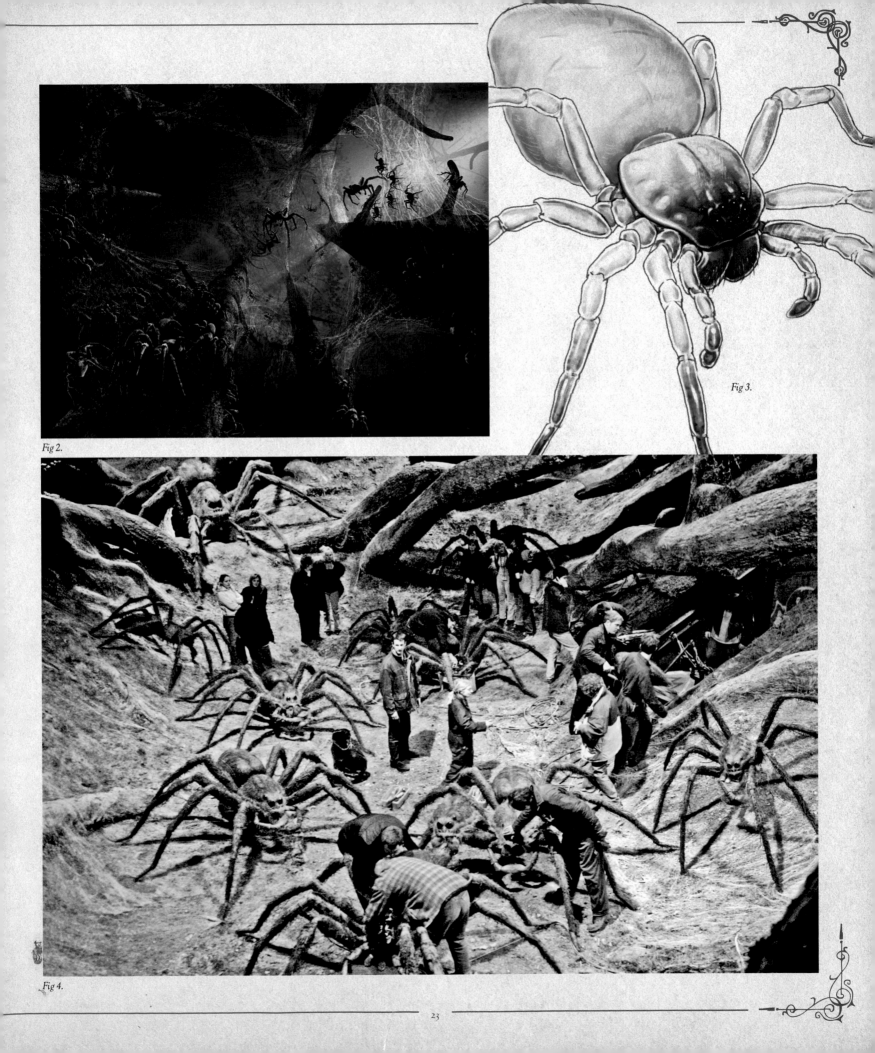

Fig 2.

Fig 3.

Fig 4.

Fig 1.

*Acromantula example 1.*

# ARAGOG.

Aragog, the leader of a colony of Acromantula, was brought to Hogwarts by Rubeus Hagrid when he was a student, fifty years before the events of *Harry Potter and the Chamber of Secrets*. Harry and Ron encounter this beloved pet of Hagrid's during their second year at Hogwarts, as they try to uncover the truth behind the identity of the heir of Slytherin. Sadly, Aragog passes away from old age during the events of *Harry Potter and the Half-Blood Prince*.

When the designers read the script for *Harry Potter and the Chamber of Secrets* and discovered that a spider with an eighteen-foot leg span would be required, their obvious initial thought was that the creature would be computer-generated. Upon further consideration, however, it was decided that Aragog's myriad offspring would be digital, but not Aragog. The creature shop realized that constructing the Acromantula would be more economical than CGI, and it would also allow them to make Aragog walk and talk on a life-size scale.

Aragog was crafted using an Aquatronic system that utilizes cables pumped with water instead of the oil-based system used in hydraulics. Aquatronics create a smoother, more graceful movement. Being the size of an elephant, Aragog needed to move with a similar unhurried elegance. The slow movements also imitated the quiet, menacing way that spiders creep around. The spider's back legs were manipulated by puppeteers while his forelegs were mechanical. These mechanical legs were operated by a motion-control device called a waldo that reproduces movements made by a controller. Then, Aragog was fitted onto a system that resembled a seesaw, with a counterweight on one end. Placed into a depression in the soundstage, when Aragog was tipped up, he literally walked forward.

A voice-activated system was installed in Aragog's head so that his mouth would move in synchronization to a broadcast recording of actor Julian Glover's voice as the character. This allowed Daniel Radcliffe (Harry Potter) and Rupert Grint (Ron Weasley) to act in real time with the creature.

Aragog was completely redesigned for *Harry Potter and the Half-Blood Prince* to show his age. The creature was cast in a urethane that allowed light through it in order to emulate the translucent glow of an actual dead spider. The same "hair" materials were used for both Aragog versions in *Chamber of Secrets* and *Half-Blood Prince*, including broom hairs for the finer ones and feathers with a coating of fluff and Lurex for the bigger, hairier ones. The hairs were inserted one at a time.

The script for *Half-Blood Prince* called for Aragog to be slid into a grave on a hill, so the designers knew that the Acromantula needed to be much heavier than the original in order to give the correct heft of a huge, upside-down dead spider. The creature was such a beloved character that the design crew wore black armbands while the spider's final scene was filmed.

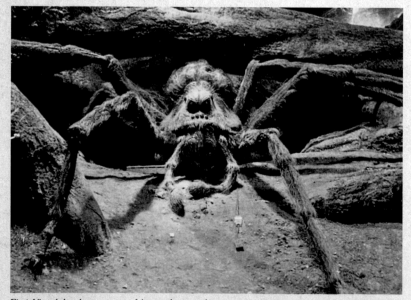

Fig 1. Visual development art of Aragog by an unknown artist for *Harry Potter and the Chamber of Secrets*; Fig 2. (above) The animatronic Aragog awaits his cue on the set of *Chamber of Secrets*.

*Fig 3.*

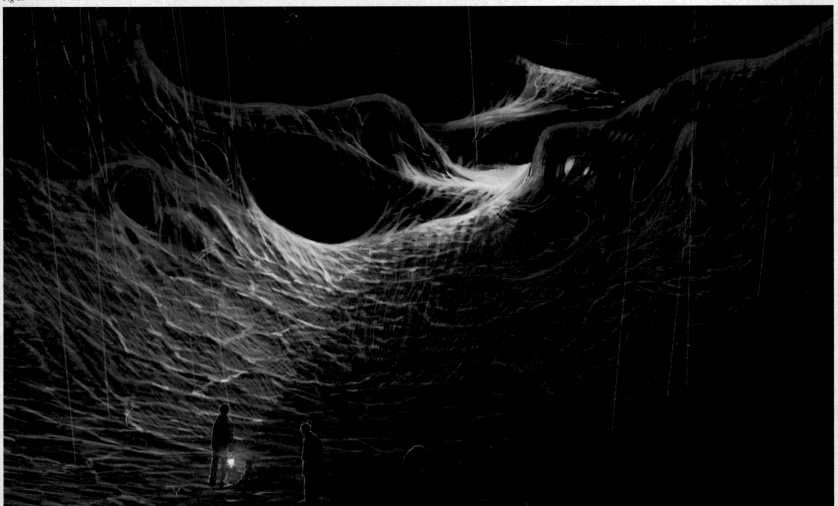

*Fig 4.*

Fig 3. Ron Weasley (Rupert Grint) is grabbed by an Acromantula through the driver's-side window of the flying Ford Anglia in a scene from *Chamber of Secrets*; Fig 4. Harry, Ron, and Fang come upon a heavily spiderweb-draped design of Aragog's lair in art by Dermot Power.

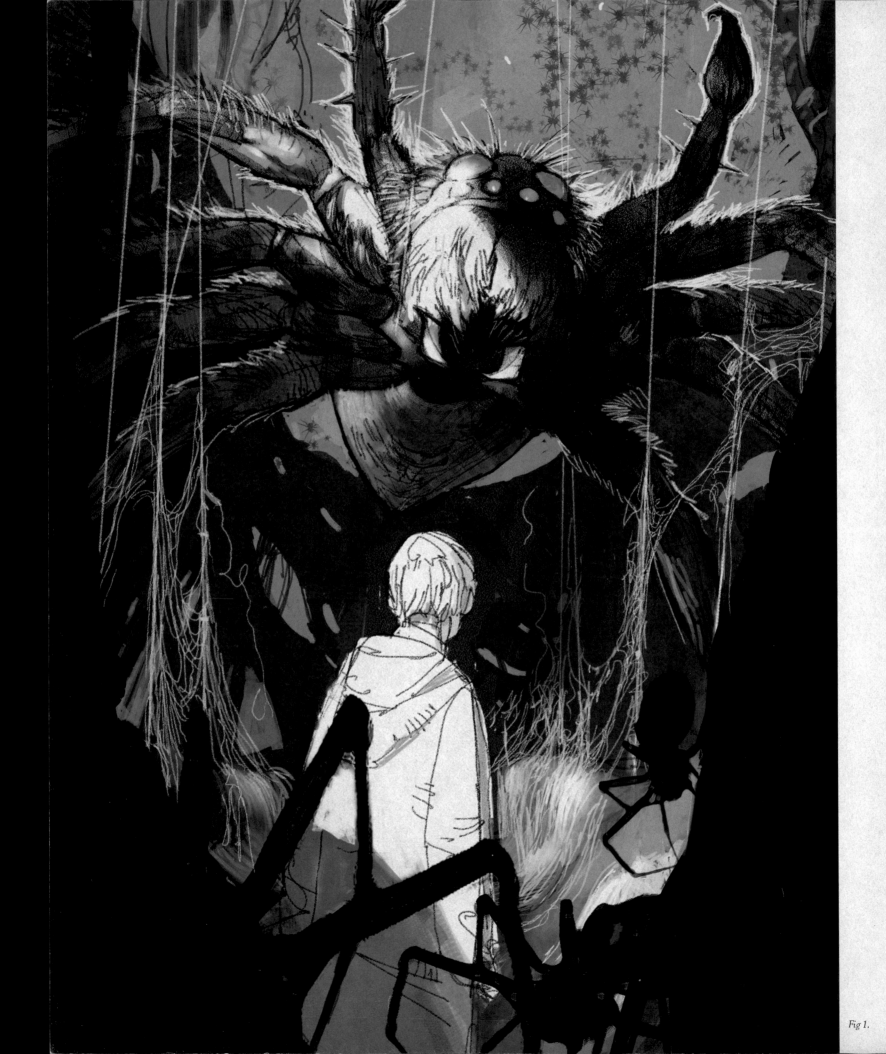

Fig 1.

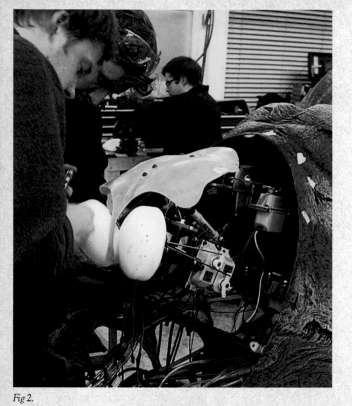

Fig 2.

# FAST FACTS

## ARAGOG

✴

I. FIRST FILM APPEARANCE: *Harry Potter and the Chamber of Secrets*

II. ADDITIONAL FILM APPEARANCE: *Harry Potter and the Half-Blood Prince*

III. LOCATION: Forbidden Forest

IV. TECH TALK: The final version of Aragog in *Half-Blood Prince* weighed three quarters of a ton.

V. DESCRIPTION FROM *HARRY POTTER AND THE CHAMBER OF SECRETS* BOOK, CHAPTER FIFTEEN:

*"And from the middle of the misty, domed web, a spider the size of a small elephant emerged, very slowly. There was gray in the black of his body and legs, and each of the eyes on his ugly, pincered head was milky white."*

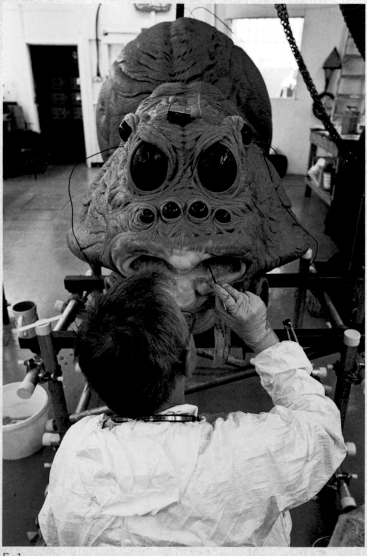

Fig 3.

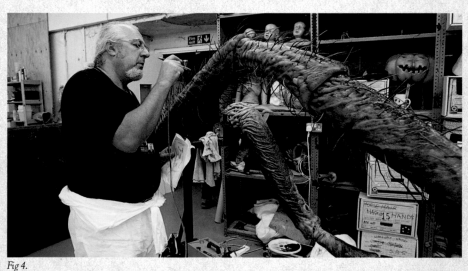

Fig 4.

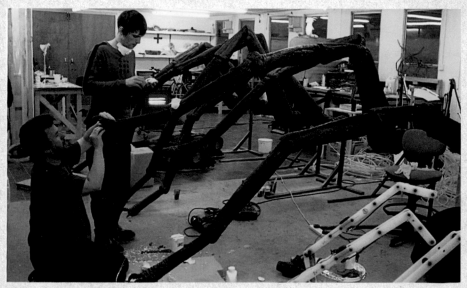

Fig 5.

Fig 1. Harry Potter comes face to mandible with Aragog in artwork by Dermot Power for *Harry Potter and the Chamber of Secrets*; Figs 2. — 5. In the creature shop, designers build the animatronics, and paint, airbrush, and "hair" Aragog.

*Fig 1.*

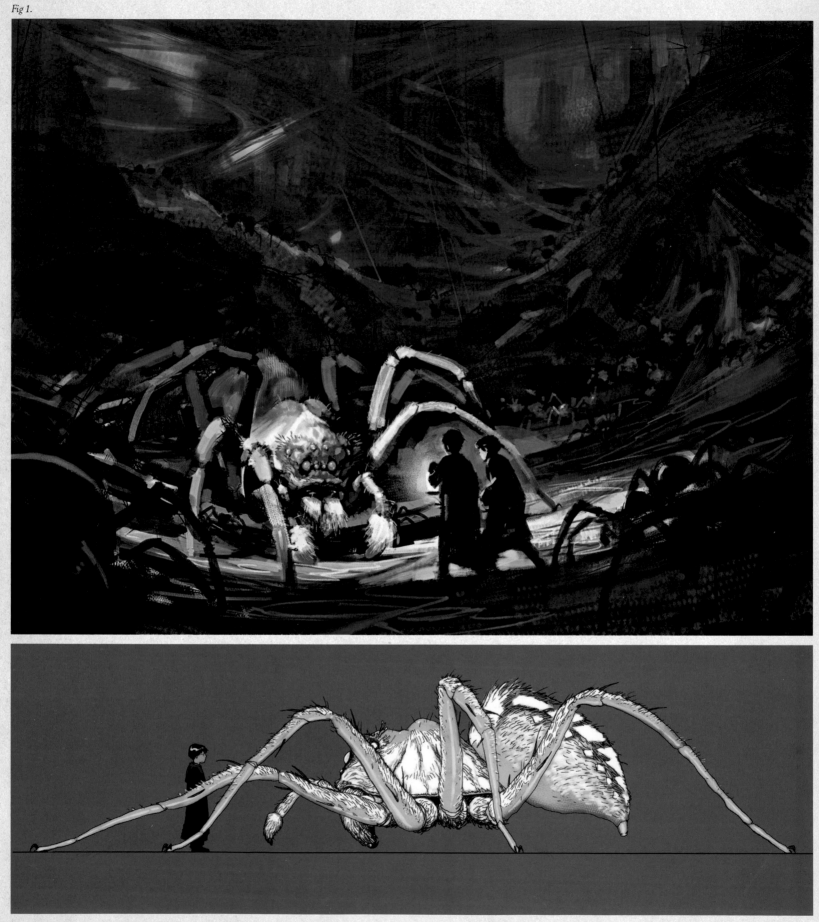

Fig 1. Adam Brockbank's portrayal of Harry and Ron's first meeting with Aragog in the Forbidden Forest in *Harry Potter and the Chamber of Secrets*; Fig 2. (above) A size comparison of wizard and creature by Adam Brockbank.

Fig 3.

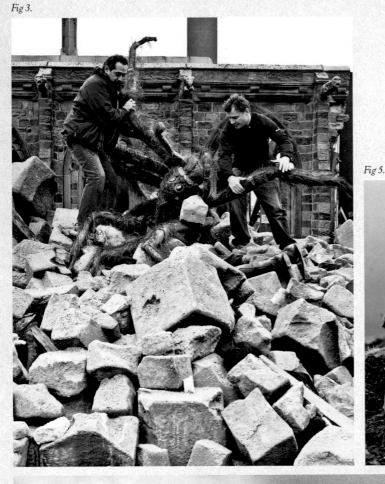

Fig 5.

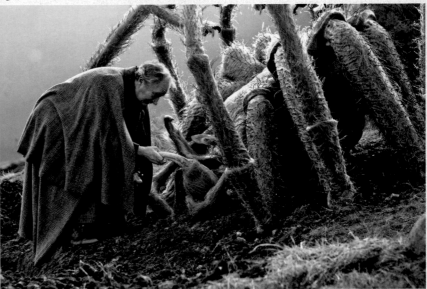

"*Farewell, Aragog, king of the arachnids.*
*The body will decay, but your spirit lingers*
*on in your human friends . . .*"
— EXCERPT FROM ARAGOG'S EULOGY
DELIVERED BY HORACE SLUGHORN
*Harry Potter and the Half-Blood Prince* film

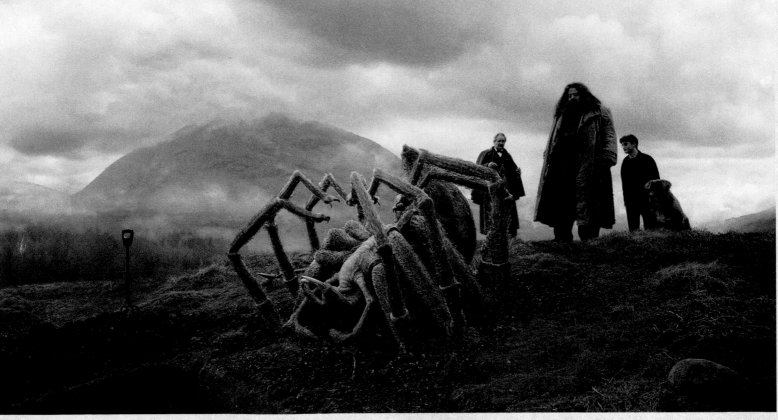

Fig 4.

Fig 3. A relative of Aragog's is carefully positioned onto the rubble of the destroyed Hogwarts set by Esteban Mendoza (left) and Joe Scott (right) for *Harry Potter and the Deathly Hallows – Part 2*; Figs 4. & 5. The emotional burial of Aragog as seen in *Harry Potter and the Half-Blood Prince* attended by Hagrid (Robbie Coltrane), Harry Potter (Daniel Radcliffe), Horace Slughorn (Jim Broadbent), and Fang.

# Hippogriff.

The Hippogriff is an eagle-headed equine that can fly as well as gallop. As taught by Rubeus Hagrid, Care of Magical Creatures professor for third years in _Harry Potter and the Prisoner of Azkaban_, proper etiquette must be observed when meeting a Hippogriff: bow, and always wait for the creature to come to you.

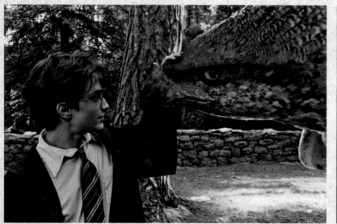

Fig 1.

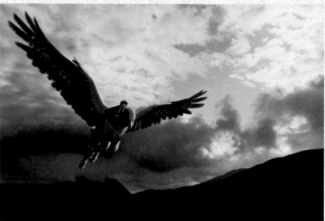

Fig 2.

Figs 1. & 2. Harry Potter (Daniel Radcliffe) meets and rides Buckbeak the Hippogriff in scenes from _Harry Potter and the Prisoner of Azkaban_; Figs 3. – 5. Visual development art of Buckbeak by Dermot Power, exploring the placement of Harry, Hermione, and Sirius upon the Hippogriff's back in the latter two pieces.

Fig 3.

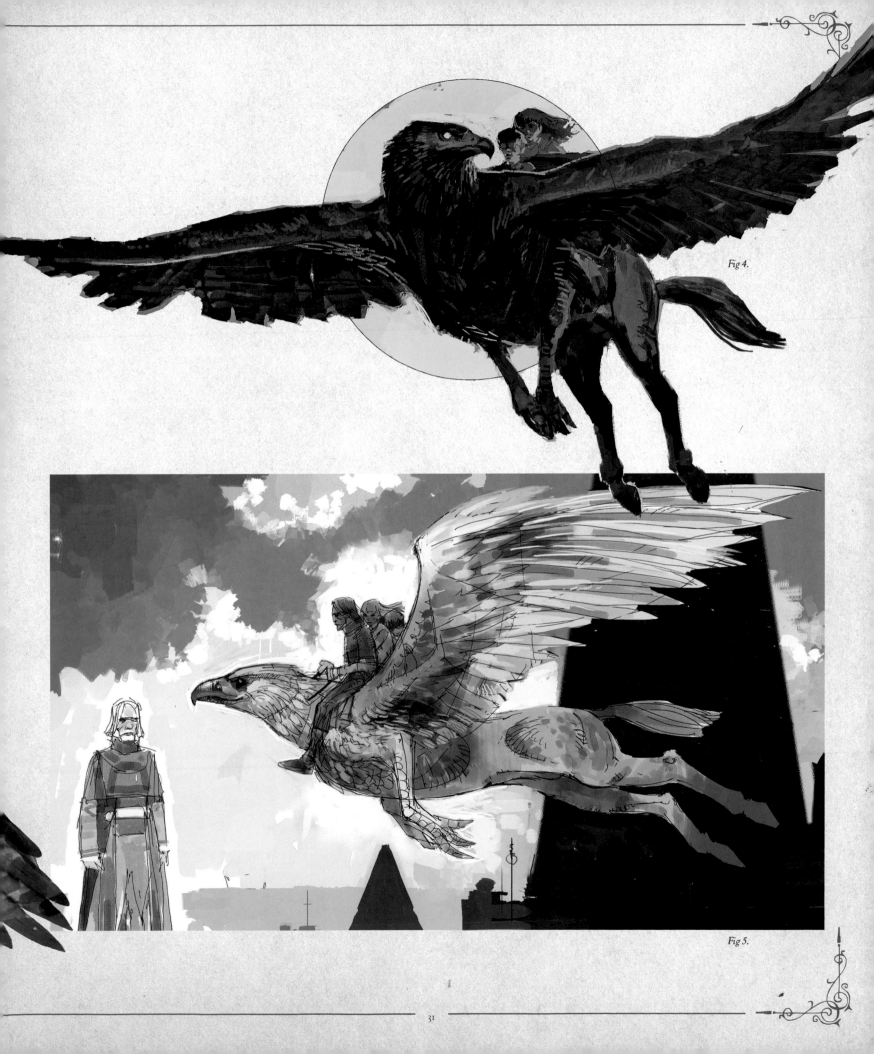

Fig 4.

Fig 5.

Fig 1.

Fig 2.

Fig 3.

Fig 4.

Fig 5.

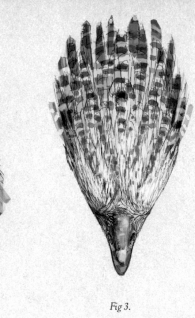

Fig 6.

*First thing yeh wan' t' know about Hippogriffs is that they're very proud creatures. Very easily offended. You do not want to insult a Hippogriff. It may just be the last thing you ever do. Now—who'd like to come and say hello?"*

—RUBEUS HAGRID
*Harry Potter and the Prisoner of Azkaban* film

Fig 7.

*Fig 8.*

*Fig 9.*

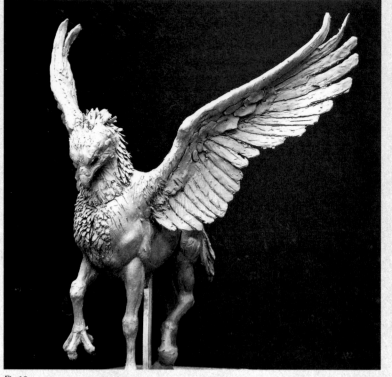

*Fig 10.*

Figs 1. – 5., 7. & 11. Studies of Buckbeak by Dermot Power for *Harry Potter and the Prisoner of Azkaban*; Fig 6. Buckbeak digitally placed into Hagrid's paddock in his first scene in *Prisoner of Azkaban*; Figs 8. – 10. Maquette versions of Buckbeak at different sizes.

*Fig 11.*

# BUCKBEAK.

Buckbeak, the Hippogriff that Hagrid introduces during his first Care of Magical Creatures class in *Harry Potter and the Prisoner of Azkaban,* needed to be able to bow to Harry, and even be ridden by him. Buckbeak is valuable to two rescue operations during the events of *Prisoner of Azkaban,* the first when Harry and Hermione are pursued by the werewolf form of Remus Lupin, and then again when Harry and Hermione save Sirius Black; Buckbeak flew Sirius away from Hogwarts castle.

The designers of Buckbeak drew upon the mythological representations of Hippogriffs when developing the creature for *Harry Potter and the Prisoner of Azkaban,* as well as real birds, primarily the golden eagle, for the creature's profile. To develop Buckbeak's movement, they studied the flight motion of birds and the gaits of horses. They also consulted with veterinarians and physiologists to ensure that there was logic to the proportion of Buckbeak's wings to his legs.

Early development sketches were turned into computer-generated models to test all aspects of the creature's motion—galloping, flying, and, most important, landing. The CGI model was also used to explore Buckbeak's personality, which is alternately regal and coltish. One challenge accomplished by the visual effects team was to create smooth, uninterrupted movement as Buckbeak's wings went from a twenty-eight foot extended wingspan to fully folded wings.

Four models of the Hippogriff were constructed to satisfy different needs. Three were life-size: a digitally controlled standing Buckbeak on a counterbalanced pole arm was used for foreground shots, a freestanding Buckbeak was used for background shots, and the third was the condemned Buckbeak who sat in the pumpkin patch behind Hagrid's hut. The sitting Buckbeak was literally placed into his environment—a very muddy, rocky Scottish hillside— and controlled by Aquatronics. These three Hippogriffs needed to match exactly, and utilized time- and labor-intensive construction methods. Their bird half was accomplished using the same sizes and colors of feathers for each version, with each feather cut, colored, and inserted or glued on individually. Their horse half had their hairs inserted by the complicated flocking process, like the method used for the centaurs, with additional hairs inserted one at a time. It was then airbrushed and art-worked. The fourth Buckbeak was created digitally and used whenever the animal needed to walk or fly.

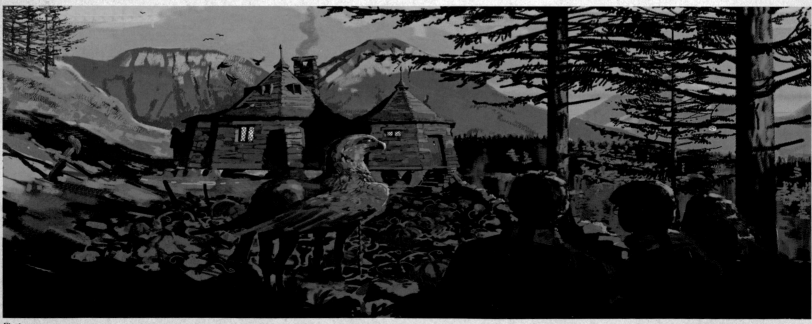

*Fig 1.*

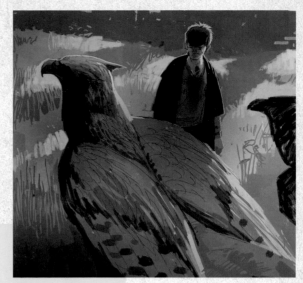

Fig 3.

Fig 2.

Fig 1. Harry, Ron, and Hermione approach Hagrid's hut to rescue Buckbeak, artwork by Andrew Williamson; Fig 2. Artwork of Harry atop Buckbeak by Dermot Power; Fig 3. Harry among several Hippogriffs by Dermot Power; Fig 4. Dermot Power portrays Hagrid's introduction of Buckbeak to Harry.

Fig 4.

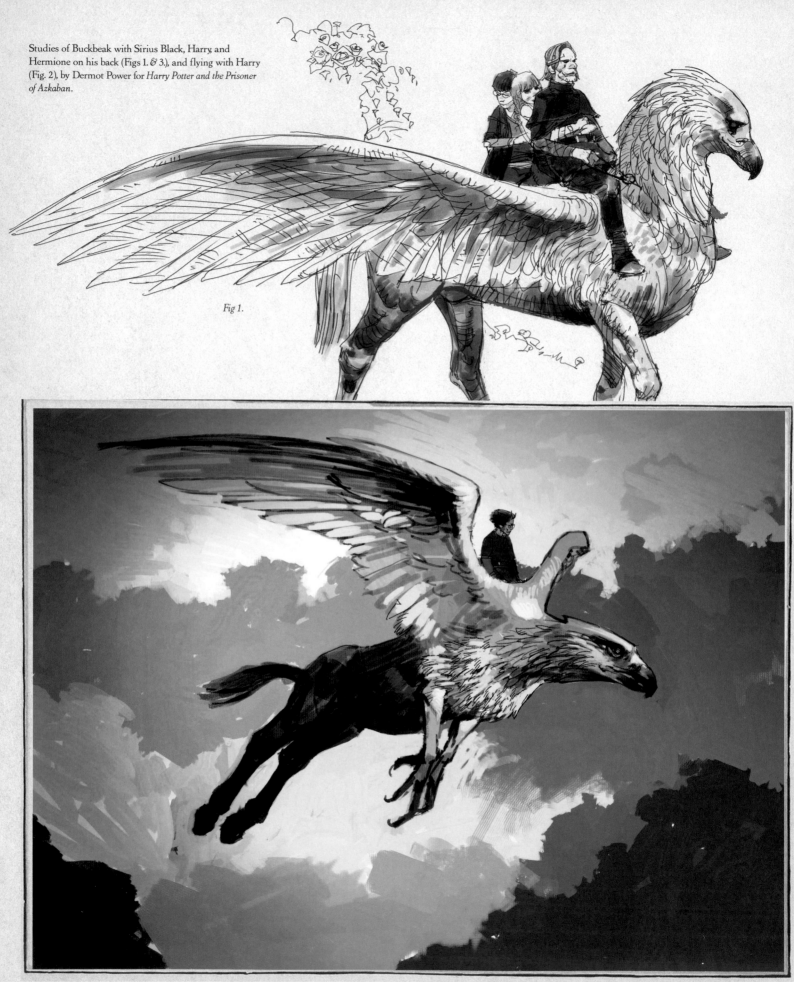

Studies of Buckbeak with Sirius Black, Harry, and Hermione on his back (Figs 1. & 3.), and flying with Harry (Fig. 2), by Dermot Power for *Harry Potter and the Prisoner of Azkaban*.

Fig 1.

Fig 2.

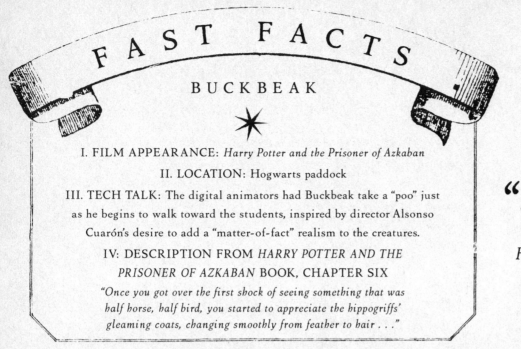

# FAST FACTS

## BUCKBEAK

✦

I. FILM APPEARANCE: *Harry Potter and the Prisoner of Azkaban*

II. LOCATION: Hogwarts paddock

III. TECH TALK: The digital animators had Buckbeak take a "poo" just as he begins to walk toward the students, inspired by director Alsonso Cuarón's desire to add a "matter-of-fact" realism to the creatures.

IV: DESCRIPTION FROM *HARRY POTTER AND THE PRISONER OF AZKABAN* BOOK, CHAPTER SIX

*"Once you got over the first shock of seeing something that was half horse, half bird, you started to appreciate the hippogriffs' gleaming coats, changing smoothly from feather to hair . . ."*

"*Isn't he beautiful? Say hello to Buckbeak.*"
—RUBEUS HAGRID
*Harry Potter and the Prisoner of Azkaban film*

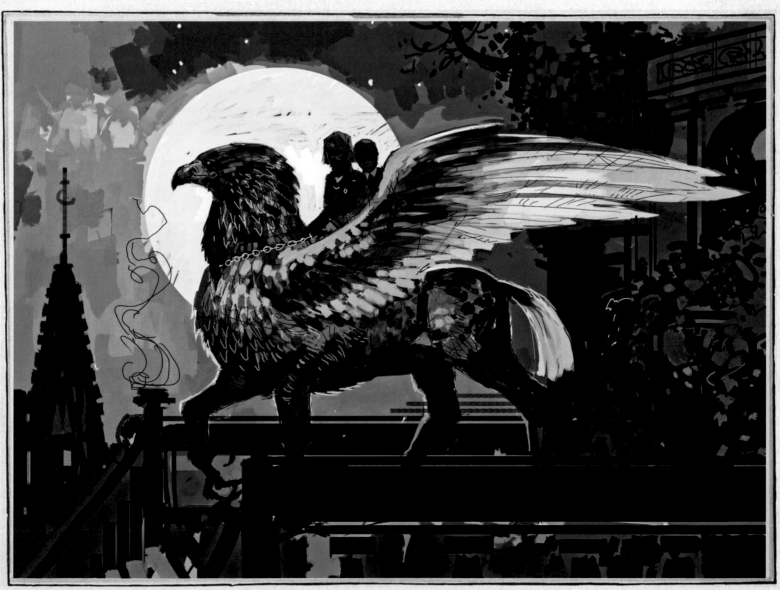

*Fig 3.*

# Thestral.

**I**n the first four *Harry Potter* films, the carriages that shuttle between *Hogsmeade Station* and *Hogwarts* castle appear to be pulled by nothing, but in fact they are pulled by *Thestrals*, which did not need to be realized visually until <u>*Harry Potter and the Order of the Phoenix*</u>. It is only after the events of <u>*Harry Potter and the Goblet of Fire*</u> that *Harry* is able to see these black, skeletal, dragon-faced creatures, as *Thestrals* are visible only to those who have seen death.

Thestrals help transport Harry and other members of Dumbledore's Army to the Ministry of Magic during *Order of the Phoenix*. A Thestral is also used as part of the plan to rescue Harry Potter from Privet Drive in *Harry Potter and the Deathly Hallows – Part 1*, ridden by Bill Weasley and his bride, Fleur Delacour.

The Thestral, a creature unique to the world of Harry Potter, is depicted as having a delicate walk, a quiet cry similar to whale song, and translucent, bat-like wings that enhance its mysterious, disturbing character. The Thestrals are computer-generated, but the creature shop created a full-scale model to ensure that its thirty-foot wingspan would fit into the Forbidden Forest set in *Harry Potter and the Order of the Phoenix*. This model was cyberscanned for the digital artists to utilize. As the Thestral is so emaciated, the computer animators created a detailed skeleton, with special care taken to ensure that the creature's thin skin didn't get "sucked" into its bones. The black coloring of the creature provided a challenge to the designers—a dark, gloomy black would not film well for the screen. It was determined that the model should be painted paler than assumed, and had a mottled color scheme, giving the Thestral a moody radiance among the shadows of the forest set.

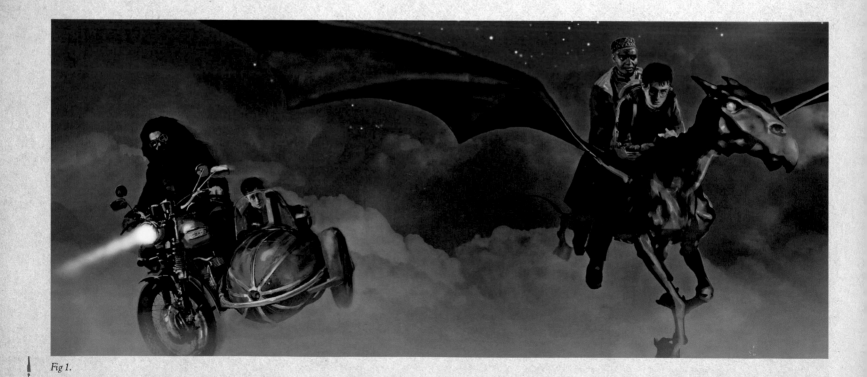

*Fig 1.*

Fig 2.

Fig 3.

At times, the Thestral's horselike anatomy worked against what was required in the script, specifically when Luna feeds the Thestral foal in the forest. Its long legs and short neck made it difficult for its head to reach the ground. The task was finally accomplished when the digital artists had the Thestral position its legs like a giraffe's in order to scoop up the treat.

Adjustments also needed to be implemented for Thestrals in flight. The creatures only carried one passenger each in *Order of the Phoenix*, but to accommodate two passengers in *Deathly Hallows — Part 1*, the Thestral's spine was elongated. The flight scenes were a composite of aerial cinematography and actors filmed riding a fully realized midsection of a Thestral in front of a blue screen. These sculpts had a jointed back and articulated movements that the actors could respond to. Placed on a pre-programmed motion-controlled gimbal, the Thestral model flew in unison with the filmed sequence.

Fig 4.

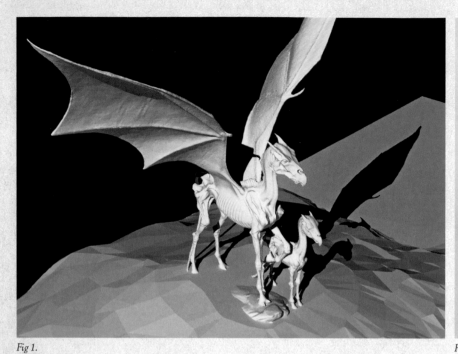
Fig 1.

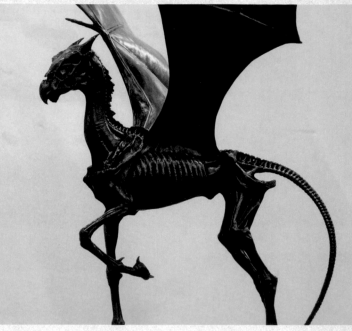
Fig 2.

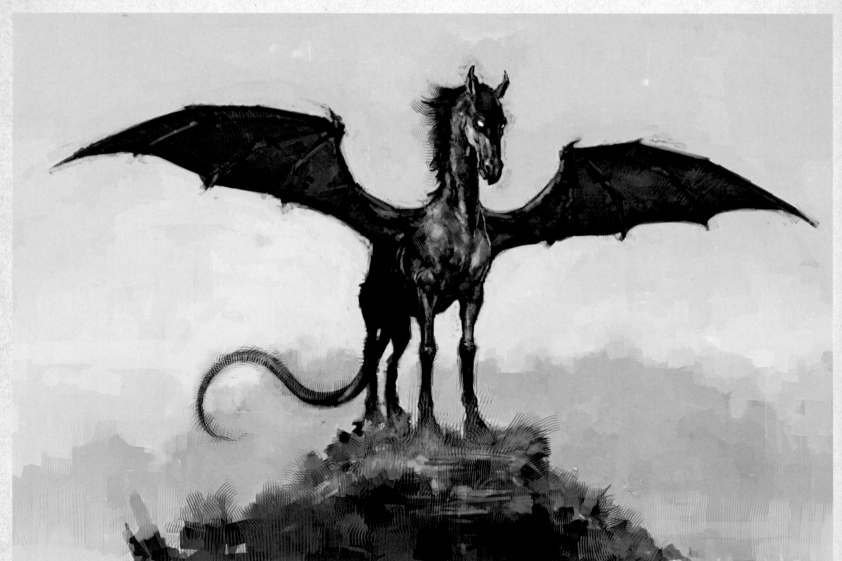

Fig 1. Maquette of a Thestral and its foal for *Harry Potter and the Order of the Phoenix*; Fig 2. Thestral maquette by creature shop sculptor Kate Hill; Fig 3. (above) A Thestral, wings extended, by Rob Bliss; Fig 4. The Thestrals arrive over London on a stormy night by Rob Bliss; Fig 5. Shooting a scene for *Order of the Phoenix*, Daniel Radcliffe (Harry Potter) and Evanna Lynch (Luna Lovegood) use a silhouetted Thestral held by a crewmember for an eyeline; Fig 6. Rob Bliss depicts Luna and Harry's encounter with the Thestral herd in the Forbidden Forest.

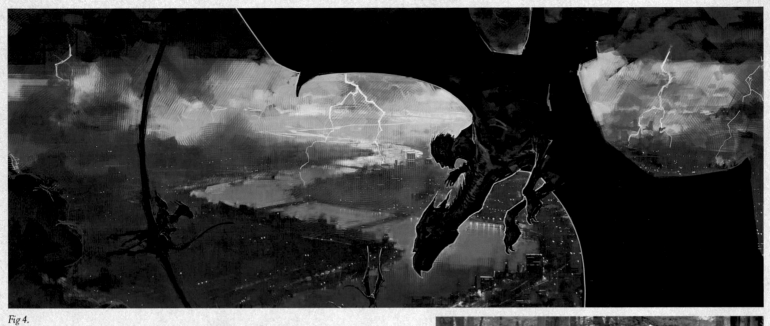

Fig 4.

> "They're called Thestrals. They're quite gentle,
> really, but people avoid them because
> they're a bit . . . different."
> —LUNA LOVEGOOD AND HARRY POTTER
> Harry Potter and the Order of the Phoenix film

Fig 5.

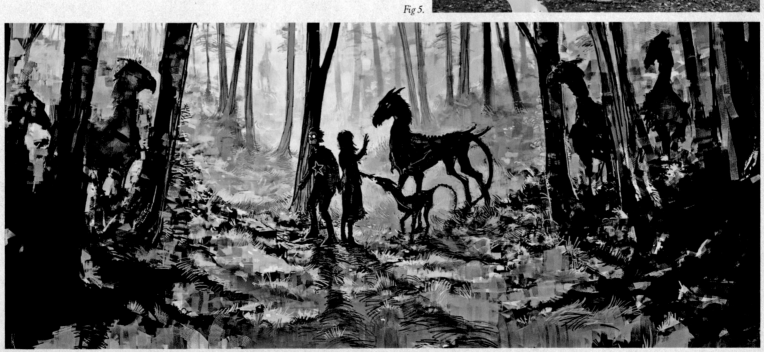

Fig 6.

Fig 1.

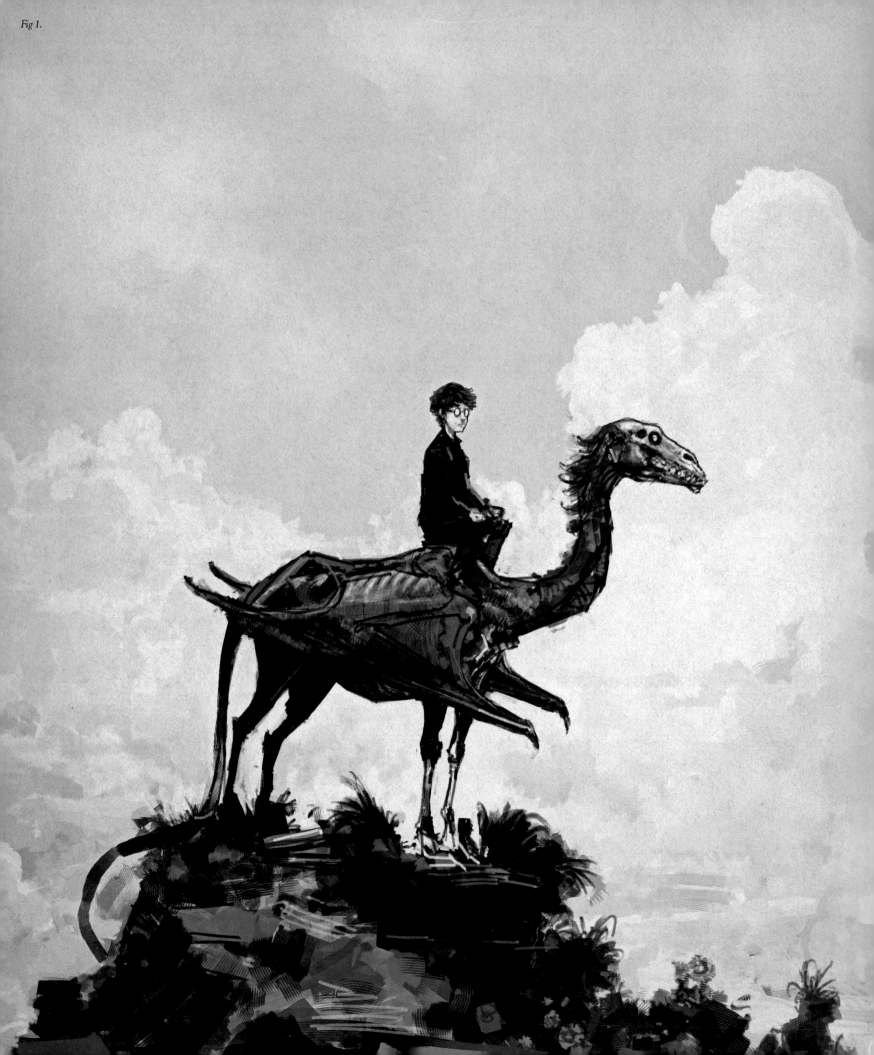

# FAST FACTS

## THESTRAL

✶

I. FIRST FILM APPEARANCE: *Harry Potter and the Order of the Phoenix*

II. ADDITIONAL FILM APPEARANCE:
*Harry Potter and the Deathly Hallows – Part 1*

III. LOCATION: Hogsmeade Station, Forbidden Forest

IV: DESIGN NOTE: The designers had the Thestrals flick flies away from their bodies with their tails just like horses.

V: DESCRIPTION FROM *HARRY POTTER AND THE ORDER OF THE PHOENIX* BOOK, CHAPTER TEN:

*"Wings sprouted from each wither—vast, black leathery wings that looked as though they ought to belong to giant bats. Standing still and quiet in the gloom, the creatures looked eerie and sinister."*

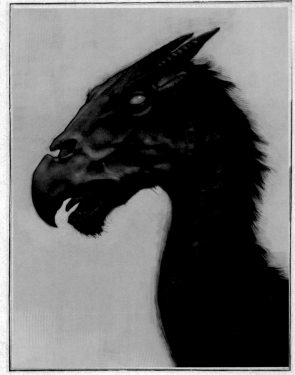

*Fig 2.*

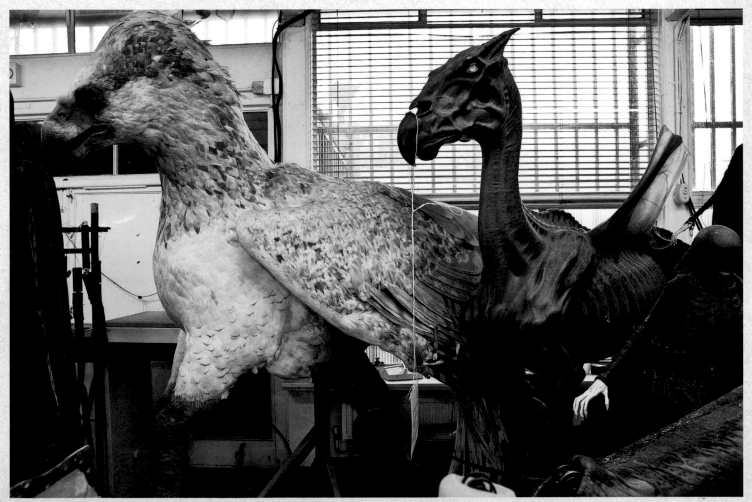

Fig 1. Harry Potter sits a bit awkwardly atop a Thestral in artwork by Rob Bliss for *Harry Potter and the Order of the Phoenix*; Fig 2. Rob Bliss Thestral head study; Fig 3. (above) In the creature shop, the maquettes of Buckbeak, a Thestral, and a Dementor stand side by side.

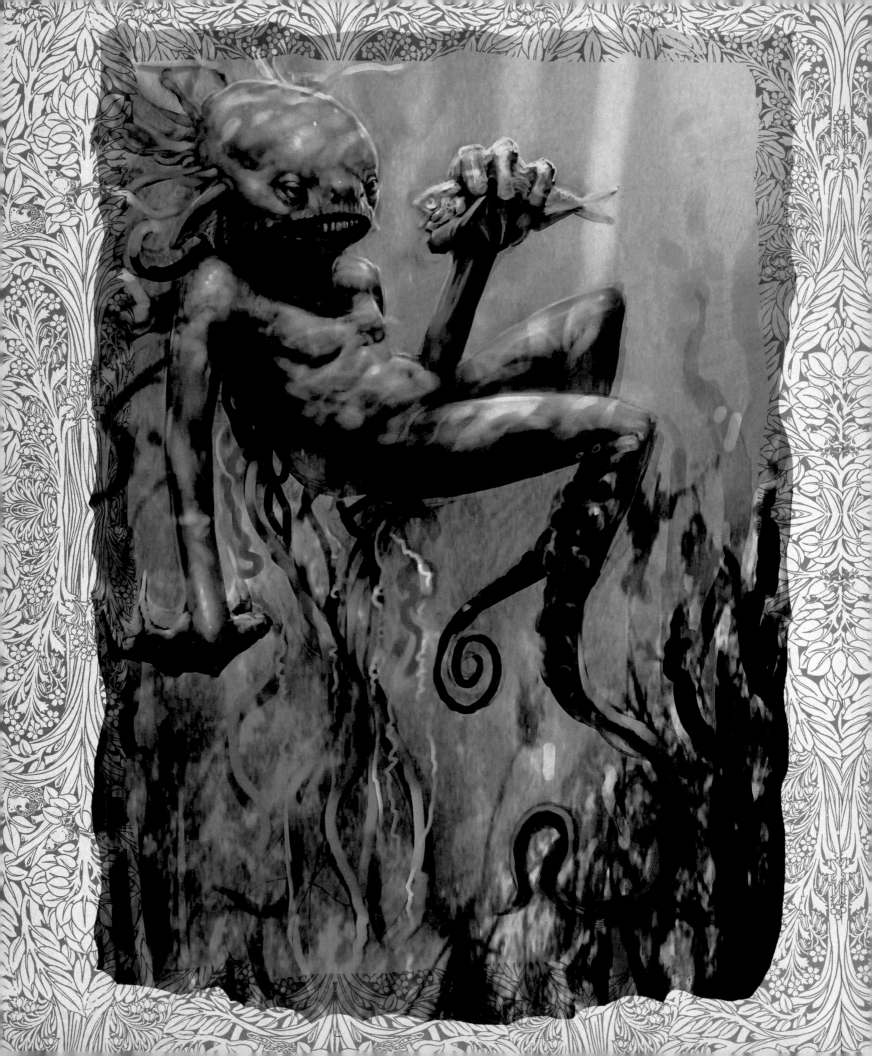

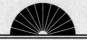

# CHAPTER II

# LAKE DWELLERS

*I*n the Harry Potter films, Hogwarts castle perches on a cliff beside the great black lake, which is the location for the second task of the Triwizard Tournament in <u>Harry Potter and the Goblet of Fire</u>. Inhabitants of the black lake include the merpeople, a blend of human and fish, whose speech is only understandable underwater. The champions of the tournament also encounter another resident community of the lake, the impish Grindylows.

Fig 1.

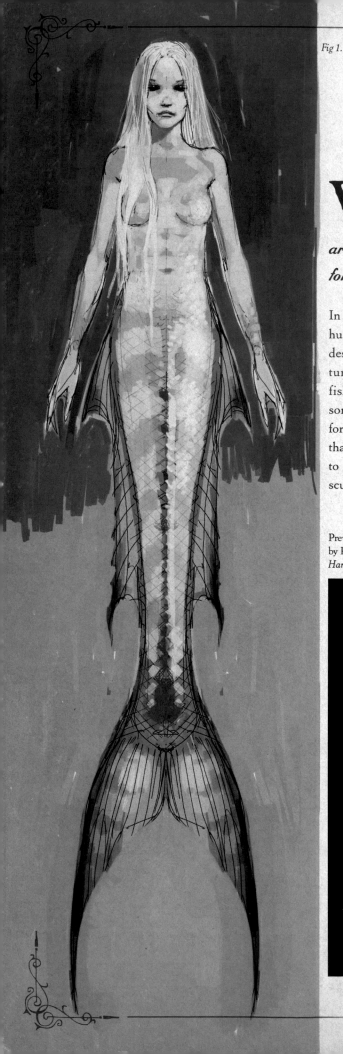

# Merperson.

**W**ielding tridents, the merpeople of the black lake monitor the Triwizard champions in a forest of kelp and coral-crusted architecture to ensure that the students follow the parameters of their mission for the second task of the Triwizard Tournament.

In traditional folklore and artwork of mermaids, there is a noticeable break between their human and their fish halves. But for the merpeople in *Harry Potter and the Goblet of Fire*, the designers distributed the fishiness throughout the being's anatomy to craft a composite creature. This seamless combination morphs a human and, specifically, a sturgeon, with large, fishlike eyes and a bulging mouth. Other breaks with convention were having the merperson's tail move from side to side instead of up and down, and adding dorsal and pelvic fins for stability. Their scaly skin even imitates the bony scutes of a sturgeon, shield-like plates that appear in parallel rows down the body. The designers chose a dark, muddy color palette to emphasize the merpeople's menacing personality. Once the design was finalized, it was sculpted, molded, and then cyberscanned to become computer-generated creatures.

Previous: A two-legged Grindylow prepares to eat a tasty meal among the kelp leaves of the black lake in concept artwork by Paul Catling for *Harry Potter and the Goblet of Fire*; Fig 1. An early concept drawing of a merperson by Dermot Power for *Harry Potter and the Goblet of Fire*; Fig 2. Adam Brockbank artwork portrays a merperson with octopus-like hair.

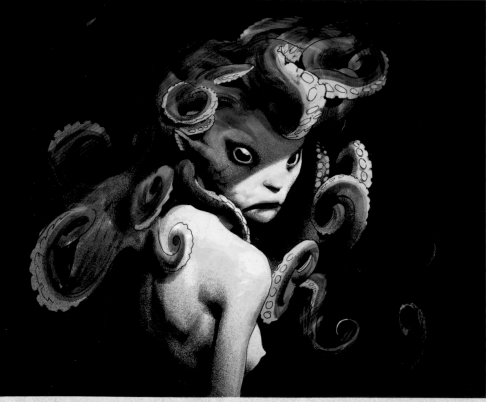

Fig 2.

Fig 3. Merperson spear and trident by Adam Brockbank; Fig 4. (above) A later development concept of a merperson by Adam Brockbank.

Fig 1.

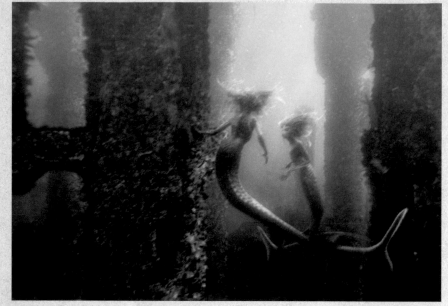

Fig 1. Merpeople swim among their organically encrusted architecture under the black lake in a scene from *Harry Potter and the Goblet of Fire*; Fig 2. Artwork of merpeople showcasing the parallel rows of scutes that run down their backs, by Adam Brockbank; Fig 3. A pencil sketch defines the forms of a merperson, fully realized and contoured in Fig 4., both by Adam Brockbank.

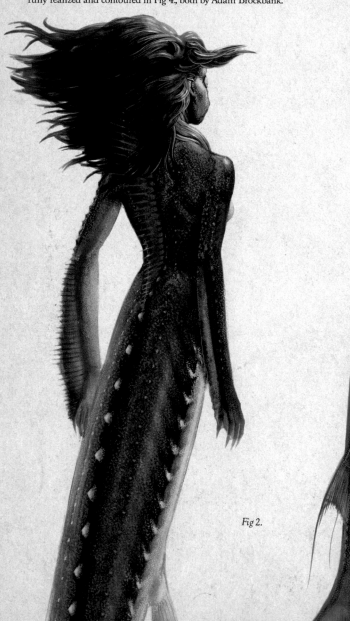

Fig 2.

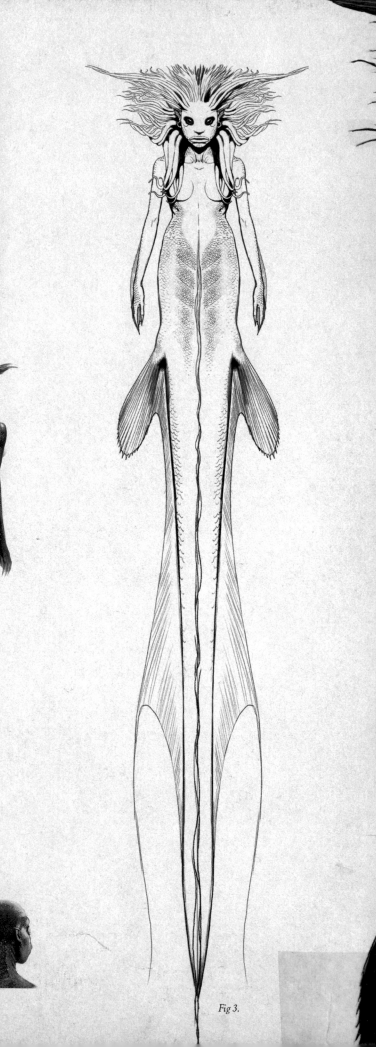

Fig 3.

# FAST FACTS

## MERPERSON

✦

I. FILM APPEARANCE: *Harry Potter and the Goblet of Fire*

II. LOCATION: The black lake

III. DESIGN NOTE: The merpeople's hair was designed to float underwater like translucent sea anemones.

IV: DESCRIPTION FROM *HARRY POTTER AND THE GOBLET OF FIRE* BOOK, CHAPTER TWENTY-SIX:

*"The merpeople had grayish skin, and long, wild, dark green hair. Their eyes were yellow, as were their broken teeth, and they wore thick ropes of pebbles around their necks."*

*Fig 4.*

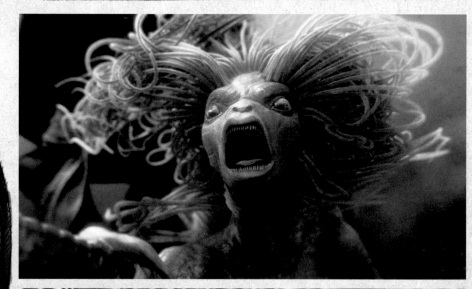

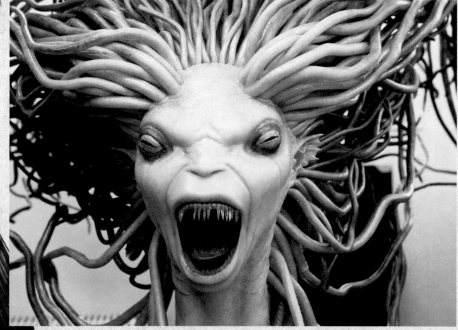

Fig 5. (top) A merperson reprimands Harry during the second task of the Triwizard Tournament; Fig 6. (above) A merperson maquette with the same admonishing face.

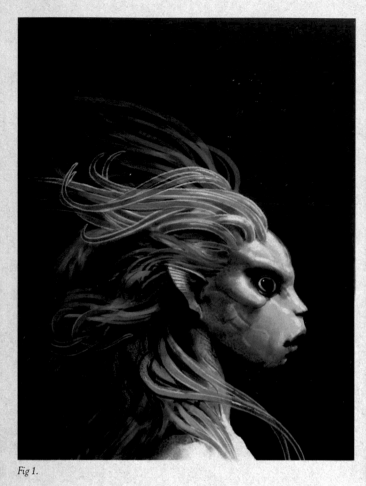

Fig 1.

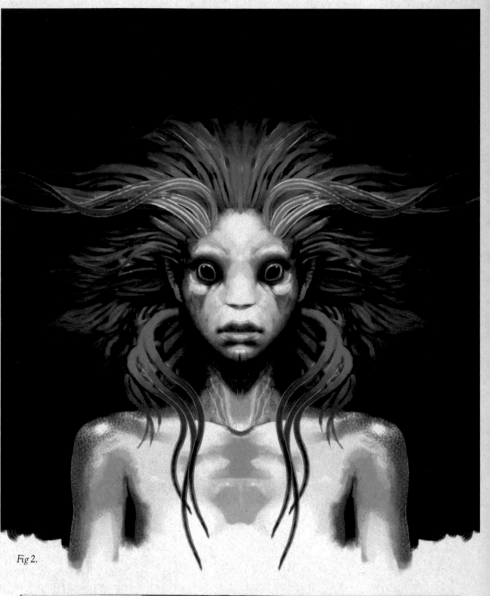

Fig 2.

> "Come seek us where our voices sound,
> we cannot sing above the ground.
> An hour long you'll have to look
> to recover what we took."
> —MERPEOPLE'S CLUE
> FOR THE SECOND TASK
> OF THE TRIWIZARD
> TOURNAMENT
> Harry Potter and the Goblet of Fire film

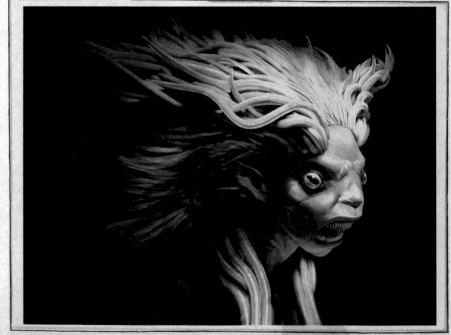

Fig 3.

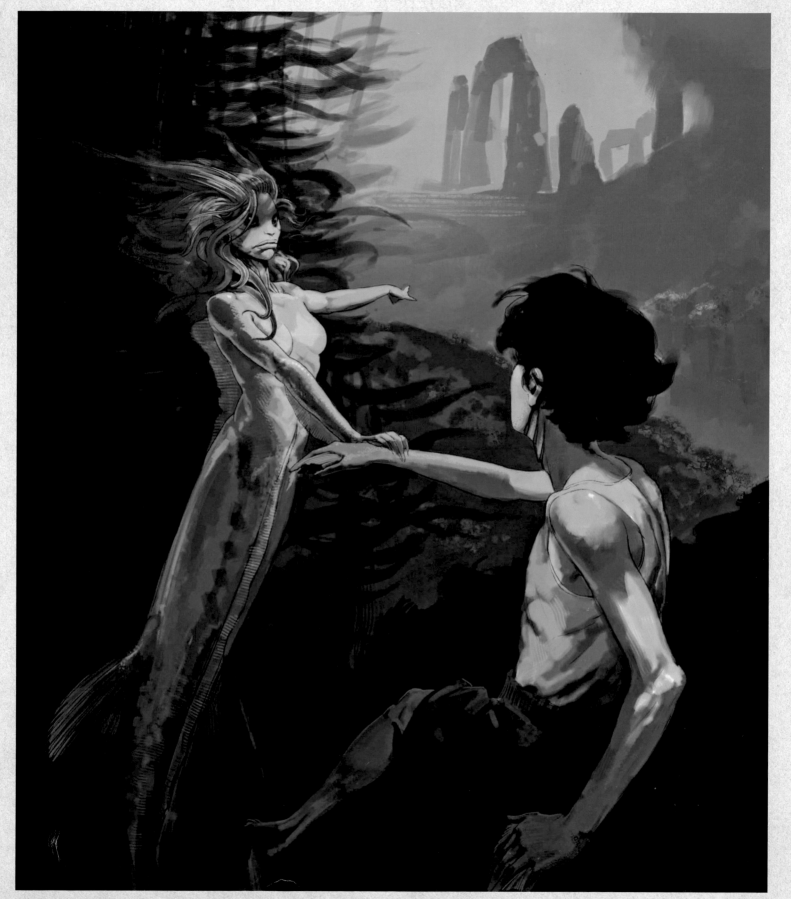

Figs 1. — 3. Head studies of merpeople by Adam Brockbank for *Harry Potter and the Goblet of Fire*; Fig 4. (above) Adam Brockbank's depiction of
a merperson helping Harry during the second task of the Triwizard Tournament, a circumstance that did not actually occur in *Goblet of Fire*.

# Grindylow.

In the *Harry Potter* films, Grindylows are unfriendly little creatures with short octopus-like arms and bulbous, tentacled heads that live in the black lake. Harry Potter narrowly escapes their grasp in <u>Harry Potter and the Goblet of Fire</u> during the second task of the Triwizard Tournament.

Fig 1.

When given the task of bringing the Grindylows to life on-screen in *Harry Potter and the Goblet of Fire*, the visual development artists came up with many different versions of what this underwater creature could be. Grindylows were designed with small heads, two legs, two webbed feet, eight webbed hands, huge glowing eyes, or large pointed ears. Several were luminescent, similar to fish that live in the darkest corners of the deep sea. Some bodies were shaped to resemble frogs, others were seal-like, and several had their own version of a mermaid's tale. With this many ideas in the mix, a design was chosen based on what Grindylows needed to do physically. That's when the creature shop produced a design they described as a cross between "a nasty child and an octopus," complete with a significantly large grinning mouth filled with sharp teeth. As was done with so many of the other creatures in the Harry Potter film series, full-size silicone maquettes were created and painted, then cast again as fiberglass models to be cyberscanned for the CGI artists to animate. Additionally, new software was developed by the visual effects team to handle the large number of Grindylows in a simplified way.

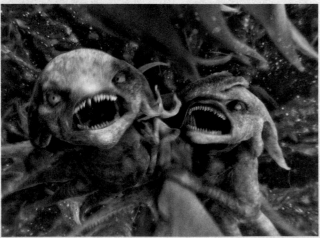

Fig 2.

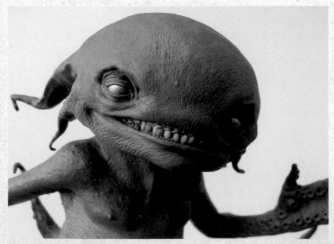

Fig 3.

Fig 1. A mass of Grindylows peers from a kelp forest in early concept art by Paul Catling for *Harry Potter and the Goblet of Fire*; Fig 2. The Grindylows attack Harry in a scene from the film; Fig 3. A Grindylow maquette; Fig 4. A digital maquette with sucker-strewn tentacles by Paul Catling.

Fig 4.

Fig 1.

Fig 3.

Fig 2.

GRINDYLOW

✳

I. FILM APPEARANCE: *Harry Potter and the Goblet of Fire*

II. LOCATION: The black lake

III. TECH TALK: Two stuntmen pulled and clawed at
Daniel Radcliffe's (Harry Potter) legs in a green-screen
underwater tank to imitate the grasping Grindylows.

IV: DESCRIPTION FROM *HARRY POTTER AND THE
GOBLET OF FIRE* BOOK, CHAPTER TWENTY-SIX:

*"Harry . . . saw a Grindylow, a small, horned water demon, poking out of the weed,
its long fingers clutched tightly around Harry's leg, its pointed fangs bared . . ."*

Figs 1. — 3. Grindylow anatomy studies by Paul Catling for *Harry Potter and the
Goblet of Fire*; Figs 4. — 7. Paul Catling's visual development artwork explored
myriad possibilities for Grindylow colors, arms, legs, and teeth.

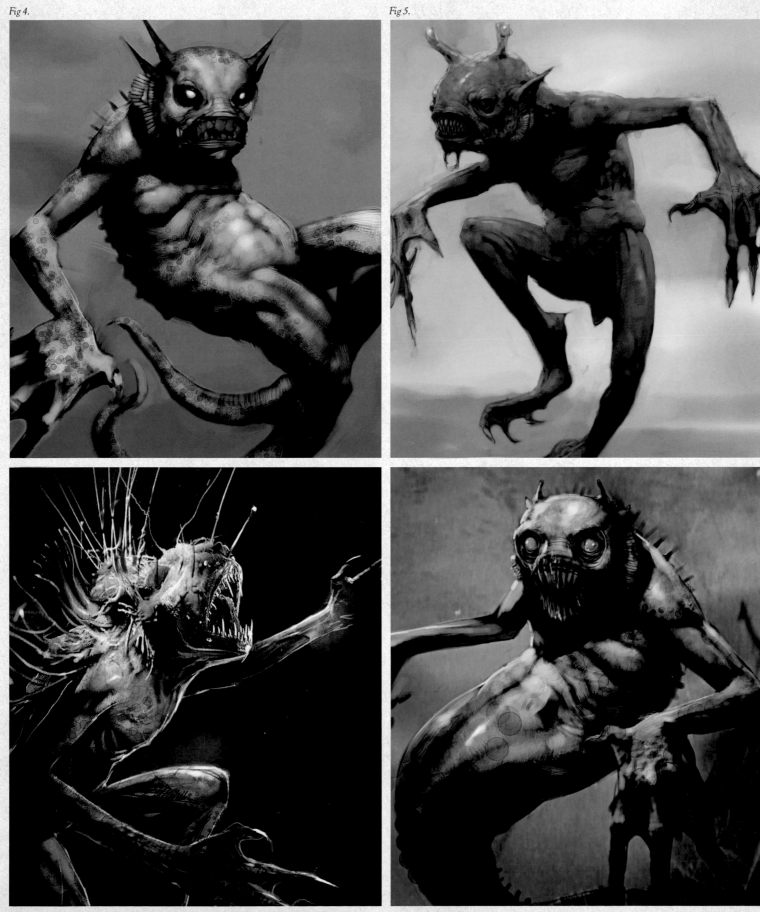

Fig 4.

Fig 5.

Fig 6.

Fig 7.

Fig 1.

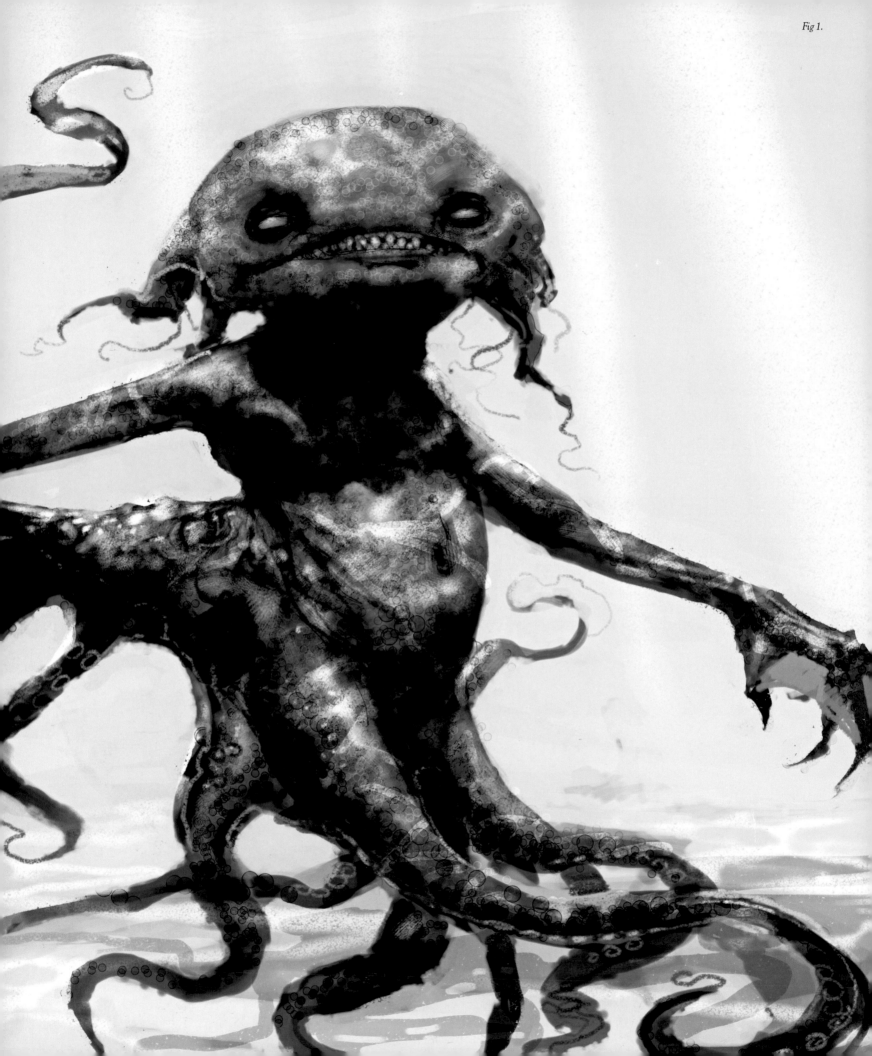

"*Fleur never got past 'ze Grindylows!*"
— HERMIONE GRANGER
*Harry Potter and the Goblet of Fire* film

Fig 1. Near-final concept art of the Grindylow with tentacles by Paul Catling for *Harry Potter and the Goblet of Fire*; Fig 2. Digital maquettes portray different mouth and eye positions of the ill-behaved Grindylows by Paul Catling.

*Fig 2.*

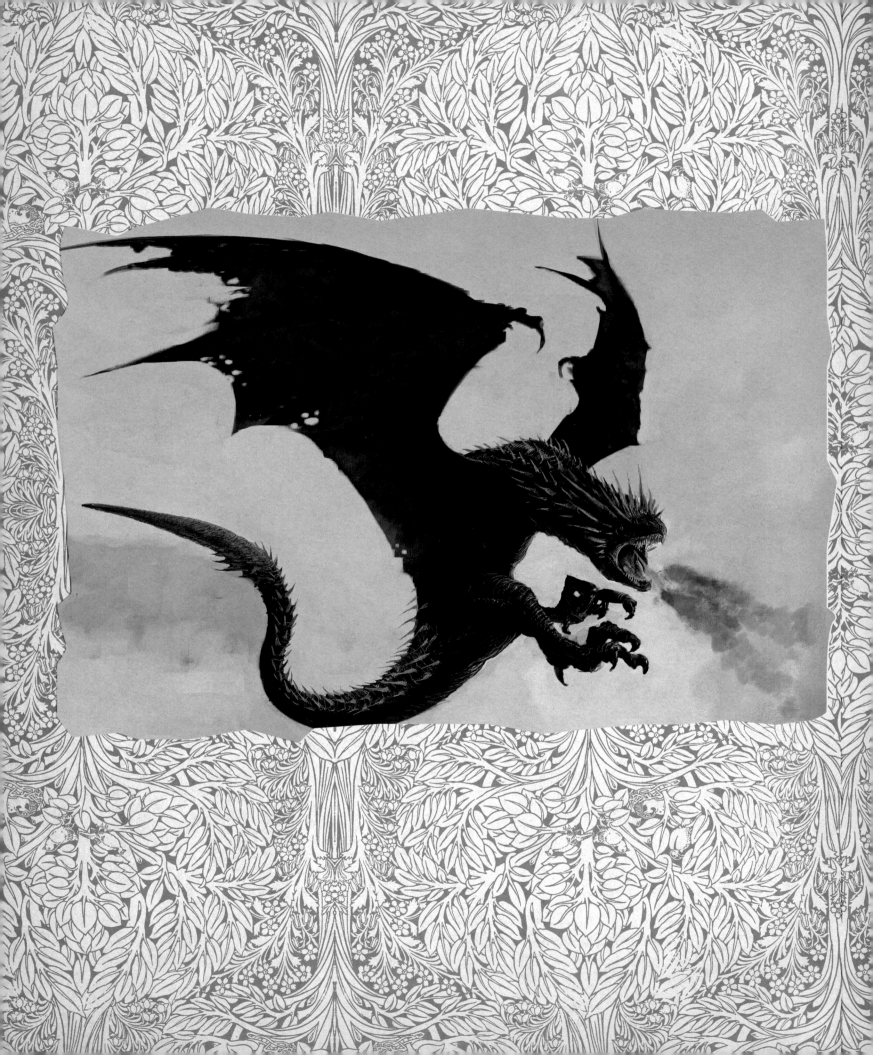

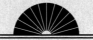

# CHAPTER III

# SKY DWELLERS

*O*wls and crows, among other creatures, including Hippogriffs and Thestrals, fly in the blue skies above Hogwarts castle throughout the Harry Potter films. But there have been times when additional flying creatures—large and small—have been brought onto the school grounds. Cornish pixies were released in the Defense Against the Dark Arts classroom for a teaching demonstration that didn't turn out exactly as planned. And dragons soared above and around the arena built for the first task of the Triwizard Tournament, in a clash with four champions.

# Dragon.

Throughout the *Harry Potter* films, one of the most thrilling of the flying creatures is the fire-breathing dragon, and the filmmakers were offered several opportunities to portray these powerful reptilian creatures using time-honored and new techniques. Hagrid's dream of fostering a dragon comes true, albeit for a short time. Four powerful dragons are used in the first task of the Triwizard Tournament. And Gringotts bank employs an old but powerful dragon to guard its deepest vaults.

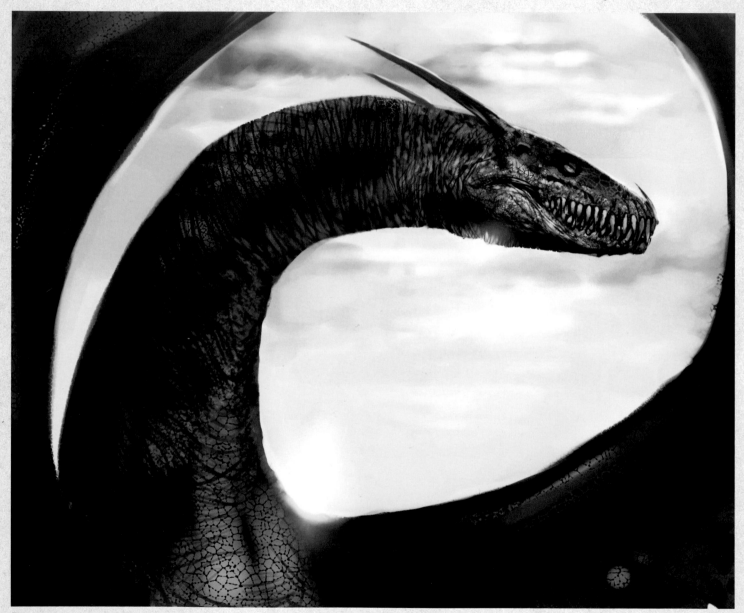

*Fig 1.*

Previous: The fire-breathing Hungarian Horntail by Paul Catling for *Harry Potter and the Goblet of Fire*; Figs 1. & 2. Visual development art by Paul Catling of unidentified dragons for *Harry Potter and the Goblet of Fire*.

"*Dragons are seriously misunderstood creatures.*"
— RUBEUS HAGRID
*Harry Potter and the Goblet of Fire* film

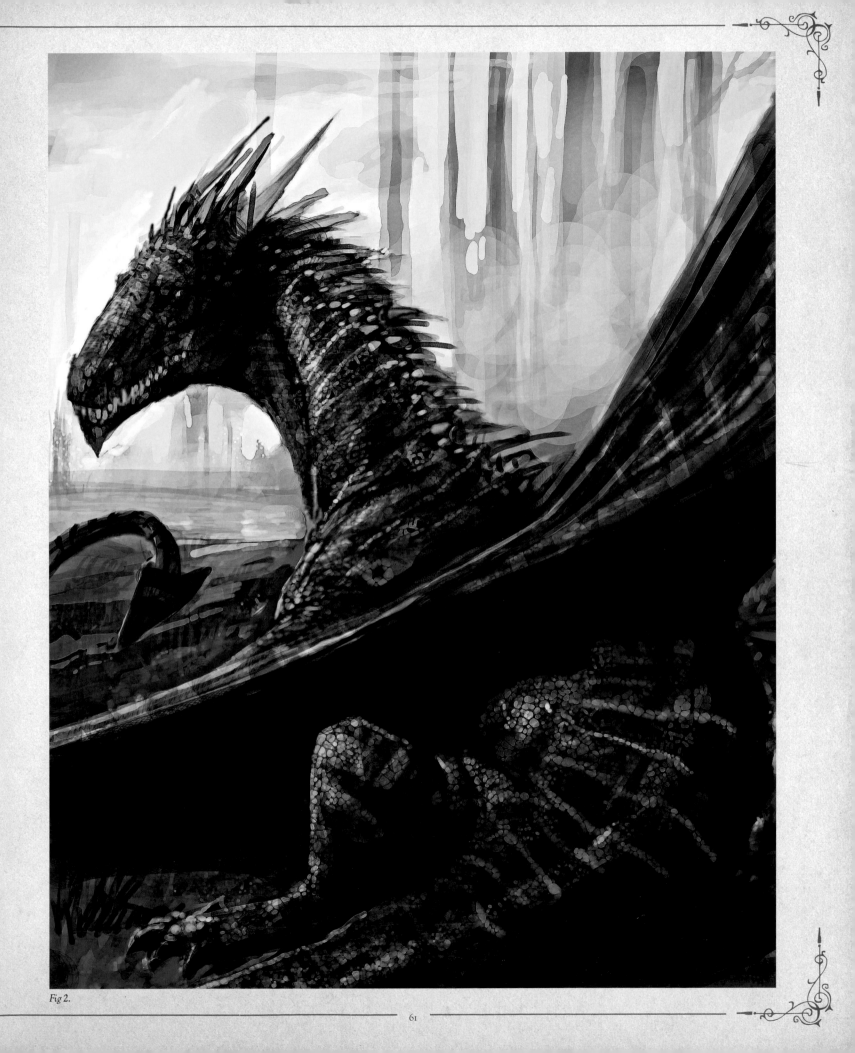

Fig 2.

*Fig 1.*

*Dragon example 1.*

# NORWEGIAN RIDGEBACK.

In *Harry Potter and the Sorcerer's Stone*, Hagrid wins a dragon egg, which hatches into a wobbly-legged, shiny, grayish-green, drooling baby Norwegian Ridgeback dragon. Dragons are usually built on the larger side of the scale, but Norbert is newly hatched and so the designers needed to work on the smaller side. The filmmakers decided that at this stage, the ridge in "Ridgeback" wouldn't be quite developed, and in the film the infant dragon's head and legs are larger in proportion to its body than those of the more mature dragons that they created. In *Harry Potter and the Sorcerer's Stone*, Norbert is a completely digital construction, as is the fire that singes Hagrid's beard when the dragonet hiccups out his first flame.

*Fig 2.*

" *Isn't he beautiful? Oh, bless 'im, look,*
*he knows 'is mummy. Hallo, Norbert.*"
— RUBEUS HAGRID
*Harry Potter and the Sorcerer's Stone* film

*Fig 3.*

## FAST FACTS

### NORWEGIAN RIDGEBACK

✦

I. FILM APPEARANCE: *Harry Potter and the Sorcerer's Stone*

II. LOCATION: Hagrid's hut

III. DESCRIPTION FROM *HARRY POTTER AND THE SORCERER'S STONE* BOOK, CHAPTER FOURTEEN:

"*It wasn't exactly pretty; Harry thought it looked like a crumpled, black umbrella. Its spiny wings were huge compared to its skinny jet body, and it had a long snout with wide nostrils, the stubs of horns, and bulging, orange eyes.*"

Fig 1. Norwegian Ridgeback concept art for *Harry Potter and the Sorcerer's Stone*; Figs 2. & 3. Paul Catling portrays the fledgling Norwegian Ridgeback Norbert's awkward gawkiness; Fig 4. Harry (Daniel Radcliffe) and Ron (Rupert Grint) witness Norbert's hatching in a scene from *Sorcerer's Stone*.

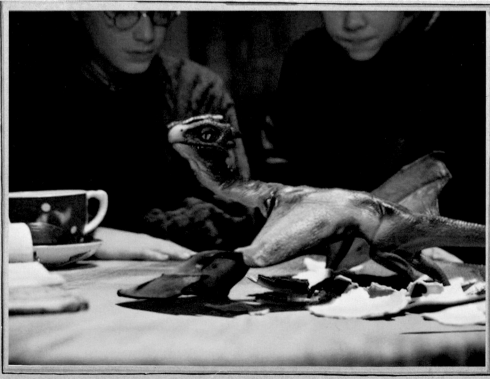

" *That's not just a dragon.*
*That's a Norwegian Ridgeback!*"
— RON WEASLEY
*Harry Potter and the Sorcerer's Stone* film

*Fig 4.*

# HUNGARIAN HORNTAIL.

The first task of the Triwizard Tournament in *Harry Potter and the Goblet of Fire* requires the champions to retrieve one of four golden eggs guarded by different breeds of dragon. The concept artists explored innumerable colors, textures, profiles, and wing and tail forms to realize the variety of dragons to be seen on-screen. Harry is the last champion to draw the miniature representation of the dragon he will fight from the velvet bag Ministry supervisor Bartemius Crouch, Sr., holds, and it is none other than the Hungarian Horntail. The dragon model of the Horntail shows up again in *Harry Potter and the Half-Blood Prince*, where it is being used to roast chestnuts on a cart outside of Weasley Wizard Wheezes in Diagon Alley.

Aware of the legacy of dragons in mythology and media, the creative team on *Harry Potter and the Goblet of Fire* admitted their challenge was not *what* to do but what *not* to do when creating the dragons of the Triwizard Tournament—not have their dragons look like others that had come before. Visual development artists offered a dragon's horde of choices. Options included dragons with rows of large teeth, no teeth at all, or teeth like a walrus's. Some designs took their cue from recognizable animals: dragons had the heads of rhinos, snakes, lizards, tortoises, and even a Doberman dog. For the dragon that Harry Potter would draw, they had some specific direction given the name of the creature: Hungarian Horntail.

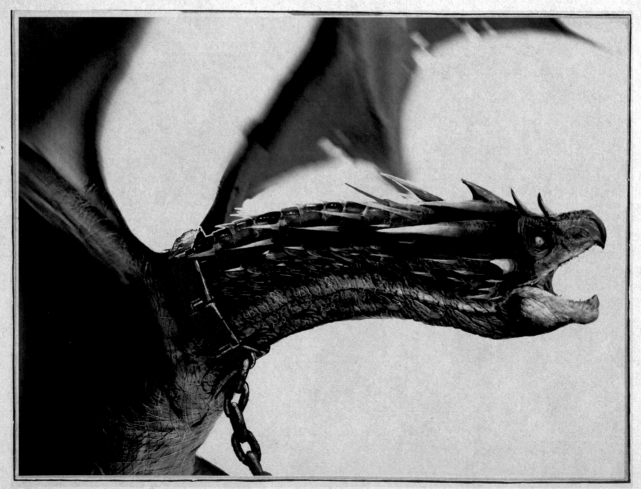

*Fig 1.*

Previous: Harry confronts a Hungarian Horntail in the first task of the Triwizard Tournament in artwork by Paul Catling for *Harry Potter and the Goblet of Fire*; Fig 1. Visual development art of the Hungarian Horntail by Adam Brockbank; Fig 2. A scale version maquette of the Hungarian Horntail; Fig 3. Caged prior to the first task, the Hungarian Horntail shoots a stream of fire out of the bars in a scene from *Goblet of Fire*; Fig 4. The fully realized, fire-breathing Hungarian Horntail head sits beside the Basilisk in the creature shop.

*Fig 2.*

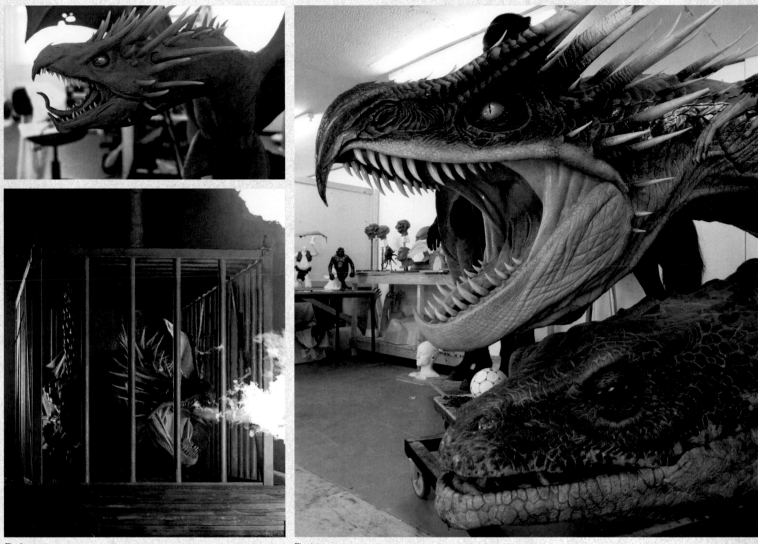

*Fig 3.*

*Fig 4.*

Initial approaches to the "horntail" part of the dragon included a tail resembling a scorpion's, a tail with one long spike, a tail with rows of spikes, and a tail with a cluster of spikes at its end. The final design gave the Horntail a blunt, hawklike head, huge taloned wings, two heavily clawed legs, and a ruff of spikes that runs down to her tail, which ends in a spear-shaped spike covered in smaller spikes.

The Horntail's movements were taken from those of predatory birds—falcons, hawks, and eagles. Her wings could be animated in concert or independently, she could "walk" across the Hogwarts castle roofs, and even hang with her wings folded like a bat.

The creature department created a fully painted fiberglass maquette of the Horntail at half scale—thirty feet long with a fourteen-foot wingspan—that was used for cyberscanning. They were then asked to build a bigger model, and so they built the head of the Horntail at full scale, which was used for lighting references and sight lines. Then they were asked to build the actual creature, to be used in the scene where Harry sees the caged dragons in the Forbidden Forest. The crew not only constructed a moving, threatening dragon, they also made it breathe fire.

Parts of the Basilisk from *Harry Potter and the Chamber of Secrets* were recycled to build a dragon's body that would fit inside the cage. The Horntail's actions were controlled by puppeteers who flapped the creature's wings and shook the cage's bars. The final dragon was nearly forty feet long, stood seven feet tall at the shoulder, and had an extended wingspan of seventy feet.

The skin of the Horntail was crafted in polyurethane and the spikes were resin. Six sizes of spikes were molded, with many of them cracked or bent or broken, as the film's producers imagined that this dragon would have already had a long life of fighting. Her wings were aged and torn up to give her even more history. The special effects department was asked to install a flamethrower device, so a new head was recast in fiberglass, painted, and spiked, with its snout coated in Nomex, which made it fireproof. The dragon fire could reach up to thirty feet, so computer-controlled performance machinery was added to insure the movement and fire blasts were accurate and safe. The Horntail's beak was crafted in steel and glowed red when the fire passed by it—an unexpected design perk.

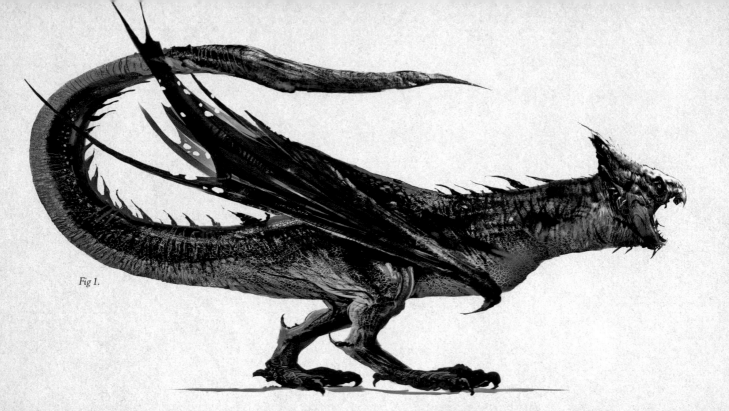

Fig 1.

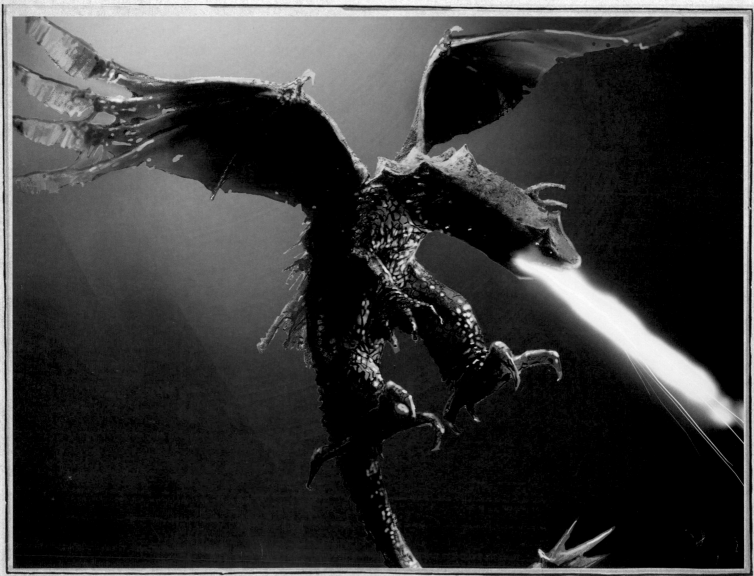

Fig 2.

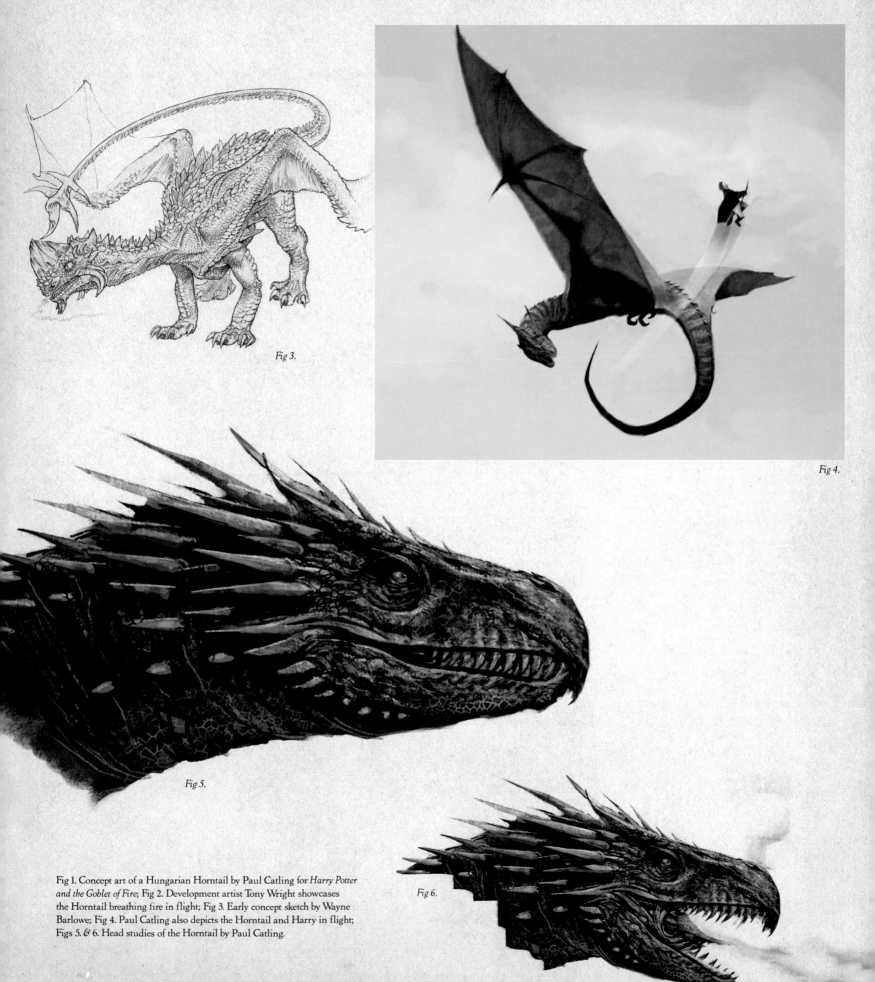

*Fig 3.*

*Fig 4.*

*Fig 5.*

*Fig 6.*

Fig 1. Concept art of a Hungarian Horntail by Paul Catling for *Harry Potter and the Goblet of Fire*; Fig 2. Development artist Tony Wright showcases the Horntail breathing fire in flight; Fig 3. Early concept sketch by Wayne Barlowe; Fig 4. Paul Catling also depicts the Horntail and Harry in flight; Figs 5. & 6. Head studies of the Horntail by Paul Catling.

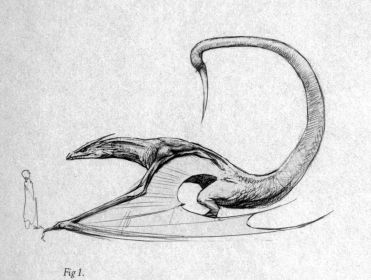

Fig 1.

Fig 4.

Fig 2.

> "*I have to admit, that Horntail is a right nasty piece of work.*"
> —RUBEUS HAGRID
> Harry Potter and the Goblet of Fire film

Fig 3.

# FAST FACTS
## HUNGARIAN HORNTAIL

✳

I. FILM APPEARANCE: *Harry Potter and the Goblet of Fire*

II. ADDITIONAL FILM APPEARANCE
(MODEL ONLY): *Harry Potter and the Half-Blood Prince*

III. LOCATION: Triwizard Tournament arena (*the model also appeared in Diagon Alley, outside Weasleys' Wizard Wheezes*)

IV. TECH TALK: Pre-made poses of the Horntail were created in the computer to make the animation process of getting from pose A to pose B more efficient.

V. DESCRIPTION FROM *HARRY POTTER AND THE GOBLET OF FIRE* BOOK, CHAPTER TWENTY:

*"And there was the Horntail . . . her wings half furled, her evil, yellow eyes upon him, a monstrous, scaly black lizard, thrashing her spiked tail . . ."*

Figs 1. & 2. Early pencil studies by Wayne Barlowe; Fig 3. Paul Catling produced several studies of the Horntail's eye; Fig 4. Sculptor Kate Hill works on the Hungarian Horntail's spikes in the creature shop during a construction phase for *Harry Potter and the Goblet of Fire*; Paul Catling also portrayed a sleeked-down side view of the Horntail (Fig 5.) and a painting of wizards trying to control an uncaged Horntail in the forbidden forest (Fig 6.).

*Fig 5.*

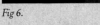
*Fig 6.*

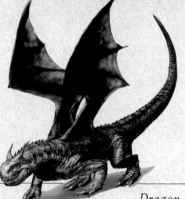

*Dragon example 3.*

# COMMON WELSH GREEN.

Fleur Delacour from Beauxbatons Academy of Magic selects the Common Welsh Green, a dragon native to the United Kingdom, for the first task of the Triwizard Tournament. Concept artist Paul Catling's artwork carefully explores the textures and details of the Common Welsh Green, which were realized in its miniature version on the big screen.

*Fig 1.*

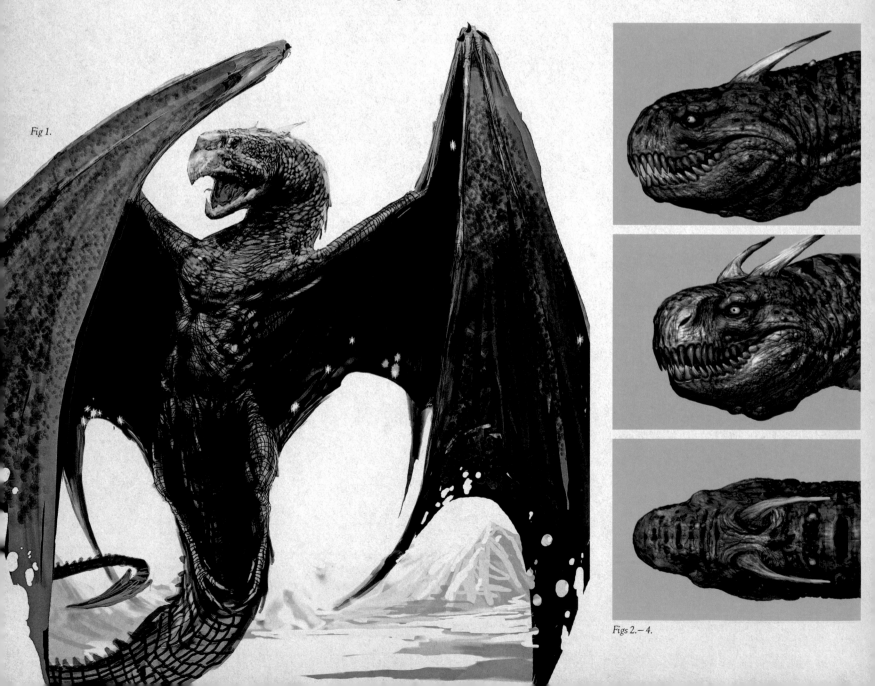

*Figs 2.– 4.*

# FAST FACTS

## COMMON WELSH GREEN

✸

I. FILM APPEARANCE: *Harry Potter and the Goblet of Fire*

II. LOCATION: Triwizard Tournament arena

III. DESCRIPTION FROM *HARRY POTTER AND THE GOBLET OF FIRE* BOOK, CHAPTER NINETEEN:

*"There was . . . a smooth-scaled green one, which was writhing and stamping with all its might . . ."*

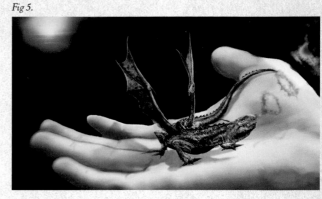

Fig 5.

Fig 1. Paul Catling depicts a Common Welsh Green with battle-scarred wings; Figs 2. – 4. Face and texture studies by Paul Catling. Fig 5. A close-up of the miniature Welsh Green in Fleur Delacour's hand by Paul Catling. Fig. 6 Wing studies of the Welsh Green by Paul Catling.

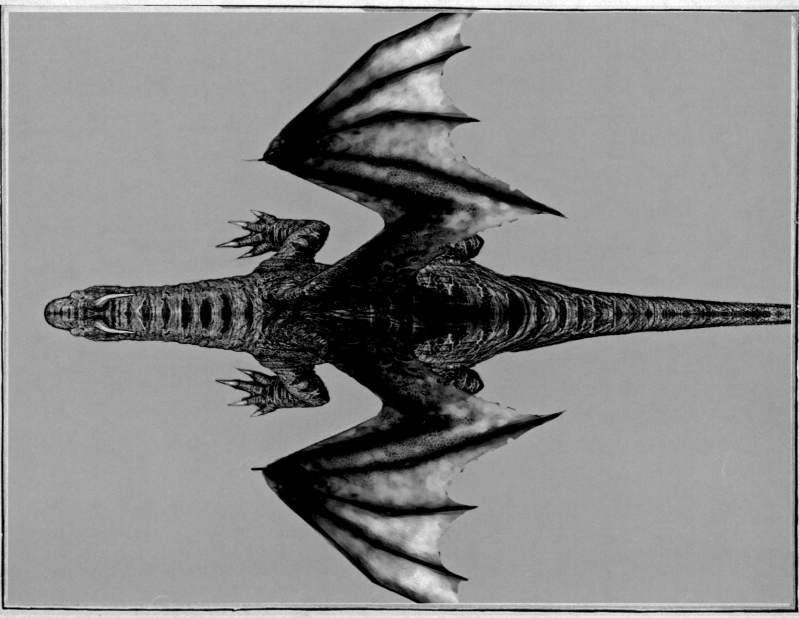

Fig 6.

*Dragon example 4.*

# CHINESE FIREBALL.

Second to draw his dragon during the first task of the Triwizard Tournament is the Durmstrang Academy champion, Viktor Krum. Viktor pulls out the Chinese Fireball. The concept artists took into account that iconic dragons from different countries may have different looks, as seen in the more lizard-like body of the Chinese Fireball.

*Fig 1.*

Figs 1. & 2. Color studies of the Chinese Fireball by Paul Catling; Fig 3. Early concept painting of a Chinese Fireball by Paul Catling, with a wyvern-like anatomy.

# FAST FACTS

## CHINESE FIREBALL

✳

I. FILM APPEARANCE: *Harry Potter and the Goblet of Fire*

II. LOCATION: Triwizard Tournament arena

III. DESCRIPTION FROM *HARRY POTTER AND THE GOBLET OF FIRE* BOOK, CHAPTER NINETEEN:

*"There was . . . a red one with an odd fringe of fine gold spikes around its face, which was shooting mushroom-shaped fire clouds into the air . . ."*

Fig 2.

Fig 3.

# SWEDISH SHORT-SNOUT.

Cedric Diggory, the first-selected champion for Hogwarts, picks the Swedish Short-Snout during the first task of the Triwizard Tournament. The designers of the Swedish Short-Snout experimented with widely diverse approaches, though recognizing that, of course, the focus needed to always be about the dragon's most distinctive feature—its short snout.

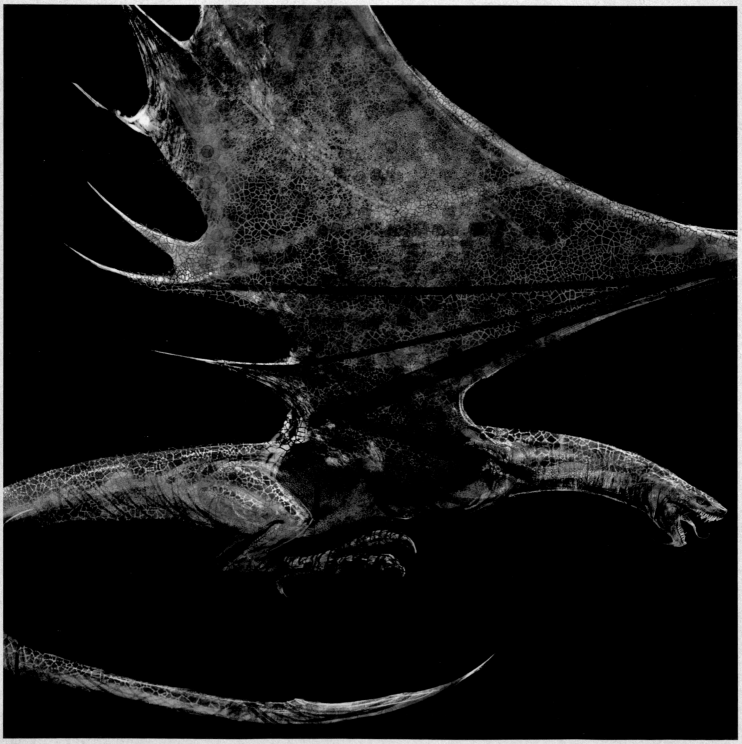

Fig 1.

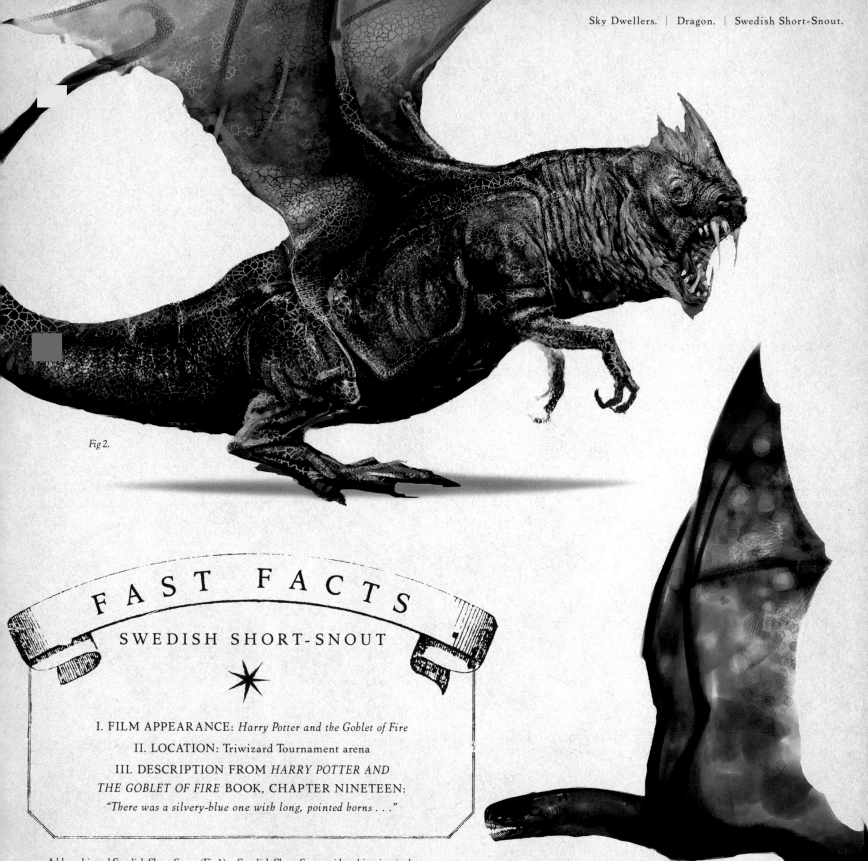

Fig 2.

# F A S T   F A C T S
## SWEDISH SHORT-SNOUT
✶

I. FILM APPEARANCE: *Harry Potter and the Goblet of Fire*

II. LOCATION: Triwizard Tournament arena

III. DESCRIPTION FROM *HARRY POTTER AND
THE GOBLET OF FIRE* BOOK, CHAPTER NINETEEN:
*"There was a silvery-blue one with long, pointed horns . . ."*

A blue-skinned Swedish Short-Snout (Fig 1.), a Swedish Short-Snout with a rhino-inspired head (Fig 2.), and concept art of snout and wing studies (Fig 3.), all by Paul Catling for *Harry Potter and the Goblet of Fire.*

Fig 3.

# UKRAINIAN IRONBELLY.

In the lowest level of Gringotts bank, visited in *Harry Potter and the Deathly Hallows – Part 2*, a Ukrainian Ironbelly dragon guards the treasure vaults of the oldest and richest wizarding families. The goblins control this neglected, angry dragon with threats of pain, so the filmmakers needed to give this creature the appearance of a captive. To gain access to the Lestranges' vault, Harry Potter, Hermione Granger, and Ron Weasley, with the help of Griphook,

must get past the Ironbelly, and then, to escape, they must fly the dragon out of the bank to freedom.

The Ukrainian Ironbelly that lives in the cavernous cage of vaults beneath Gringotts bank in *Deathly Hallows – Part 2* needed to have rust-tinged scars from its chains. The creature's coloring has faded to a sickly white and it is partially blind from living in the dark. It's

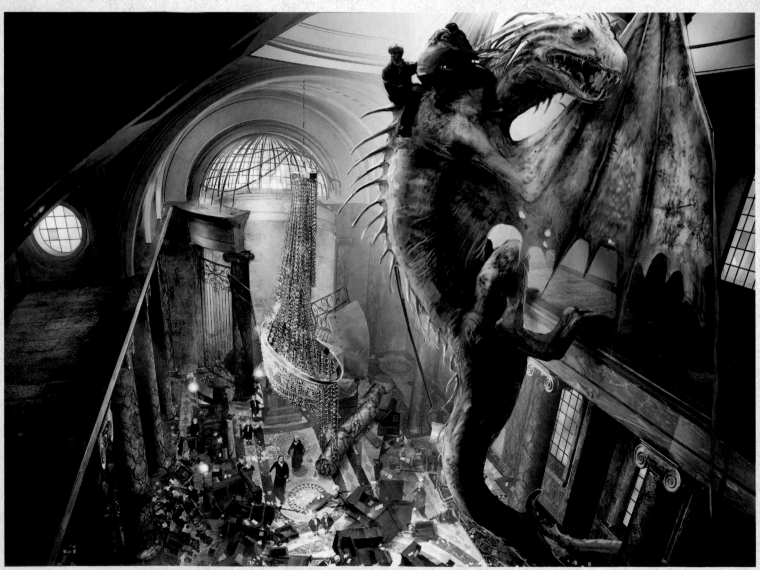

*Fig 1.*

Fig 2.

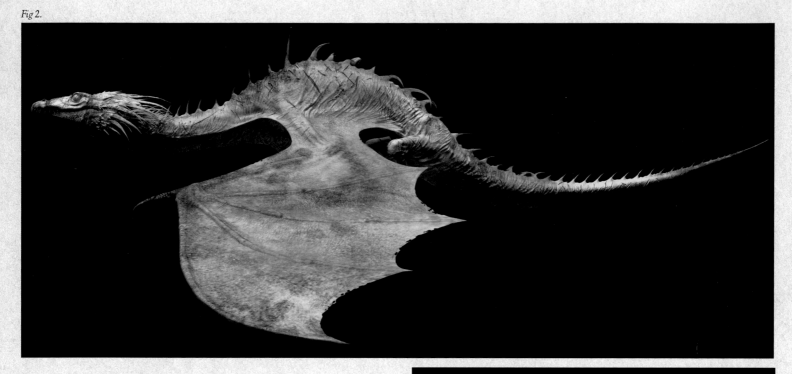

emaciated from lack of care and years of maltreatment. As a result, it's very dangerous—and very different from most dragons seen on-screen.

It was important to have the Ironbelly look unhealthy but not so much that you couldn't feel sympathy toward it. CGI started with a defined skeleton, layered with a simple muscle frame. Digital animation allowed the muscles to deform and then inflate or deflate the skin so it "slid" between the bones and muscle. Tendons were then laid across its neck, shoulders, and hips that were each independently controlled for a shifting movement, and enhanced by another control for the dragon's veins underneath the thin skin. There was even a "wobble" control for loose skin under the dragon's neck.

Unlike the Hungarian Horntail in *Harry Potter and the Goblet of Fire*, the creature shop did not create a full-size model of the Ukrainian Ironbelly. However, the dragon still needed to be ridden. So that section of its torso, twelve foot long at full scale, was constructed and covered with a silicone hide. This was mounted on a motion-based gimbal programmed with the same movements of the digital dragon flying away from the bank. The section contained fully jointed shoulders that moved in sync with the flapping of the dragon's wings.

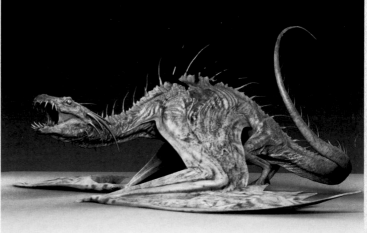

Fig 3.

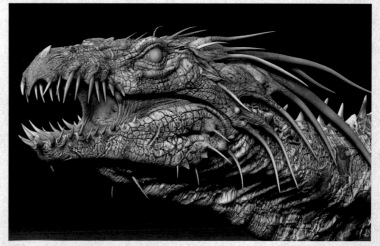

Fig 4.

"
*That doesn't sound good.*"

— RON WEASLEY

*Harry Potter and the Deathly Hallows – Part 2* film

Fig 1. Concept artist Andrew Williamson's painting of the Ukrainian Ironbelly escaping from Gringotts bank as Hermione, Harry, and Ron hold on, for *Harry Potter and the Deathly Hallows – Part 2*; Fig 2. Study of the Ironbelly's coloration and aging by Paul Catling; Fig 3. The Ironbelly with silhouetted figures astride by Paul Catling; Fig 4. Study of the Ironbelly head by Paul Catling.

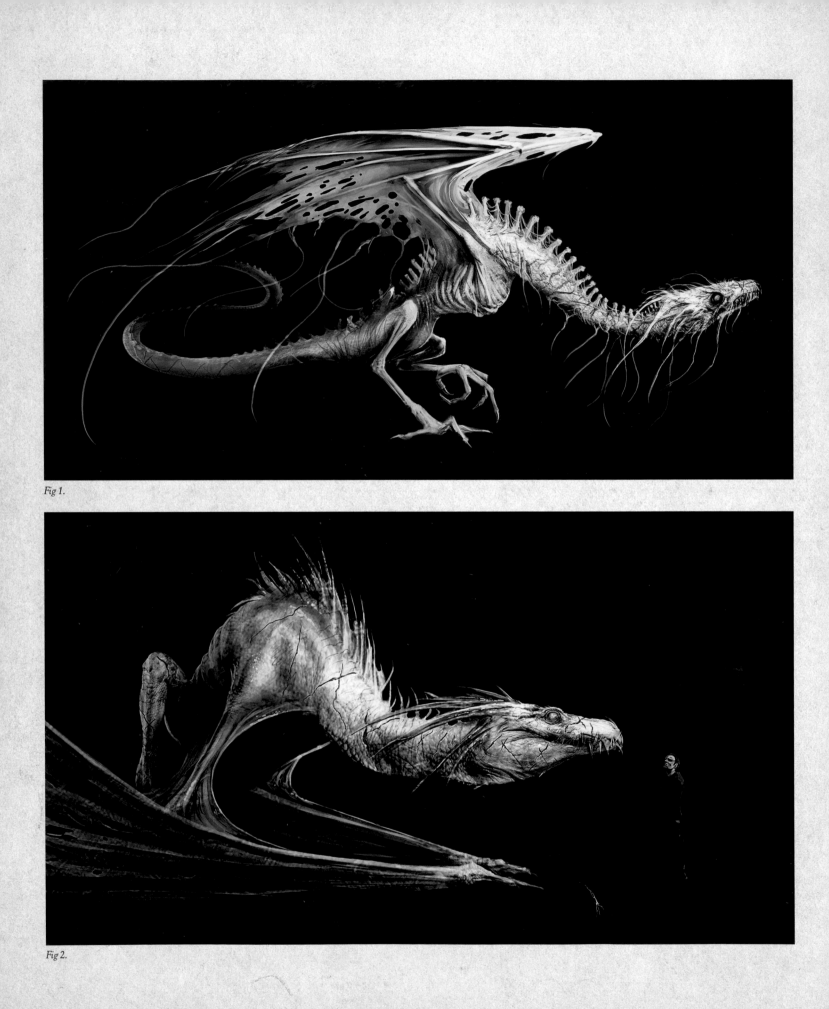

Fig 1.

Fig 2.

Figs 4.—6.

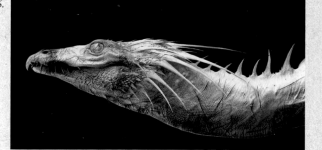

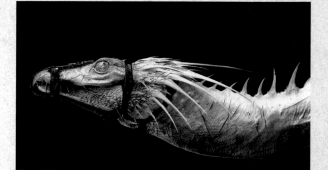

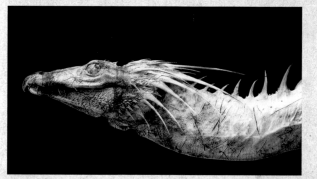

# FAST FACTS
## UKRAINIAN IRONBELLY

✶

I. FILM APPEARANCE: *Harry Potter and the Deathly Hallows — Part 2*

II. LOCATION: Gringotts Wizarding Bank

III. DESIGN NOTE: The animators made the dragon's skin an anemic grayish-white, without any green or blue tones.

IV. DESCRIPTION FROM *HARRY POTTER AND THE DEATHLY HALLOWS* BOOK, CHAPTER TWENTY-SIX:

*"Harry could see it trembling, and as they drew nearer he saw the scars made by vicious slashes across its face . . ."*

Fig 1. A tattered, emaciated Ukrainian Ironbelly by Paul Catling for *Harry Potter and the Deathly Hallows — Part 2*; Fig 2. Proportion study of man and dragon by Paul Catling; Figs 3. — 5. Studies by Paul Catling of the Ironbelly's head with straps and scars; Fig 6. The Ironbelly escapes his captivity through the top of Gringotts bank in artwork by Paul Catling.

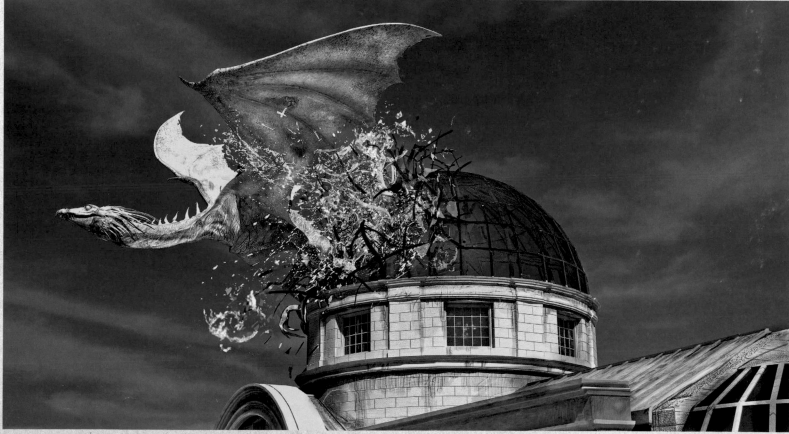

Fig 3.

# Cornish Pixie.

**C**ornish pixies are mischievous, ill-behaved flying creatures that are relatively harmless but can cause damage if not restrained. They wreak havoc in Professor Lockhart's classroom during his first Defense Against the Dark Arts class. The Cornish pixies make their second appearance in the Room of Requirement in *Harry Potter and the Deathly Hallows – Part 2*.

The Harry Potter books describe Cornish pixies as being blue, which the filmmakers faithfully represented. History has given us Cornish Blue roosters, Cornish Blue pottery, and an award-winning Cornish Blue cheese. But another possible provenance for the creatures in *Harry Potter and the Chamber of Secrets* is the historically based myth that pixies were a remnant of the Picts tribes, who lived in the Cornwall area during Celtic times and are said to have painted their skin blue.

Fig 1.

Fig 2.

Figs 1, 3. & 4. Concept art of the raucous, ill-disciplined Cornish pixies by Rob Bliss for *Harry Potter and the Chamber of Secrets*; Fig 2. Concept art of a Cornish pixie in flight for *Chamber of Secrets*; Figs 5. & 6. The Cornish pixies in and out of their cages in Professor Gilderoy Lockhart's unsuccessful Defense Against the Dark Arts class in a scene from *Chamber of Secrets*.

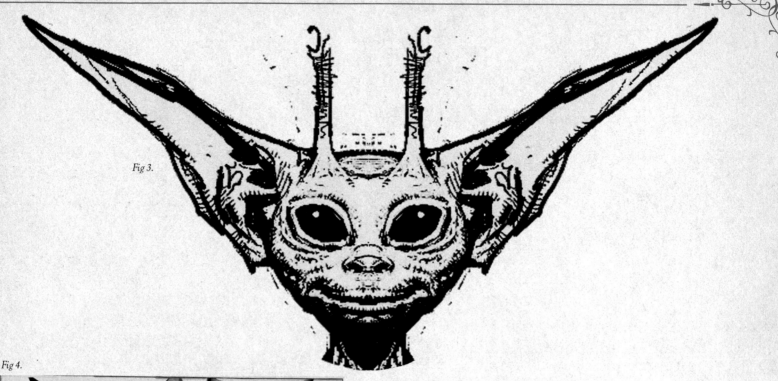

*Fig 3.*

*Fig 4.*

For the films, a scale model of a Cornish pixie was created and painted an electric blue, and was then cyberscanned and animated by the digital artists. Depth of field was created by scattering the twenty or so pixies between the background, the foreground, and the middle at different heights in the filmed classroom. Actor Matthew Lewis (Neville Longbottom) had clips placed behind his ears to push them forward, to create the effect of two pixies pulling him up by the ears to suspend him above the room.

*Fig 5.*

*Fig 6.*

Fig I.

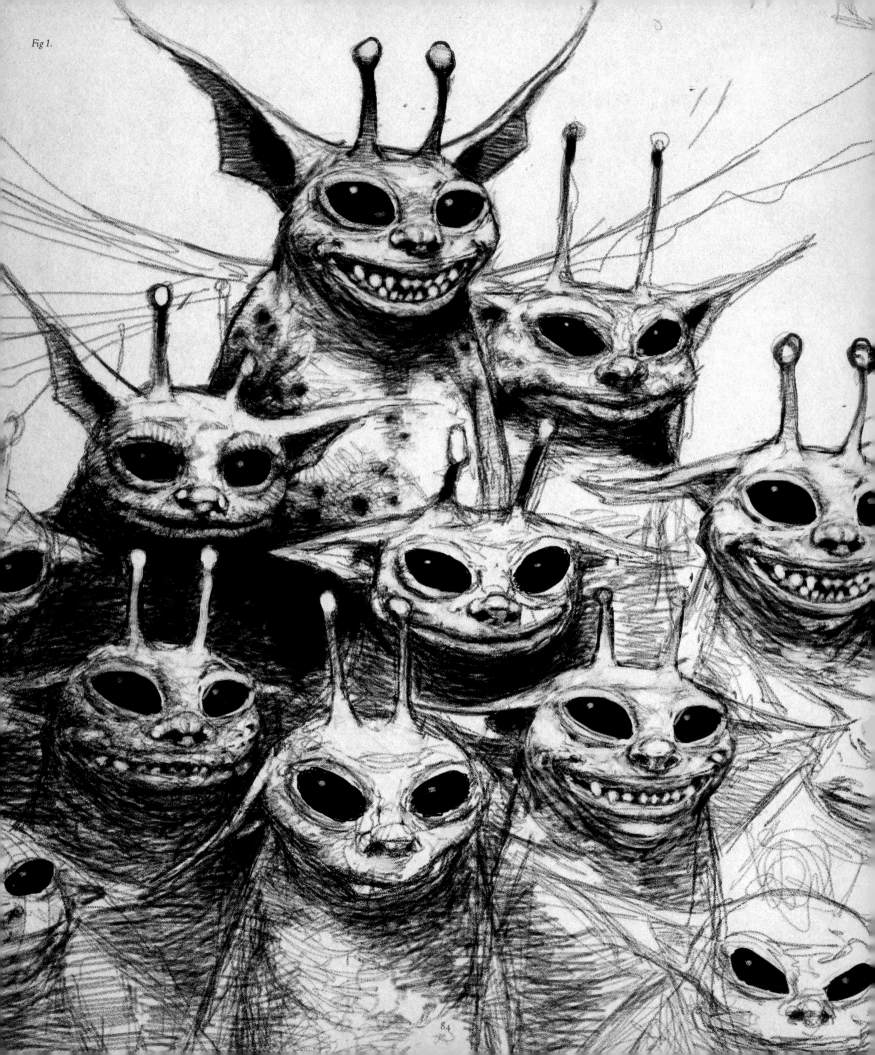

# FAST FACTS

## CORNISH PIXIE

✴

I. FIRST FILM APPEARANCE: *Harry Potter and the Chamber of Secrets*

II. ADDITIONAL FILM APPEARANCE: *Harry Potter and the Deathly Hallows – Part 2*

III. LOCATION: Defense Against The Dark Arts classroom, Room of Requirement

IV. TECH TALK: Time-honored practical effects were used to pull books off shelves and pull the students' hair by using thin wires.

V. DESCRIPTION FROM *HARRY POTTER AND THE CHAMBER OF SECRETS* BOOK, CHAPTER SIX:

*"The pixies were electric blue and about eight inches high, with pointed faces . . ."*

Figs 1.–4. A plethora of Cornish pixies portrayals by Rob Bliss for *Harry Potter and the Chamber of Secrets*.

Fig 2.

Fig 3.

"*Laugh if you will, Mr. Finnegan, but pixies can be devilishly tricky little blighters.*"

—GILDEROY LOCKHART

*Harry Potter and the Chamber of Secrets* film

Fig 4.

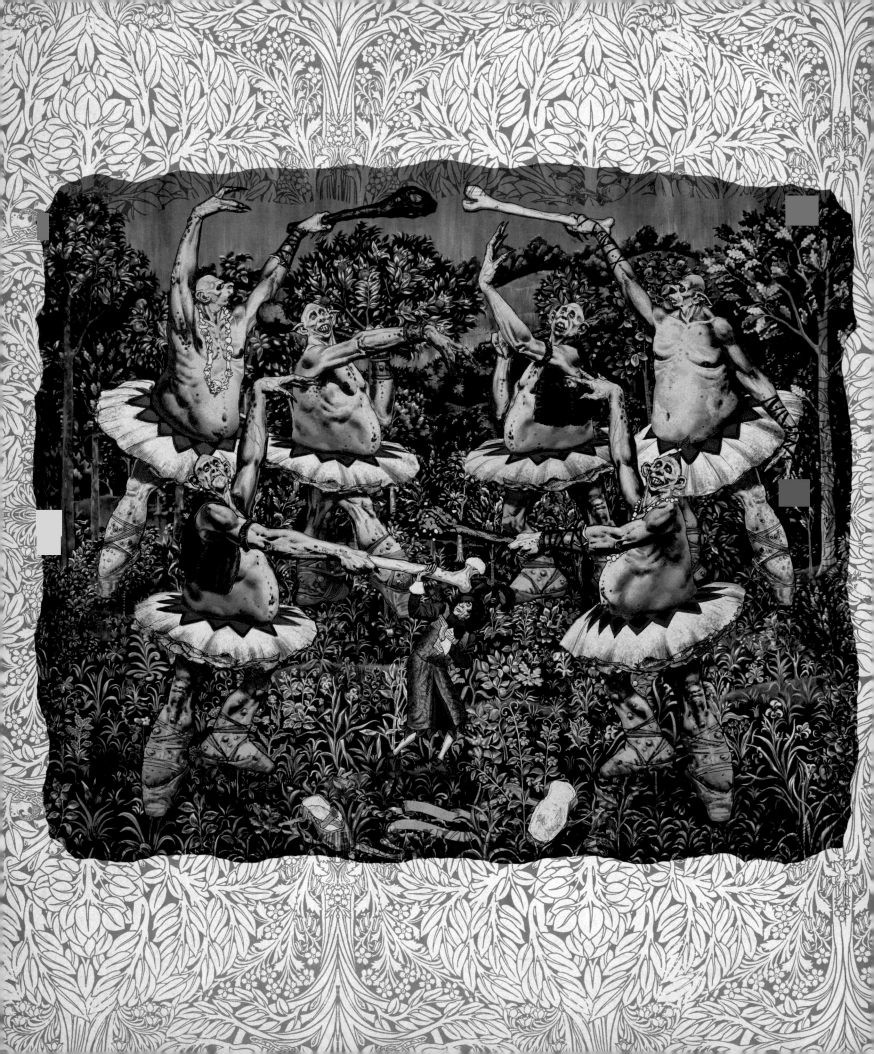

CHAPTER IV

# TRESPASSERS

*O*ccasionally during the Harry Potter film series, Hogwarts castle, among other places, is an unwitting host to creatures that are uninvited or unwanted. Through the course of Harry Potter's years at Hogwarts, the castle has had a mountain troll trespass into the girls' bathroom—though it was intentionally brought into the castle by Professor Quirrell—and a small giant hide in the Forbidden Forest, brought in by Hagrid. Large giants invade the grounds during the battle of Hogwarts.

# Troll.

Trolls are described as extremely large creatures, roughly twelve feet in height. They are very dangerous and very stupid. A troll first appears in the films when, during the Halloween feast in _Harry Potter and the Sorcerer's Stone_, Professor Quirrell races into the Great Hall shrieking that there is a troll in the dungeon. When Harry Potter and Ron Weasley find Hermione Granger—and the troll—in the girls' bathroom, they manage to defeat it when Ron is finally able to correctly use the _Wingardium Leviosa_ spell.

Fig 1.

Fig 2.

## FAST FACTS

### TROLL

✴

I. FILM APPEARANCE: _Harry Potter and the Sorcerer's Stone_

II. LOCATION: Girls' bathroom, Hogwarts castle

III. TECH TALK: The troll's hands and legs were worn by Martin Bayfield, who was also the double for Robbie Coltrane (Hagrid).

IV. DESCRIPTION FROM _HARRY POTTER AND THE SORCERER'S STONE_ BOOK, CHAPTER TEN:

_"Twelve feet tall, its skin was a dull, granite gray, its great lumpy body like a boulder with its small bald head perched on top like a coconut It had short legs thick as tree trunks with flat, horny feet."_

Previous: A tapestry featuring Barnabus the Barmy attempting to teach trolls to dance. Artwork by Adam Brockbank for a scene intended but not created for _Harry Potter and the Half-Blood Prince_; Fig 1. Concept art by Rob Bliss of the very warty, rather stupid troll encountered by Harry, Ron, and Hermione in _Harry Potter and the Sorcerer's Stone_; Fig 2. The troll enters the girls' bathroom at Halloween in a scene from _Sorcerer's Stone_.

Fig 3. Color concept art of the troll by Rob Bliss; Fig 4. Hermione Granger (Emma Watson) stares at a hand of the conquered, unconscious troll in a scene from *Sorcerer's Stone*.

Fig 3.

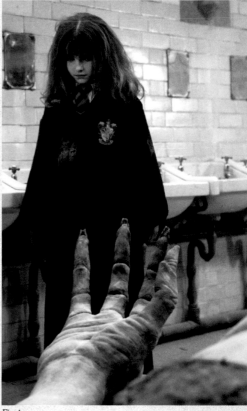

Fig 4.

The troll sequence in *Harry Potter and the Sorcerer's Stone* uses a blend of several types of visual effects techniques. First, the creature shop designed a troll and constructed a maquette that included his vacant expression, three-toed limbs, and the large spiky warts on his legs. Next, a full-grown painted and costumed troll model was fabricated, as it was needed when the troll is knocked out on the girls' bathroom floor. Additionally, the troll's hand and his lower half, including his legs, were produced at full size for Emma Watson (Hermione Granger) to act against.

Another actor performing in a troll costume was filmed by a traditional camera for digital reference, as *Sorcerer's Stone* was shot years before motion capture technology became prevalent. The practical sight gags were filmed: the bathroom doors exploding from a strike of the troll's club, the sink being destroyed above Hermione, and a hydraulic rig raised Daniel Radcliffe (Harry Potter) to "drop" on top of the troll's shoulders and swing about. All these live-action shots were placed in the proper timeline for the scene and then composited with digital footage to create one continuous scene.

Trolls were proposed to appear in another of the Harry Potter films, *Harry Potter and the Half-Blood Prince*. The filmmakers had intended to use them in a "moving" tapestry, in the same way the photographs and paintings were animated. Two dancers wearing troll suits outfitted with pink tutus and "toe" shoes were filmed for a tableaux portraying Barnabus the Barmy teaching trolls to dance ballet. In fact, the performers were filmed dancing in front of a blue screen a total of four times so that an octet of trolls would perform the choreography together. Their dance, which landed on the cutting room floor, was named the *pas de trolls*.

# Giant.

The films of the Harry Potter series showcased a large amount of creatures, none so large as the giants. Giants can reach up to twenty feet in height, only four feet taller than trolls, and only as proportionately higher in intelligence. Prior to the events of _Harry Potter and the Order of the Phoenix_, as Voldemort is gathering his strength and his supporters, Hagrid is sent to parlay with the giants. During this journey, he finds his giant half brother, Grawp.

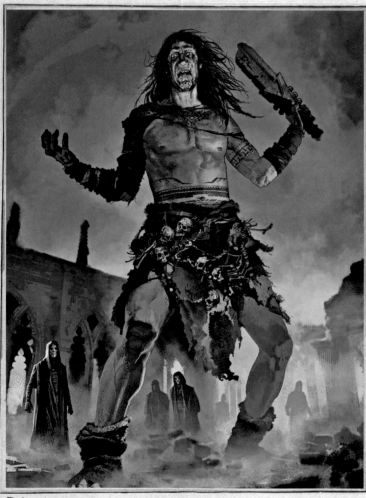

Fig 1.

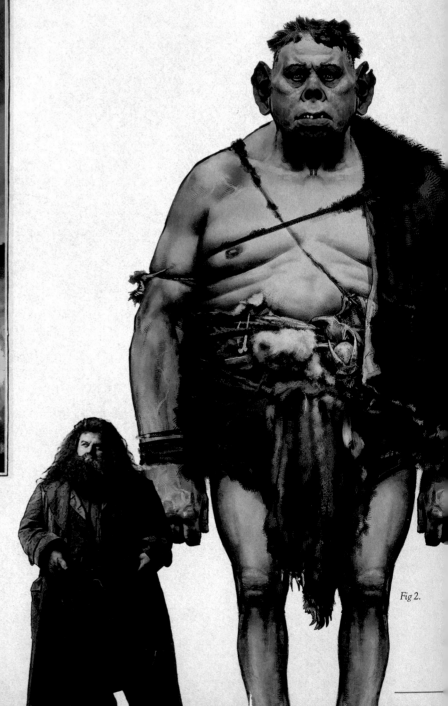

Fig 2.

> " _Well, they're not that hard ter find, ter be perfectly honest._
> _They're so big, see?_"
>
> —RUBEUS HAGRID
> _Harry Potter and the Order of the Phoenix film_

"*I tried to convince 'em ter join the cause....*
*But I wasn't the only one that was trying to win them over.*"
— RUBEUS HAGRID
*Harry Potter and the Order of the Phoenix film*

*Fig 3.*

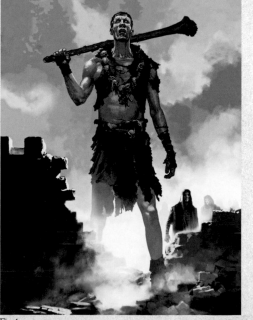

*Fig 4.*

# FAST FACTS

## GIANT

✴

I. FILM APPEARANCE: *Harry Potter and the Deathly Hallows — Part 2*

II. LOCATION: Hogwarts castle

III. DESIGN NOTE: The clubs the giants used as weapons
were digitally "fashioned" from small trees.

IV. DESCRIPTION FROM *HARRY POTTER AND THE
DEATHLY HALLOWS* BOOK, CHAPTER THIRTY-TWO:
"*A giant stood before him, twenty feet high, its head hidden in shadow, nothing
but its treelike, hairy shins illuminated by light from the castle doors.*"

Fig 1. Artwork by Adam Brockbank of a skull-draped giant during the Battle of Hogwarts in *Harry Potter and the Deathly Hallows — Part 2*; Fig 2. Half-giant Hagrid juxtaposed with his giant half brother, Grawp, visualized by Adam Brockbank for *Harry Potter and the Order of the Phoenix*; Concept art by visual development artists Julian Caldow (Fig 3.) and Rob Bliss (Fig 4.) of giants in the climactic battle scene of *Harry Potter and the Deathly Hallows — Part 2*.

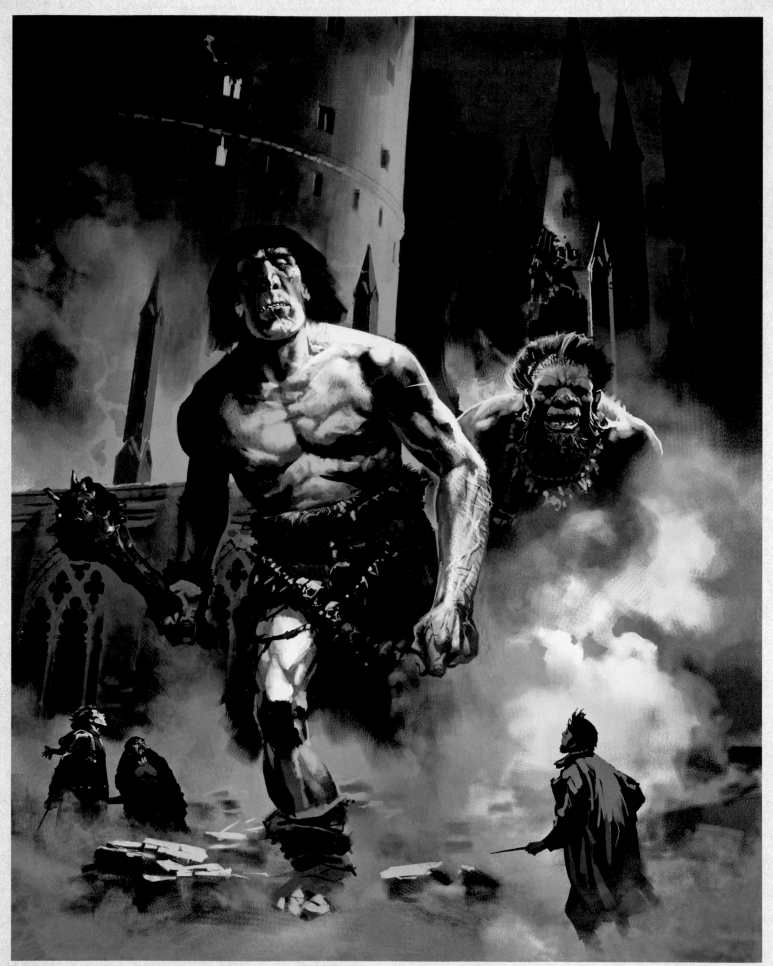

Fig 1. Students stare up at the fighting giants in *Harry Potter and the Deathly Hallows — Part 2* in artwork by Adam Brockbank.

The giants who participate in the battle of Hogwarts in *Harry Potter and the Deathly Hallows – Part 2* were to be computer-generated, but the digital crew knew it would be beneficial to start the design process with film of live-action actors. Prosthetics were created to scale up features on the actors' faces. Actors of varying oversized proportions wore the prosthetic makeup, along with loincloths, and were filmed running on treadmills. Then these green-screened movements were imported into a digital format. The giants' faces were scaled up again and distorted to lessen their human features. The bottom half of the giants' legs was made broader to suggest a lower center of gravity, and some were given feet with elephant-like toes. The giants' costume design included belts of skulls and human teeth, and hairstyles that contained branches and leaves.

*Fig 2.*

Fig 2. Studies of Grawp's eyes and mouth by Adam Brockbank for *Harry Potter and the Order of the Phoenix*; Fig 3. Digital studies of giant head variations for *Deathly Hallows – Part 2*.

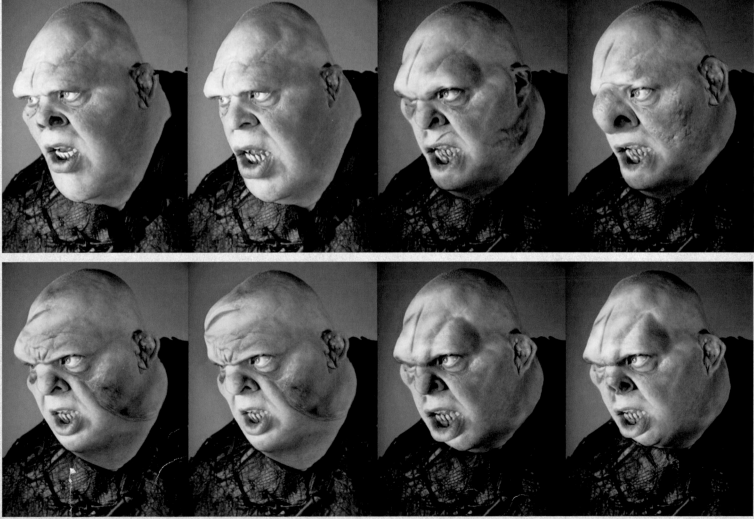

*Fig 3.*

*Giant example 1.*

# GRAWP.

In *Harry Potter and the Order of Phoenix*, half-giant Hagrid brings Harry Potter, Hermione Granger, and Ron Weasley to meet his half brother, Grawp, who he has hidden in the Forbidden Forest. Grawp is sixteen feet tall in the films. Although fully computer generated, the creature effects shop constructed Grawp's head at full scale in an economical move to explore the finer details of his skin and hair, which always present challenges in CGI. Additionally, Grawp's head was used on the Forbidden Forest set in *Harry Potter and the Order of the Phoenix* for the actors' benefit as a sight line and as reference for the cinematography and lighting crews. A puppeteer dressed in a blue-screen suit was raised via a hydraulically controlled rig to the height of sixteen feet to enact the character. Grawp's arms were also constructed practically and operated by the puppeteer, important in gauging how far they would reach in order to block the scene. And Grawp's right hand was created to use in front of a green screen. Emma Watson (Hermione Granger) and Imelda Staunton (Dolores Umbridge) were filmed riding a motion-controlled giant's hand as part of being picked up by Grawp, then the hand was replaced by its digital version and the two elements were painstakingly composited together.

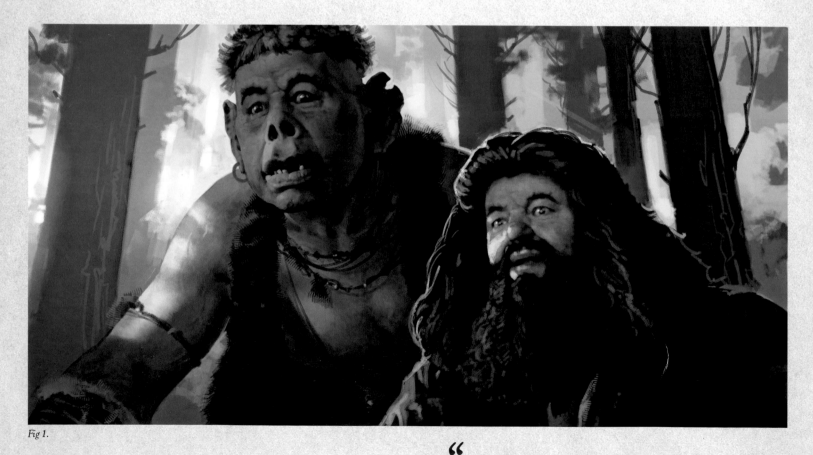

*Fig 1.*

" *He's completely harmless, just like I said.*
*A little high-spirited is all.*"
— RUBEUS HAGRID
*Harry Potter and the Order of the Phoenix* film

"*Grawp! Put me down ... Now.*"

—HERMIONE GRANGER

*Harry Potter and the Order of the Phoenix* film

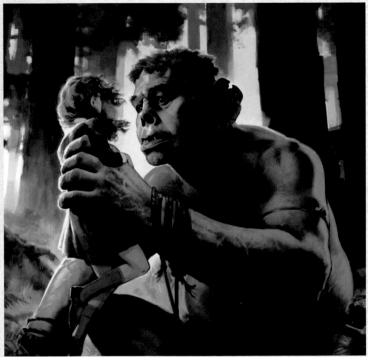

Fig 2.

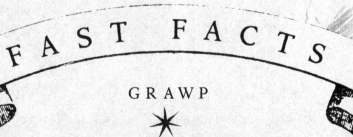

## FAST FACTS

### GRAWP

✳

I. FILM APPEARANCE: *Harry Potter and the Order of the Phoenix*

II. LOCATION: The Forbidden Forest

III. TECH TALK: Motion capture footage of actor Tony Maudsley enacting Grawp's lines and movements was shot as performance reference.

IV. DESCRIPTION FROM *HARRY POTTER AND THE ORDER OF THE PHOENIX* BOOK, CHAPTER THIRTY:

"*What Harry had taken to be a vast mossy boulder to the left of the great earthen mound he now recognized as Grawp's head. It was much larger in proportion to the body than a human head...*"

"

*Grawp! Put me down ... Now.*"

Fig 3.

Grawp and his half brother, Hagrid (Fig 1.), and Grawp and Hermione (Fig 2.) by Adam Brockbank; Fig 3. Pencil sketch of Grawp by an unknown artist.

# Gnome.

It is a sad reality in filmmaking that the script will contain scenes that don't make it into the movie. In the initial script for _Harry Potter and the Chamber of Secrets_, the Weasley twins and Ron must de-gnome the garden behind _The Burrow_, a punishment for using the flying Ford Anglia. Concept art of the gnomes was created, but the scene was edited out of the final shooting script. However, for _Harry Potter and the Half-Blood Prince_, the prop shop created a gold-skinned, tutu-wearing immobilized gnome that the Weasleys use as a Christmas tree topper.

In _Harry Potter and the Deathly Hallows – Part 1_, Luna Lovegood tells Harry that she has been bitten by one near the wedding tent at the wedding of Bill Weasley and Fleur Delacour.

The gnomes intended for a scene in _Harry Potter and the Chamber of Secrets_ did not make it on-screen but were portrayed in visual development artwork by Paul Catling (Figs 1. & 3.) and Adam Brockbank (Fig 2.).

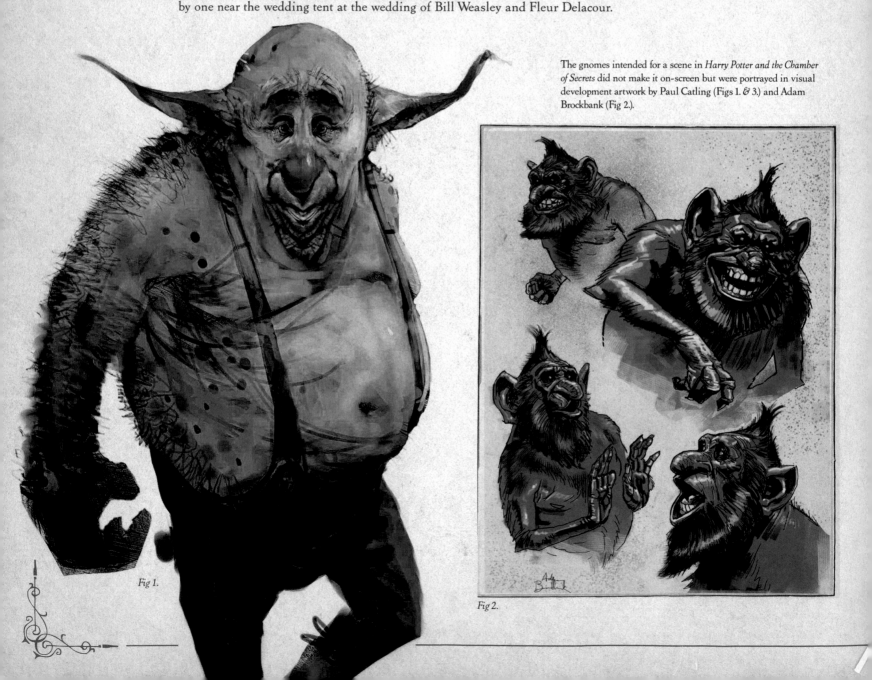

Fig 1.

Fig 2.

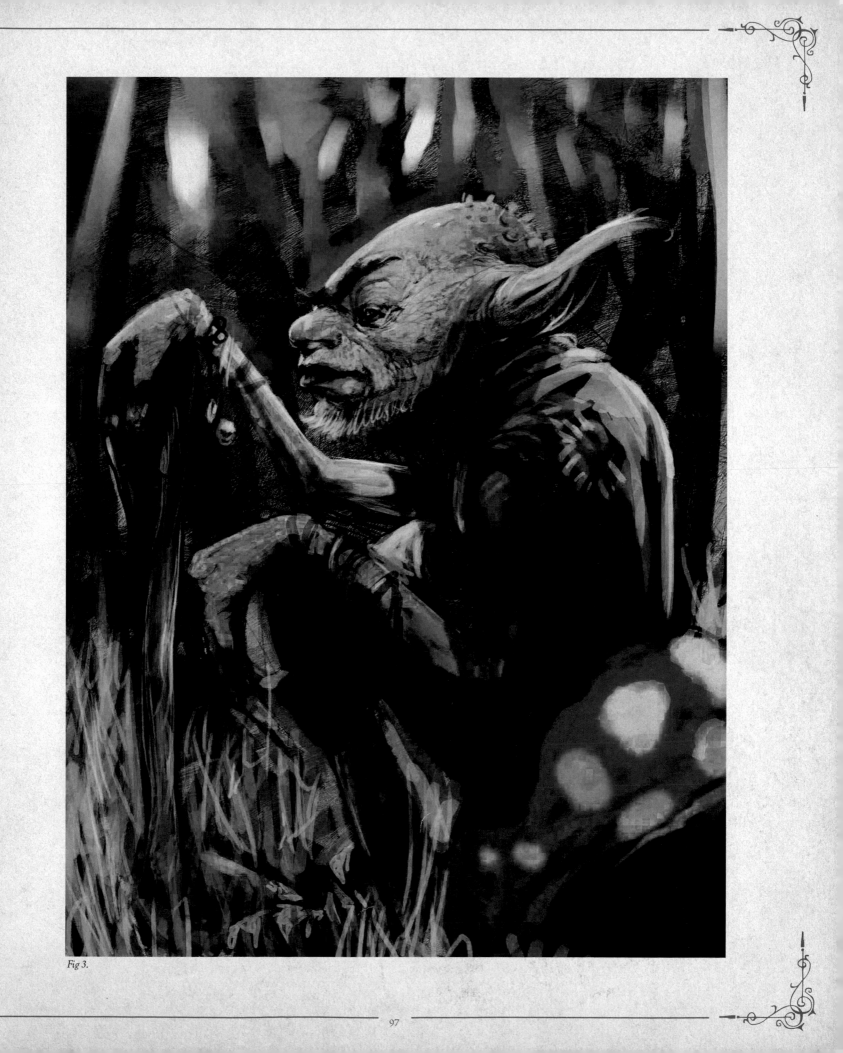

Fig 3.

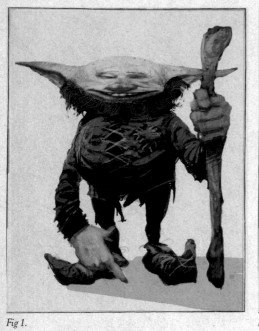

Fig 1.

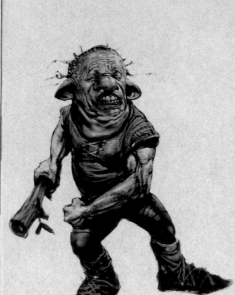

Fig 2.

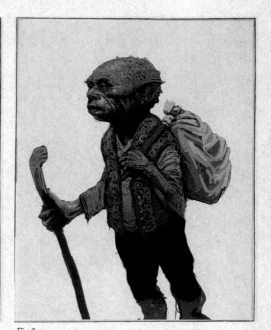

Fig 3.

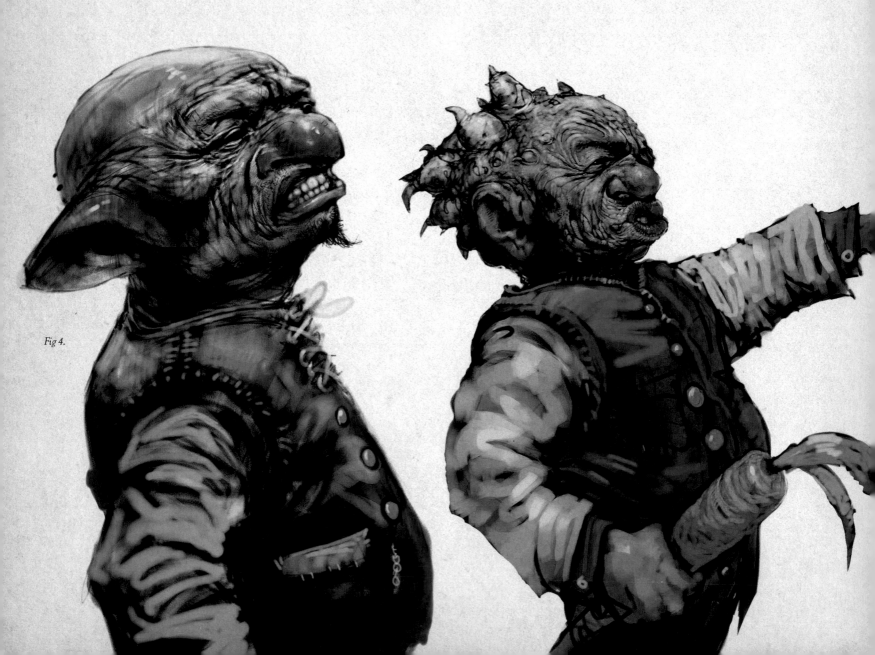

Fig 4.

"*I got bitten by a garden gnome only moments ago.*"
—LUNA LOVEGOOD
*Harry Potter and the Deathly Hallows – Part 1* film

Figs 1. — 8. Paul Catling's artwork infests these pages with garden gnomes, several of them sprouting vegetation from their heads for a scene at The Burrow intended for *Harry Potter and the Chamber of Secrets.*

*Fig 5.*

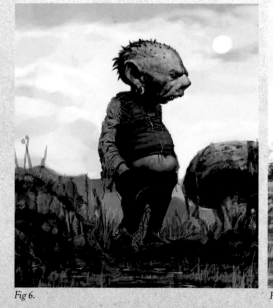

*Fig 6.*

*Fig 7.*

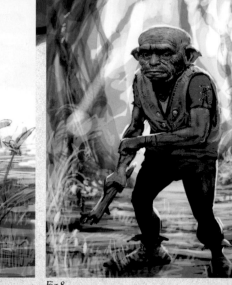

*Fig 8.*

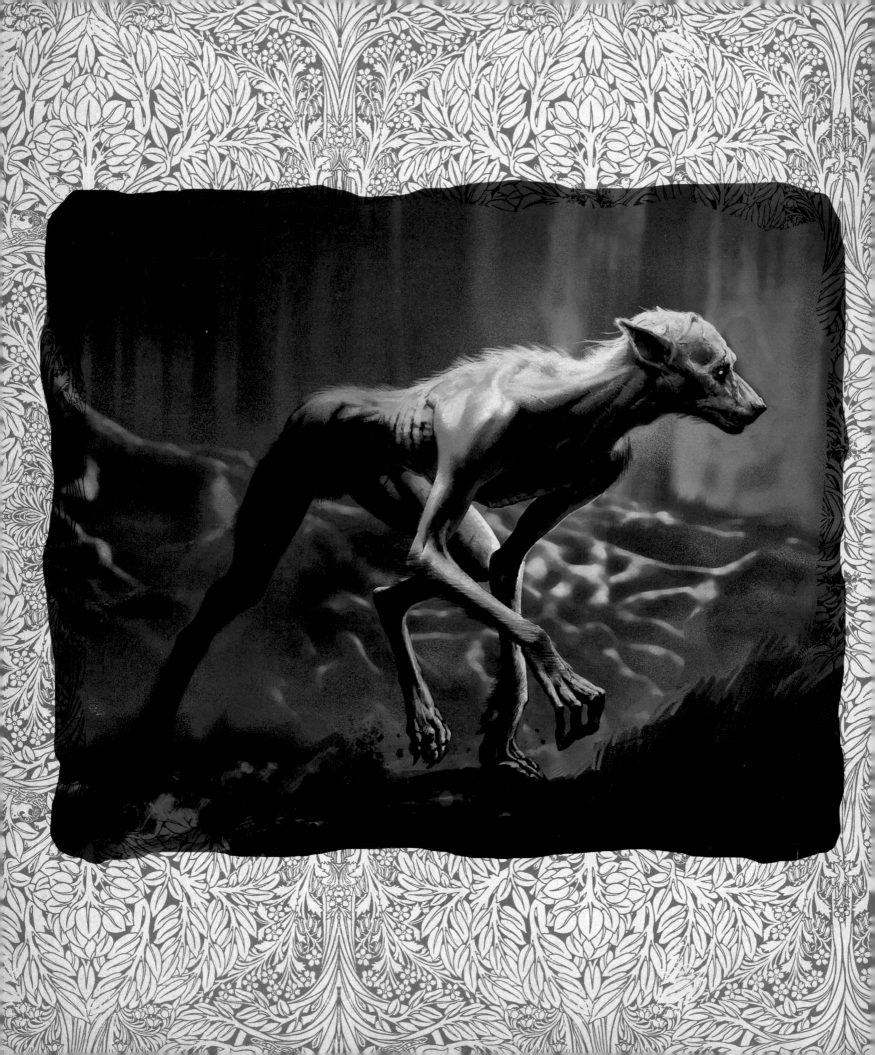

## CHAPTER V

# SHAPE-SHIFTERS

*T*he wizarding world brought to life in the Harry Potter films is populated by several shape-shifting beings. There are wizards who have studied a type of magic in which they can choose to transform themselves into an animal; they are called Animagi. Then there are wizards who have been bitten by a werewolf and are given no choice but to transform. The Boggart is a shape-shifting creature whose true form is unknown—it changes into its viewer's greatest fear.

# Animagus.

In the world of Harry Potter, an Animagus is a witch or wizard who can choose at will to turn him or herself into an animal. There are some instances where the Animagus form of a wizard may display a recognizable mark, physical or nonphysical, that can identify them, and that the Patronus of an Animagus are often the same animal species.

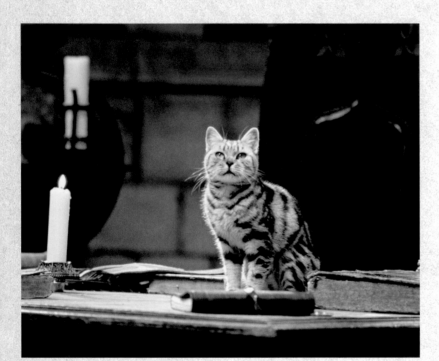

*"Harry, it's a trap. He's the dog. He's an Animagus!"*

—Ron Weasley
*Harry Potter and the Prisoner of Azkaban* film

Previous: The werewolf form of Remus Lupin lopes through the Forbidden Forest in concept art by Adam Brockbank for *Harry Potter and the Prisoner of Azkaban*; Fig 1. (above) Professor McGonagall in her Animagus form in a scene from *Harry Potter and the Sorcerer's Stone*, as played by Mrs. P. Head; Fig 2. The five-part transformation of Scabbers the rat into Peter Pettigrew in artwork by Rob Bliss for *Harry Potter and the Prisoner of Azkaban*; Fig 3. Digital construct of McGonagall transforming into her Animagus form; Fig 4. Professor McGonagall's Animagus form watches her Transfiguration class for first years in a scene from *Sorcerer's Stone*.

*Fig 2.*

# MINERVA McGONAGALL.

The Animagus form of Professor Minerva McGonagall is a gray tabby cat. This feline form of the professor allows her to covertly observe Harry Potter's relatives, the Dursleys, in *Harry Potter and the Sorcerer's Stone*. McGonagall also uses her Animagus form to monitor her first-year's Transfiguration class.

Professor McGonagall's Animagus form was played by a tabby cat named Mrs. P. Head. No additional makeup or computer effects were needed, as the cat already had the required "spectacle" markings.

When Harry and Ron Weasley enter her Transfiguration class in the film version of *Sorcerer's Stone*, McGonagall's Animagus form leaps from her desk and morphs into the human McGonagall. For this action, a trainer underneath the desk held the end of an invisible safety harness that was settled on the accomplished animal actor. Sitting directly above the trainer, Mrs. P. was given a cue to spring off the desk, and the safety harness was released at the same time. This film segment was then composited with a computer-generated transition from feline to professor.

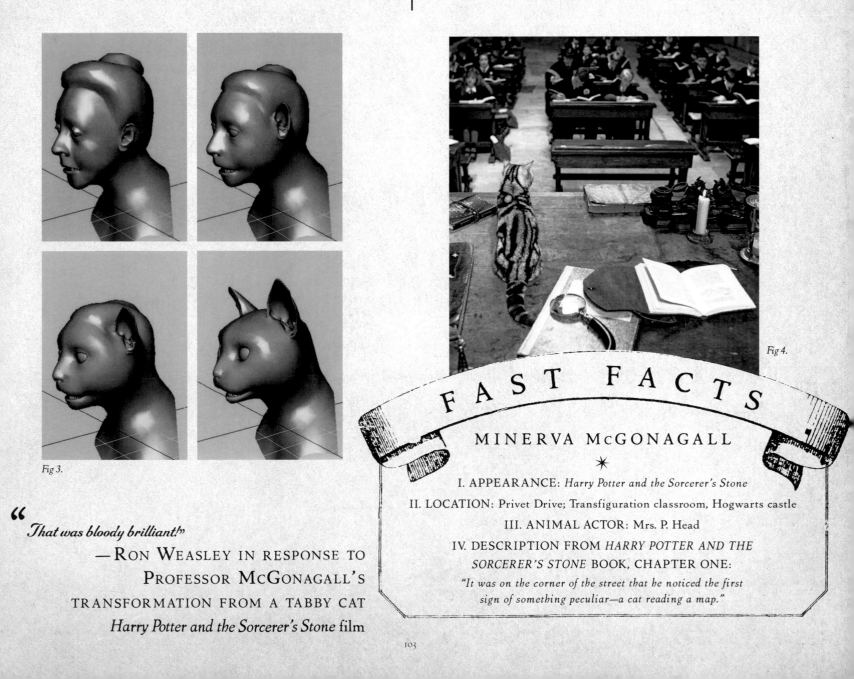

*Fig 3.*

*Fig 4.*

## FAST FACTS

### MINERVA McGONAGALL

✳

I. APPEARANCE: *Harry Potter and the Sorcerer's Stone*

II. LOCATION: Privet Drive; Transfiguration classroom, Hogwarts castle

III. ANIMAL ACTOR: Mrs. P. Head

IV. DESCRIPTION FROM *HARRY POTTER AND THE SORCERER'S STONE* BOOK, CHAPTER ONE:
*"It was on the corner of the street that he noticed the first sign of something peculiar—a cat reading a map."*

"*That was bloody brilliant!*"
— RON WEASLEY IN RESPONSE TO PROFESSOR McGONAGALL'S TRANSFORMATION FROM A TABBY CAT
*Harry Potter and the Sorcerer's Stone* film

# SIRIUS BLACK.

Sirius Black's Animagus form is that of a large black dog his friends call Padfoot, first seen in *Harry Potter and the Prisoner of Azkaban*. Sirius, James Potter, and Peter Pettigrew studied to become Animagi when they discovered that fellow Gryffindor Remus Lupin was a werewolf. Sirius and James, who turned into a stag called "Prongs", were able to control Remus during his monthly transformations. Sirius takes advantage of his Animagus form in *Harry Potter and the Order of the Phoenix* to stealthily see Harry Potter off to Hogwarts.

In *Harry Potter and the Prisoner of Azkaban*, Padfoot, who is initially mistaken for the Grim, was a computer-generated Animagus. The filmmakers brought in a show dog named Fern (full name: Champion Kilbourne Darling), a Kilbourne deerhound, as reference for the part. Fern was fitted with pointed ears and learned to jump ramps to perform the stunts needed for the character's digital template. Fern was backed up by another Kilbourne deerhound named Cleod. An award-winning show dog (full name: Champion Kilbourne MacLeod), Cleod's normally gray fur was darkened with a temporary rinsible black dye.

Sirius's Animagus form was recast for his appearance in *Harry Potter and the Order of the Phoenix*. This time he was played by a Scottish deerhound named Quinn, who was a rescue dog. Quinn's trainer describes him as being a little stubborn, but with a fun-loving nature.

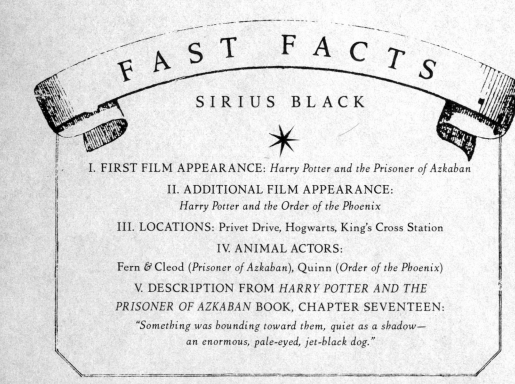

## FAST FACTS

### SIRIUS BLACK

✳

I. FIRST FILM APPEARANCE: *Harry Potter and the Prisoner of Azkaban*

II. ADDITIONAL FILM APPEARANCE:
*Harry Potter and the Order of the Phoenix*

III. LOCATIONS: Privet Drive, Hogwarts, King's Cross Station

IV. ANIMAL ACTORS:
Fern & Cleod (*Prisoner of Azkaban*), Quinn (*Order of the Phoenix*)

V. DESCRIPTION FROM *HARRY POTTER AND THE PRISONER OF AZKABAN* BOOK, CHAPTER SEVENTEEN:
*"Something was bounding toward them, quiet as a shadow—
an enormous, pale-eyed, jet-black dog."*

*Fig 1.*

Fig 1. Gary Oldman (Sirius Black) in a publicity shot for *Harry Potter and the Order of the Phoenix*; Fig 2. Rob Bliss charts the locations of Sirius Black's alchemic tattoos; Fig 3. Sirius Black's robe for *Order of the Phoenix*, sketched by Mauricio Carneiro, based on concepts by costume designer Jany Temime; Figs 4. & 5. A model of Sirius' animagus form; Fig 6. The Grim, as seen in a teacup during Professor Trelawney's Divination Class in *Harry Potter and the Prisoner of Azkaban*.

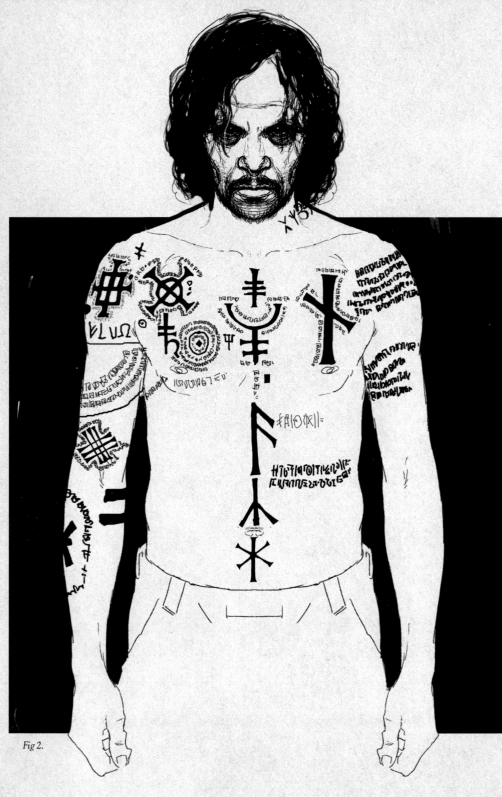

Fig 2.

Fig 3.

Figs 4.—6.

"*Normally I have a very sweet disposition as a dog. In fact, more than once, James suggested that I make the change permanent. The tail I could live with, but the fleas, they're murder.*"

—SIRIUS BLACK

*Harry Potter and the Prisoner of Azkaban* film

# PETER PETTIGREW.

During the events of *Harry Potter and the Prisoner of Azkaban*, Harry Potter learns that his father, James, was close friends with Sirius Black, Remus Lupin, and Peter Pettigrew, who attended Hogwarts together. Pettigrew became an Animagi, along with James and Sirius, transforming into a rat they called "Wormtail." When Pettigrew betrays James and Lily Potter to Voldemort, he goes into hiding as the Weasleys' family pet, Scabbers.

The Animagus form of Peter Pettigrew in *Harry Potter and the Prisoner of Azkaban* was played mainly by a rat named Dex, in addition to several animatronic rat versions. For the transformation from the rat to Peter Pettigrew in the Shrieking Shack, a combination of real and animatronic rats were used. When Sirius Black first reveals that the rat Ron Weasley is holding is not Scabbers but Pettigrew in his Animagus form, actor Rupert Grint (Ron) is holding Dex, but it is an animatronic version of Wormtail that is snatched out of his hands by Gary Oldman (Sirius).

Dex was trained to run from a point A to a point B, an example being when—in an effort to escape—Wormtail runs over the piano and across the floor in the Shrieking Shack. Any other occasion where the animal would drop, be thrown, grabbed, etc., would be enacted by an animatronic or digital version.

Unlike Professor McGonagall and Sirius Black, Peter Pettigrew exhibits obvious ratlike features in his human form. The makeup team matched the color of the rat's fur to the wigs created for Timothy Spall, the actor who played the human version of Peter Pettigrew, and gave him ratlike teeth and nails.

*Fig 1.*

*Fig 2.*

"*We thought he was our friend.*"
—REMUS LUPIN
*Harry Potter and the*
*Prisoner of Azkaban* film

Fig 3.

Fig 4.

> " *Black was vicious, he didn't kill Pettigrew; he destroyed him.*
> *A finger. That's all that was left—a finger!*"
> —CORNELIUS FUDGE
> Minister for Magic, *Harry Potter and the Prisoner of Azkaban* film

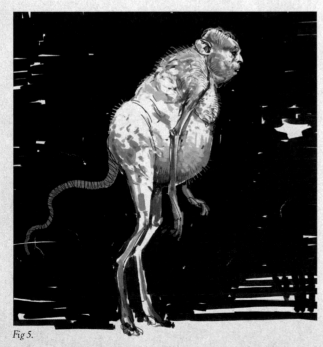

Fig 5.

# FAST FACTS
## PETER PETTIGREW

✦

I. FILM APPEARANCE AS WORMTAIL:
*Harry Potter and the Prisoner of Azkaban*

II. LOCATION: Shrieking Shack

III. ANIMAL ACTOR: Dex, plus other live and animatronic rats

IV. DESCRIPTION FROM *HARRY POTTER AND THE PRISONER OF AZKABAN* BOOK, CHAPTER ELEVEN:
*"Scabbers, once so fat, was now very skinny;
patches of fur seemed to have fallen out too."*

Fig 1. Pettigrew's decidedly rodential features are apparent in artwork by Rob Bliss; Fig 2. Peter Pettigrew (Timothy Spall) in *Harry Potter and the Half-Blood Prince*; Fig 3. Rob Bliss portrays Peter Pettigrew as he transforms into Wormtail the rat in *Harry Potter and the Prisoner of Azkaban*; Figs. 4. & 5. Full-body studies combining the rat and human forms of Peter Pettigrew by Rob Bliss.

# Boggart.

The true shape of a Boggart is unknown, as a Boggart changes its shape to that of the viewer's most horrible fear. In *Harry Potter and the Prisoner of Azkaban*, Defense Against the Dark Arts professor Remus Lupin instructs his third year students how to cast the *Riddikulus* charm to repel such a creature. Lupin also uses a Boggart in a private lesson in the same film to teach Harry Potter how to cast the Patronus charm in defense against a Dementor—Harry's worst fear.

Neville Longbottom is first to practice the *Riddikulus* charm in *Harry Potter and the Prisoner of Azkaban*, redressing Professor Snape in grandmother Longbottom's bird-topped hat and tweedy skirt ensemble. Ron imagines roller skates on the eight legs of an Acromantula. Pavarti transforms a cobra into a jack-in-the-box. But when Harry sees a Dementor, Lupin intercedes. Lupin's worst fear is a full moon creeping out of a shadowy sky, which he turns into a deflating white balloon, all effects created in the computer. Although an actual Boggart is never seen, the visual effects designers still needed to create the transition from the scary version to the laughable version, which they interpreted as a swirling tornado of the Boggart's fearful and funny forms.

"*Boggarts are shape-shifters. They take the shape of whatever a particular person fears the most.*"
—HERMIONE GRANGER
*Harry Potter and the Prisoner of Azkaban* film

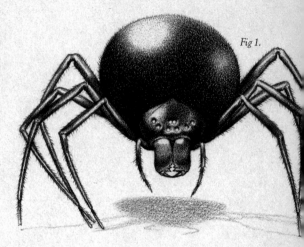

Fig 1.

Figs 1. & 2. Concept art of the spider before and after the charm by Wayne Barlowe for *Harry Potter and the Prisoner of Azkaban*; Fig 3. Harry (Daniel Radcliffe) practices the *Riddikulus* charm on a menacing jack-in-the-box Boggart in a scene from *Prisoner of Azkaban*; Fig 4. Neville Longbottom imagines the Professor Snape (Alan Rickman) form of the Boggart in his grandmother's clothing in the same scene.

Fig 2.

Fig 3.

Fig 4.

## BOGGART

✴

I. FILM APPEARANCE (THOUGH NOT ITS TRUE APPEARANCE):
*Harry Potter and the Prisoner of Azkaban*

II. LOCATION: Defense Against the Dark Arts classroom

III. DESCRIPTION FROM *HARRY POTTER AND THE
PRISONER OF AZKABAN* BOOK, CHAPTER SEVEN:

*"Nobody knows what a Boggart looks like when he is alone, but when
I let him out he will immediately become whatever each
of us most fears." —Professor Remus Lupin*

"*Luckily, a very simple charm exists to repel a Boggart. Let's practice it
now. Now, without wands, please. After me: Riddikulus!*"

—REMUS LUPIN
*Harry Potter and the Prisoner of Azkaban* film

# Werewolf.

**W**hile an Animagus chooses to turn into their animal form, like Professor McGonagall in *Harry Potter and the Sorcerer's Stone* and Peter Pettigrew in *Harry Potter and the Prisoner of Azkaban*, a werewolf has no choice but to change, a transformation that occurs at the rising of the full moon.

Fig 1.

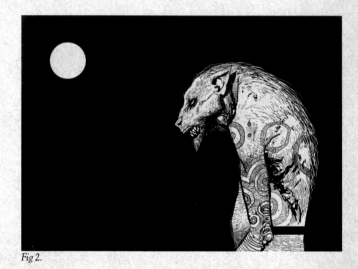

Fig 2.

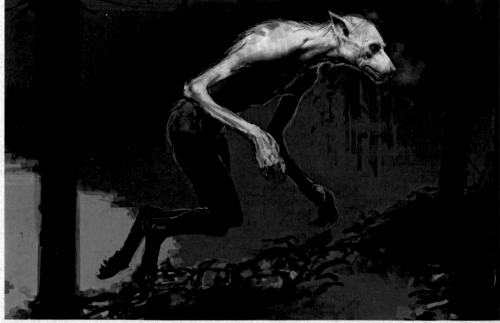

Fig 3.

Different interpretations of Professor Remus Lupin's werewolf form for *Harry Potter and the Prisoner of Azkaban* were considered in concept art by Rob Bliss (Figs 1, 2., 4. & 5.) and Adam Brockbank (Fig 3.); Figs 6. — 9. The transformative stages of Lupin into a werewolf were also explored in studies by Adam Brockbank.

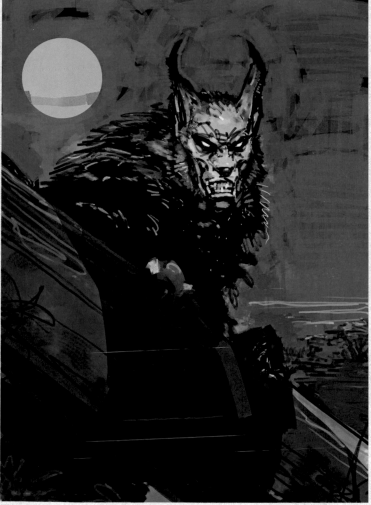

Fig 4.

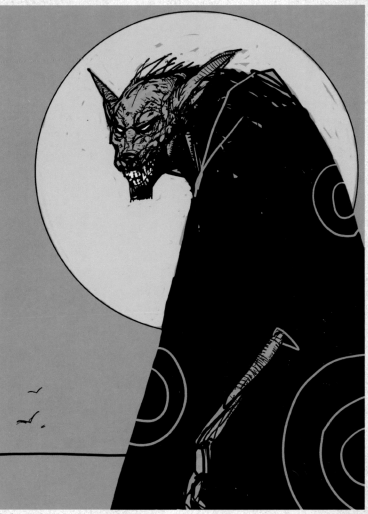

Fig 5.

Fig 7.

Fig 8.

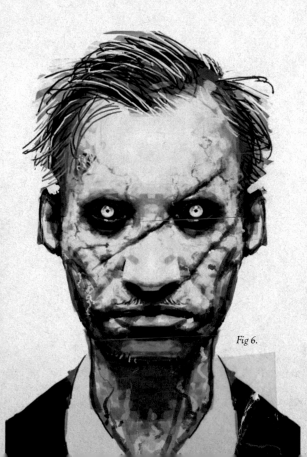

Fig 6.

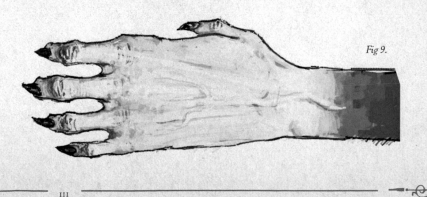

Fig 9.

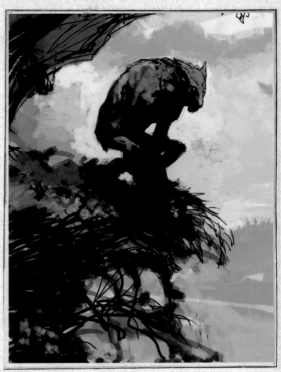

Fig 2.

"

*As an antidote to your ignorance, and on my
desk by Monday morning, two rolls of
parchment on the werewolf, with particular
emphasis on recognizing it.*"

— SEVERUS SNAPE
*Harry Potter and the Prisoner of Azkaban* film

Figs 1. — 4. Werewolf concept studies by Rob Bliss
for *Harry Potter and the Prisoner of Azkaban*.

Fig 1.

Fig 3.

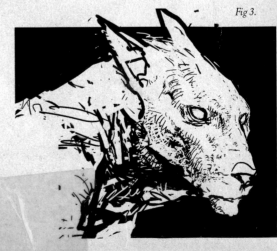

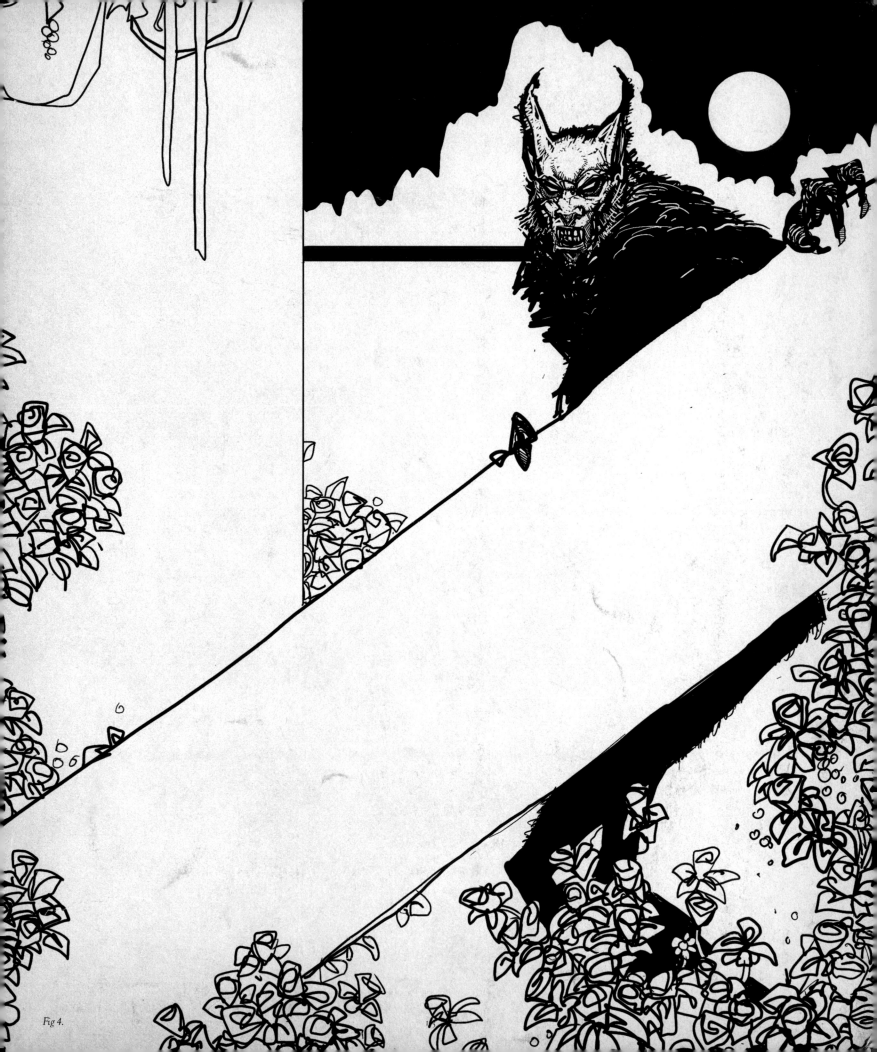

Fig 4.

# REMUS LUPIN.

It is established in *Harry Potter and the Prisoner of Azkaban* that Remus Lupin, while a child, was bitten by the werewolf Fenrir Greyback. As an adult, he is able to take Wolfsbane Potion to control his condition, but he still struggles with the shame and weight of his secret, which the filmmakers brought out through costume and makeup.

With more than one hundred werewolf transformations filmed throughout the history of cinema prior to Remus Lupin's, the visual development artists for *Harry Potter and the Prisoner of Azkaban* were eager to give this iconic character a fresh approach. Inspiration came from depicting Lupin's condition as an illness. To that end, his pallid face and scarred body mark his struggle against the affliction, and his gray, shabby clothing add to the idea that he has faced much hardship and paucity.

Lupin's werewolf form isn't meant to be as scary as conventional movie werewolves; there is a gravity and sadness about him. His makeup design is lupine but retains some of his humanity. Lupin's werewolf form is thin and disfigured, almost emaciated, with long limbs and a hunched back. One significant change from most movie werewolves is that Lupin is relatively hairless.

The creature designers began with the hope that they would be able to achieve the werewolf transformation practically, with prosthetics and animatronics. They decided to sculpt the werewolf they wanted without worrying how they would install someone to control the sculpt. The result was an extraordinary creature that was extremely tall (seven feet) and extremely thin, and would require a performer with a unique skill set who could fit inside. A kick boxer and a dancer were cast and trained for several months wearing three-foot-tall reverse stilts to give them the necessary height and stride. When they were brought to the actual set featuring the Whomping Willow, it became apparent that the performers could not achieve the same effect they had in rehearsal. The costume was tight and restrictive, not allowing the creature to be as athletic as desired. Additionally, as the scene's set was an undulating hillside strewn with rocks and tall grasses, the performers labored for balance and could not move as quickly across the terrain. Because of these reasons, it was determined that the final werewolf seen on-screen would need to be created by computer.

Up until Lupin completes his transformation, practical and makeup effects were combined to span the transition from human to werewolf. Actor David Thewlis (Remus Lupin) was fitted with several stages of prosthetics that changed his eyes, teeth, and hands. Other effects included a cable-controlled piece under the back of his coat that expanded to rip apart the material, and bladders on his neck that inflated. Visual tricks included a cutaway shot of the actor's feet elongating and stepping out of his shoes.

*Fig 1.*

> **" *Well, you'd know all about the madness within, wouldn't you, Remus?* "**
>
> —SIRIUS BLACK
> *Harry Potter and the Prisoner of Azkaban* film

Fig 2.

# FAST FACTS

## REMUS LUPIN

✦

I. FILM APPEARANCE (WEREWOLF ONLY):
*Harry Potter and the Prisoner of Azkaban*

II. LOCATION: Hogwarts castle

III. DESIGN NOTE: Two scars embedded on Remus Lupin's face echo between his two forms to signify their connection.

IV. DESCRIPTION FROM *HARRY POTTER AND THE PRISONER OF AZKABAN* BOOK, CHAPTER TWENTY:

*"Lupin's head was lengthening. So was his body. His shoulders were hunching. Hair was sprouting visibly on his face and hands, which were curling into clawed paws."*

Fig 3.

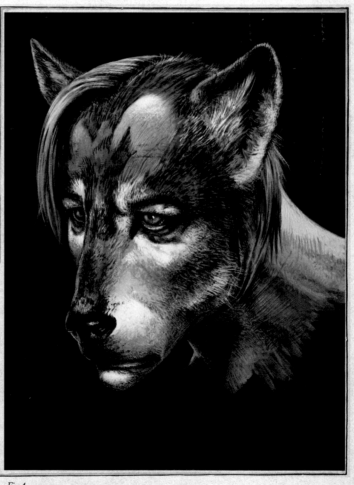

Fig 4.

Figs 1. & 2. Studies of Professor Lupin in wolf form by Wayne Barlowe; Fig 3. David Thewlis (Remus Lupin) bears the scars of the werewolf's affliction in a publicity pose for *Prisoner of Azkaban*; Fig 4. Wayne Barlowe's touching study of the man within the werewolf.

# FENRIR GREYBACK.

In the Harry Potter films, Fenrir Greyback is a werewolf who so delights in his beastly nature that he is slowly becoming a hybrid of wolf and man. Greyback is involved in the attacks on Diagon Alley, Hogwarts' Astronomy Tower, and The Burrow in *Harry Potter and the Half-Blood Prince*, and participates in the battle of Hogwarts in *Deathly Hallows – Parts 1* and 2.

There is an essential difference between the werewolves Remus Lupin and Fenrir Greyback: Greyback enjoys his transformation so much that he is retaining much of his wolfish characteristics even when he is in human form. Similar to the centaurs and mer-people, there is no obvious demarcation line in Greyback between wolf and man. The designers bought the fine down of a wolf's pelt up from his chest into his face and hair, and the creature was given no hairline. His eyebrows were removed, and actor Dave Legeno wore very dark contact lenses that reflected light back in the same way as a wolf's.

In order to achieve the subtlety of Greyback's wolfish hair, the creature makeup consisted of seven silicone prosthetics that were painted and then painstakingly punched with individual goat hairs. Punching the hairs in meant that no glue needed to be used, which gave a better freedom of movement. These pieces were placed on the actor's face, chest, and ears. The number of pieces allowed the makeup artists easier manipulation than if they used two or three large ones, and ensured a more accurate application. The pieces would be destroyed by the removing agent when they were taken off at the end of the day, so new pieces were needed for each day of filming. A multitude of each prosthetic piece was created and stored much earlier in the shooting schedule so they could be prepared and applied each day.

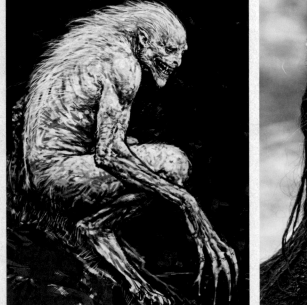

*Fig 1.*

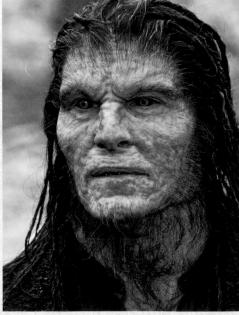

*Fig 2.*

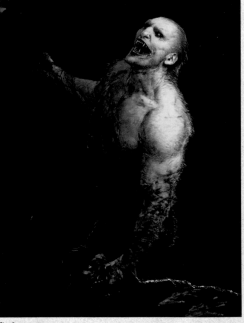

*Fig 3.*

Fig 4.

> "Owe it all to a werewolf by the name of Greyback.
> Hope to repay the favor one day."
>
> — BILL WEASLEY
> *Harry Potter and the Deathly Hallows – Part 1* film

Fig 1. Fenrir Greyback by Rob Bliss for *Harry Potter and the Half-Blood Prince*;
Fig 2. Dave Legano as the increasingly wolfish Fenrir Greyback in *Harry Potter and the Deathly Hallows – Part 2*; Fig 3. Greyback by Rob Bliss for *Deathly Hallows – Part 2*; Fig 4. A Rob Bliss portrait of Greyback for *Half-Blood Prince*; Fig 5. Dave Legano (Fenrir Greyback) strikes a snarling pose for *Half-Blood Prince*.

Fig 5.

# FAST FACTS
## FENRIR GREYBACK

✴

I. FIRST FILM APPEARANCE: *Harry Potter and the Half-Blood Prince*

II. ADDITIONAL FILM APPEARANCE: *Harry Potter and the Deathly Hallows – Parts 1* and *2*

III. LOCATION: Hogwarts, Diagon Alley, The Burrow

IV. DESIGN NOTE: The creature designers studied the patterns of a wolf's coloring for Greyback, in particular the timber wolf.

V. DESCRIPTION FROM *HARRY POTTER AND THE HALF-BLOOD PRINCE* BOOK, CHAPTER TWENTY-SEVEN:

*"[A] big, rangy man with matted gray hair and whiskers, whose black Death Eater's robes looked uncomfortably tight. . . . His filthy hands had long, yellowish nails."*

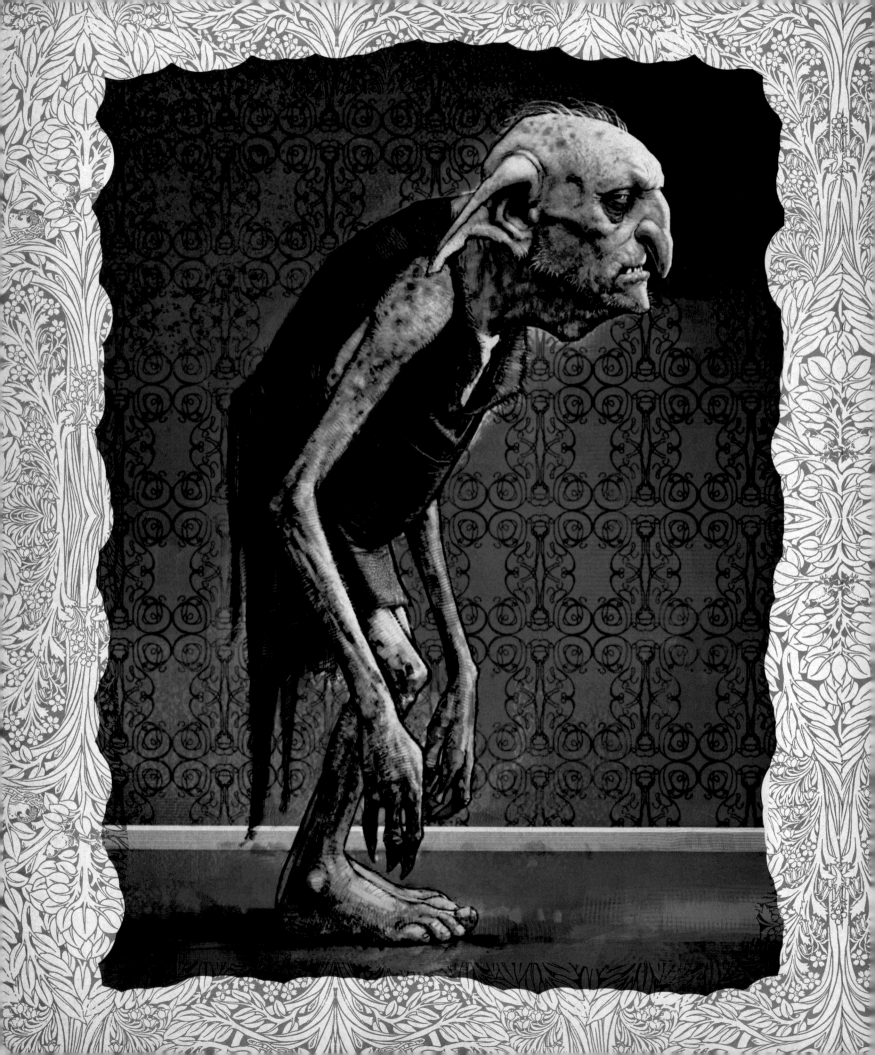

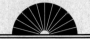

# THE WORKING WORLD

*I*n *the wizarding world of the Harry Potter films, creatures of diverse types and species are employed for various occupations. Owls are used to deliver messages and materials from place to place. House-elves serve wizarding families with unquestioning loyalty. For financial needs, goblins run the wizarding bank Gringotts, in Diagon Alley. And if you are looking for a guard dog, perhaps there could be none better than one with three heads!*

# Post Owl.

At Hogwarts, the Owl Post brings letters and packages from home, newspapers, and any other object needed to be delivered to a student. *In Harry Potter and the Sorcerer's Stone, Neville Longbottom receives a Remembrall. Ron Weasley catches a Howler in Harry Potter and the Chamber of Secrets. And throughout the Harry Potter films, Hermione Granger gets her subscription to The Daily Prophet via owl.*

The owls seen in the majority of Harry Potter films ranged in size from the smallest of species to the largest, weighing between three and a half ounces (Sunda scops owl) to five and a half pounds (European eagle owl). Sixteen owls were trained in several "behaviors" for the various tasks needed by the Owl Post, each owl accompanied by a trainer. The variety of breeds included great grays, barn owls, snow owls, and tawny owls, as different breeds have different physical wing structures in order to take advantage of their environment. Large owls are typically better at soaring, thanks to their bigger wings. Small owls are better hoppers.

The real-life owls did not actually carry the packages and letters in their talons. These props were tied to a light plastic harness that was placed over the bird's body. The harness had a release mechanism on it, attached to a long invisible cord that was held out of sight by a trainer. When the owl was required to drop its item as it flew toward its mark, the trainer would trigger the mechanism to open and the delivery would be made. Because larger owls can prey on smaller ones, any scenes with multiple live owls would be filmed with only one or a few and then composited together.

Although we think of owls as nocturnal creatures, they actually hunt around the clock, so they are easily adaptable to work in the daytime. The owls trained for the Harry Potter film series were accustomed to working on a daytime schedule, though they did take naps from time to time. With a few exceptions, the owls used in the Privet Drive sequence in *Harry Potter and the Sorcerer's Stone* were faux—either owl models or computer-generated owls.

*Fig 1.*

> " *Ah. Mail's here!* "
> — RON WEASLEY
> *Harry Potter and the Sorcerer's Stone* film

V. DESCRIPTION FROM *HARRY POTTER AND THE SORCERER'S STONE* BOOK, CHAPTER EIGHT:

*"[I]t had given him a bit of a shock on the first morning when about a hundred owls had suddenly streamed into the Great Hall during breakfast, circling the tables before they saw their owners, and dropping letters and packages onto their laps."*

The majority of owls in cages at the Hogwarts Express station were also models, including a Hedwig stand-in. Any live owl used in the scenes loading or unloading onto the train would have its cage bolted to the luggage cart. Whenever a live owl was used, it had a light, invisible safety line attached to it, even while it flew. Sixty live owls were featured in the Owlery scene of *Harry Potter and the Goblet of* [Fire,] which utilized even more faux owls, some mechanical. Many of [the Ow]lery owls were borrowed from rescue centers.

["A wise] old owl" is a common myth but owls are actually not the fast[est of] learners. Once they do learn a behavior, fortunately, it becomes [deeply] ingrained, and so it was not difficult to bring the owls up to [speed] upon returning to each film. The owls responded to a whistle [cue] that was part of their training to turn their heads on cue or to [fly fro]m point A to point B, where they would be rewarded with an [owl tr]eat.

[To b]e in the background, or to populate a scene, some owls were [flown b]y their trainer and filmed flying in front of a wind machine [and/or] against a green screen. The trainer would be digitally removed [and the] filmed owl could then be directed within the computer to fly [in any] direction necessary and as high and faraway as needed for [the s]hots.

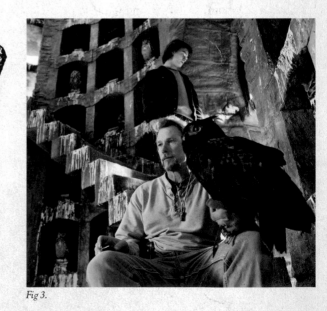

Fig 3.

Previous: Kreacher, the Black family's aged and surly house-elf by Rob Bliss for *Harry Potter and the Order of the Phoenix*; Fig 1. An owl in the woods near Hogwarts by Adam Brockbank for *Harry Potter and the Chamber of Secrets*; Fig 2. Harry Potter in the Owlery at Hogwarts by Andrew Williamson for *Harry Potter and the Goblet of Fire*; Fig 3. A post owl rests on the arm of owl wrangler David Sousa on the Owlery set with Daniel Radcliff (background) during the filming for *Harry Potter and the Goblet of Fire*.

# House-elf.

**A** house-elf is bound to serve one wizarding family for his or her entire life. House-elves are dependable, loyal, and many are even fanatical in their service to their masters. When called upon, they can utilize incredibly powerful magic. House-elves can only be released from their servitude with the gift of an article of clothing from their master. While we meet only two house-elves in the Harry Potter films, the designers evoked very different personalities and looks in their realization of these creatures, and were given the rare opportunity to physically age these characters.

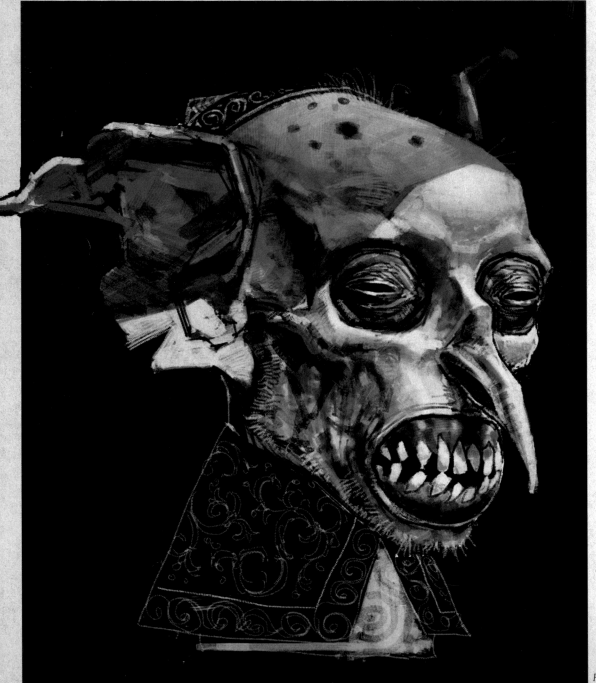

"*Not to be rude or anything, but this isn't a great time for me to have a house-elf in my bedroom.*"
— HARRY POTTER
*Harry Potter and the Chamber of Secrets* film

Figs 1. — 5. Harry Potter discovers the **Black** family's curious tradition of displaying the heads of their house-elves after their service ends when he visits number 12, Grimmauld Place in *Harry Potter and the Order of the Phoenix*. Rob Bliss's concept artwork offers eerie and enthralling possibilities of noses, ears, teeth, and even skin textures.

*Fig 1.*

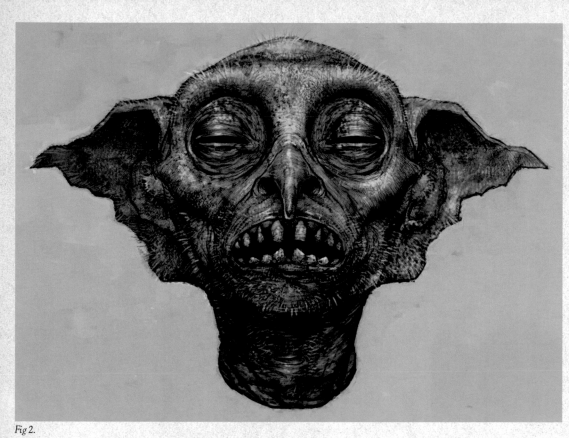

Fig 2.

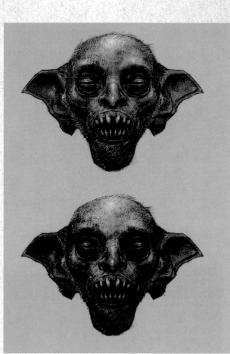

Fig 3.

> " *Dobby is bound to serve one family forever. If they ever knew Dobby was here . . .*"
>
> — DOBBY
> *Harry Potter and the Chamber of Secrets* film

Fig 4.

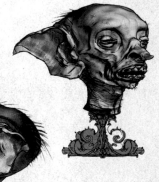

Fig 5.

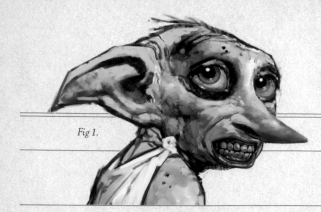

Fig 1.       House-elf example 1.

# DOBBY.

Dobby, the house-elf who serves the Malfoy family, becomes a loyal friend to Harry in *Harry Potter and the Chamber of Secrets* when Harry finds a way to release Dobby from the Malfoy family's service. They are reunited in *Harry Potter and the Deathly Hallows – Part 1*, but sadly, Dobby is killed as he tries to rescue Harry and his friends.

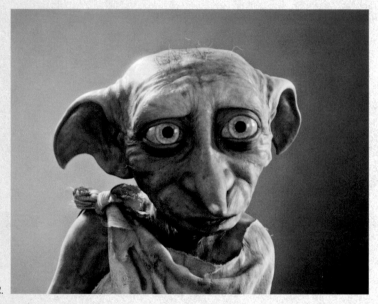

Fig 2.

A beloved and unique creature, Dobby, introduced in *Harry Potter and the Chamber of Secrets,* was the first fully computer-generated major character in the Harry Potter films. Dobby went through many design iterations before the bat-eared, soulfully big-eyed, pointy-nosed house-elf emerged. The designers took into account Dobby's background as servant to the Malfoy family, and so he was given a pasty, sallow "prisoner-of-war" appearance, enhanced by grimy skin and little or no muscle tone. His hunched posture reflects his years of abuse at the hands of the Malfoys.

Once Dobby's look was established, the creature shop fashioned a full-size, fully articulated, fully painted silicone model that left no wrinkle unfolded. With a completely functioning armature inside, the model was posable for lighting reference and for actors to create eyelines on the set. The model was also used in the film for a few over-the-shoulder shots. Dobby's movement for *Chamber of Secrets* was achieved via motion capture technology. Actor Toby Jones, who voiced the house-elf, enacted his scenes, which would then have his facial expressions and physicality imbued into the digital performance.

The digital realism that comes from cyberscanning a model so meticulously crafted can be measured by the emotional impact of the CGI character. For Dobby's final appearance, in *Harry Potter and the Deathly Hallows – Part 1*, the house-elf was given a softer, more humanized look, which the filmmakers felt would give him an even greater sympathetic resonance. His neck and face were smoothed out, his arms were shortened, and his eyes were less bulbous. As Dobby passed away in Harry's arms, the visual effects designers had his eyes appear watery, and slowly desaturated the texture of his skin to make it successively paler. Dobby's death at Shell Cottage involved not only the CGI version of the character but the life-size model and even body doubles that were composited into the live action.

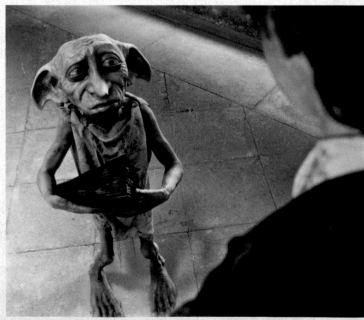

Fig 3.

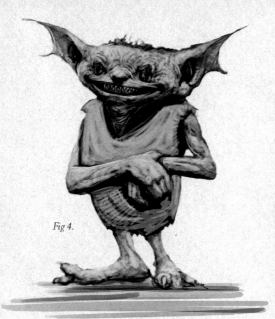

Fig 4.

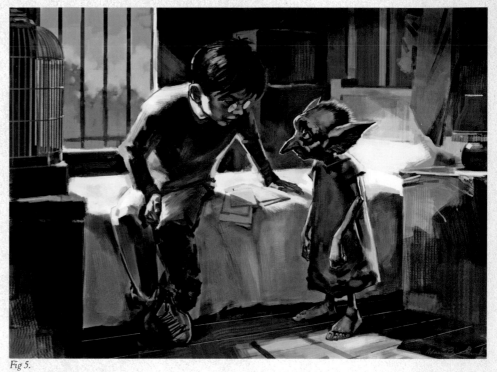

Fig 5.

"
*Dobby never meant to kill anyone!*

*Dobby only meant to maim . . . or seriously injure.*"

— DOBBY

*Harry Potter and the Deathly Hallows — Part 1* film

Fig 6.

Fig 7.

Fig 8.

Fig 9.

Fig 1. Dobby the house-elf by Rob Bliss for *Harry Potter and the Chamber of Secrets*; Figs 2. & 3. Dobby comes to the Dursleys' house to persuade Harry not to return to Hogwarts in scenes from *Chamber of Secrets*; Figs 4., 6. — 9. Visual development studies for Dobby by various artists; Fig 5. Harry lets Dobby know that nothing will stop him from going back to Hogwarts in artwork by Adam Brockbank.

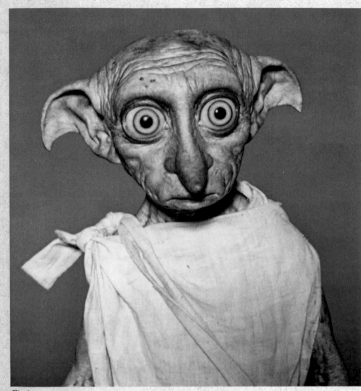

Fig 1.

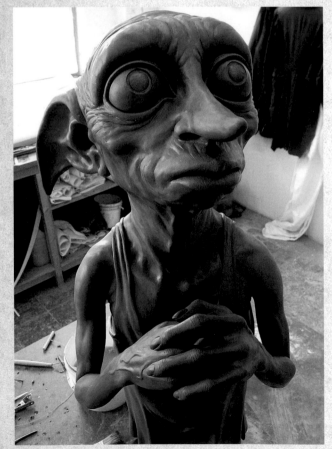

Fig 2.

## DOBBY

✳

I. FIRST FILM APPEARANCE: *Harry Potter and the Chamber of Secrets*

II. ADDITIONAL FILM APPEARANCE:
*Harry Potter and the Deathly Hallows – Part 1*

III. LOCATION: number 4 Privet Drive, Hogwarts,
number 12, Grimmauld Place, Malfoy Manor, Shell Cottage

IV. TECH TALK: The animators always had Dobby's smile turn up on the
left side whether or not he is facing in that direction on-screen.

V. DESCRIPTION FROM *HARRY POTTER AND THE
CHAMBER OF SECRETS* BOOK, CHAPTER TWO:
*"The little creature on the bed had large, bat-like ears and
bulging green eyes the size of tennis balls."*

Fig 3.

Figs 1. & 2. Maquettes of Dobby at different stages of creation for
*Harry Potter and the Chamber of Secrets*; Fig 3. Studies of Dobby and his
wrapped-towel attire by Rob Bliss; Fig 4. Early concept art of Dobby
covered in tea towels by an unknown artist; Fig 5. Head studies of
Dobby by Rob Bliss; Fig 6. Dobby's gravestone by Hattie Storey from
*Harry Potter and the Deathly Hallows – Parts 1* and 2; Fig 7. Early
concept art of a long-nosed Dobby by an unknown artist.

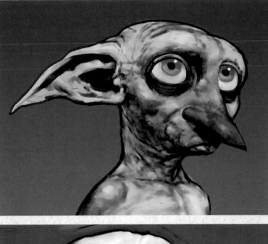

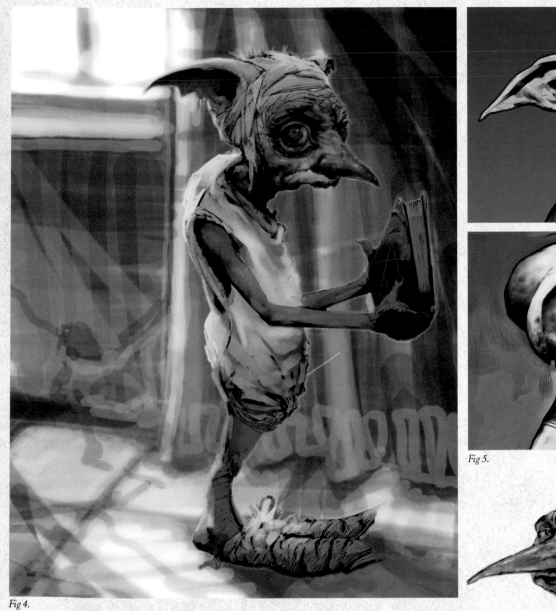

Fig 4.

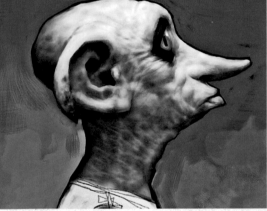

Fig 5.

Fig 6.

HERE
LIES

DOBBY

A
FREE ELF

"*Master has presented Dobby with clothes!*
*Dobby is free!*"

— DOBBY
*Harry Potter and the Chamber of Secrets* film

Fig 7.

# KREACHER.

*Fig 1.*

When Harry Potter is taken to number 12, Grimmauld Place in *Harry Potter and the Order of the Phoenix*, he meets Kreacher, the house-elf who serves the Black family. Devoted to his pure-blood wizard masters, Kreacher despises their Dumbledore-loyal son, Sirius, and the members of the Order who meet at Grimmauld Place. In *Harry Potter and the Deathly Hallows – Part 1*, Kreacher assists Harry in finding the real Horcrux locket.

Kreacher could be considered the exact opposite of Dobby, even if they are from the same species. The designers enjoyed creating Kreacher's aged, collapsing skin, and long, dragging ears (complete with ear hair). Kreacher was given a hunched back, a dewlap, rheumy eyes, and a crooked, stooped stance that exudes distaste and intolerance. Whereas Dobby bubbled with exuberant movement, Kreacher was slow and plodding, almost immobile. Kreacher was voiced by Timothy Bateson for *Order of the Phoenix*, and then Simon McBurney for *Deathly Hallows – Part 1*. For his final appearance, Kreacher also "had a little work done." His nose was shortened, his skin was smoothed out, and his ears (and ear hair) were trimmed.

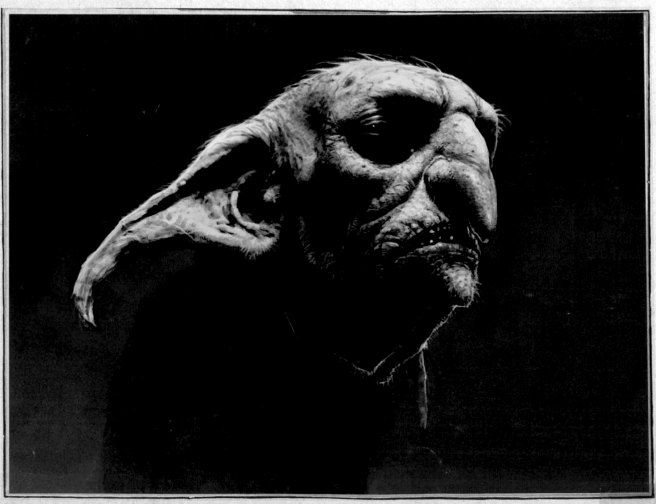

*Fig 2.*

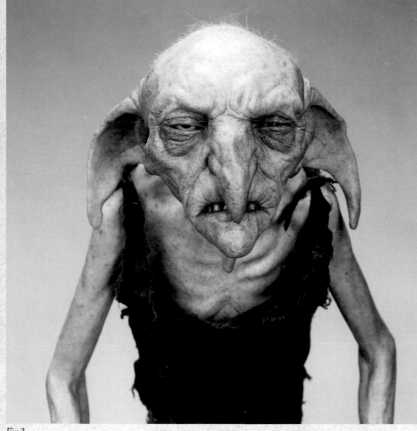

Fig 3.

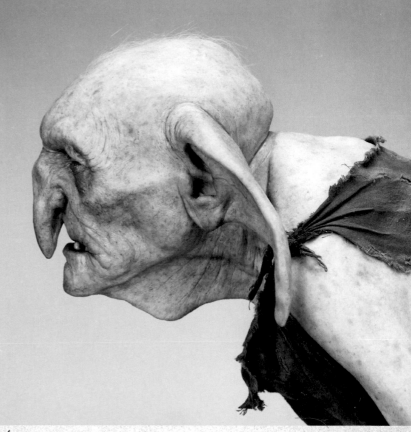

Fig 4.

"*Nasty brat standing there as bold as brass. Harry Potter, the boy who stopped the Dark Lord. Friend of Mudbloods and blood-traitors alike. If my poor mistress only knew . . .*"

—KREACHER

*Harry Potter and the Order of the Phoenix* film

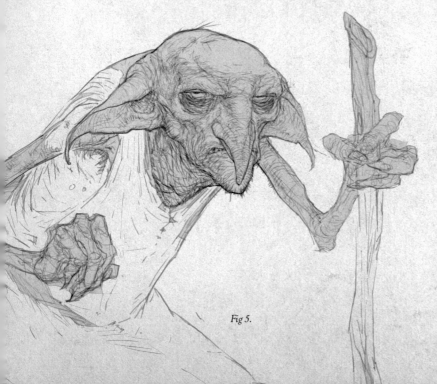

Fig 5.

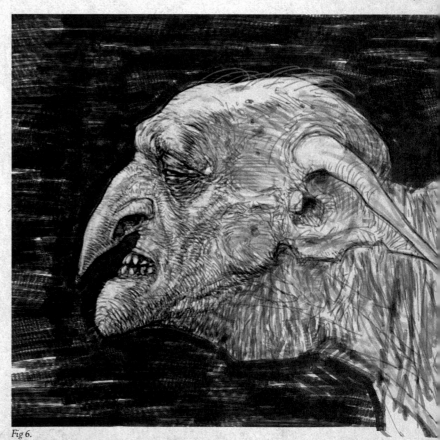

Fig 6.

Fig 1. Kreacher by Rob Bliss for *Harry Potter and the Order of the Phoenix*; Fig 2. A color study of Kreacher by Rob Bliss; Figs 3. & 4. Maquette of Kreacher; Figs 5. & 6. Kreacher sketches by Rob Bliss for *Order of the Phoenix*.

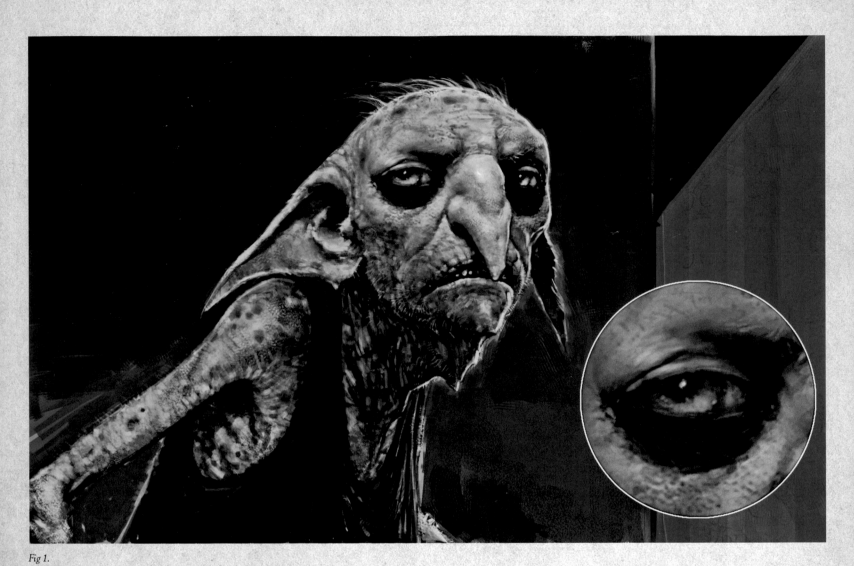

Fig 1.

Fig 2.

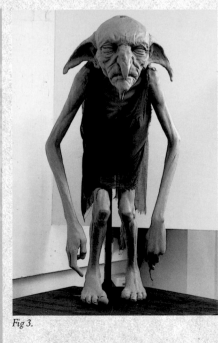

Fig 3.

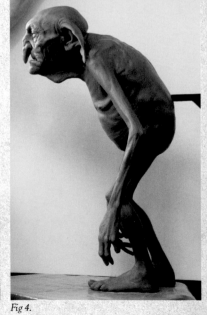

Fig 4.

Fig 1. Color study of Kreacher with a close-up of his eye by Rob Bliss for *Harry Potter and the Order of the Phoenix*; Fig 2. A contemplative Kreacher by Rob Bliss; Figs 3. & 4. Maquette of Kreacher, Fig 5. Ear studies by Rob Bliss; Fig 6. Kreacher insults Harry (Daniel Radcliffe) in the Black family Tapestry Room in a scene from *Order of the Phoenix*; Fig 7. A shorter-nosed Kreacher by Rob Bliss.

> "*Kreacher lives to serve the*
> *Noble House of Black.*"
> —KREACHER
> *Harry Potter and the Order of the Phoenix* film

## KREACHER

✶

I. FIRST FILM APPEARANCE: *Harry Potter and the Order of the Phoenix*

II. ADDITIONAL FILM APPEARANCE:
*Harry Potter and the Deathly Hallows — Part 1*

III. LOCATION: Number 12, Grimmauld Place

IV. DESIGN NOTE: The designers wanted Kreacher
to be "revolting and ghastly in every way."

V. DESCRIPTION FROM *HARRY POTTER AND THE
ORDER OF THE PHOENIX* BOOK, CHAPTER SIX:
"*Its skin seemed to be several times too big for it and though it was bald like all house-
elves, there was a quantity of white hair growing out of its large, bat-like ears.*"

Fig 5.

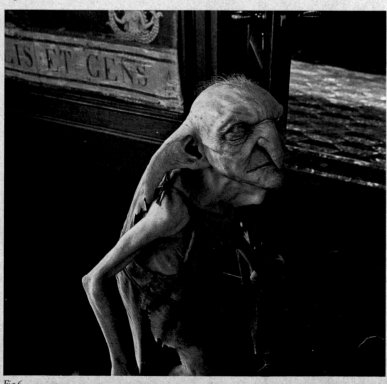

Fig 6.

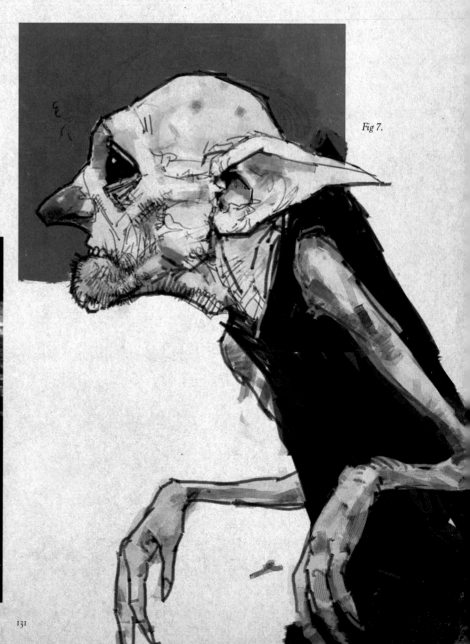

Fig 7.

# Goblin.

Goblins in the *Harry Potter* films act as bank officials and tellers at Gringotts bank in Diagon Alley. In the films, these creatures were given long fingers, long ears, and long noses as defining characteristics. Hagrid and Harry are taken by the goblin Griphook to withdraw money from the Potter family vault in *Harry Potter and the Sorcerer's Stone*. Harry, Griphook, Hermione Granger, and Ron Weasley, deceive the Gringotts goblins in *Harry Potter and the Deathly Hallows – Part 2* to break into the Lestranges' vault.

The creature designers for the Harry Potter films realized early on that the goblins' most important feature was their character, and so they created interesting character types that they then "goblinized." Each goblin was individually designed, with their personalities perceptible in their distinctive ears, chins, and noses.

In the ten years between the goblins' first appearance in *Harry Potter and the Sorcerer's Stone* and their final appearance in *Harry Potter and the Deathly Hallows – Part 2*, the technology involved in producing the prosthetic pieces that created the goblins' look had greatly advanced. While the goblin heads for both films were cast in silicone, modern silicone now moves and feels like flesh. In *Deathly Hallows – Part 2*, more than sixty goblins were needed to inhabit the bank for the film, and so the creature shop put together an assembly line of makeup artists to paint goblin faces and hands, and insert hair and eyelashes one strand at a time. The goblin prosthetics could not be reused after they were removed at the end of the day's filming, and so multiples of every goblin head were created and duplicated for each day of the shooting schedule.

Fig 1.

Fig 1. A publicity shot of a goblin in Gringotts bank from *Harry Potter and the Deathly Hallows – Part 2*; Figs 2. – 5. Goblin studies by Paul Catling for *Harry Potter and the Sorcerer's Stone*.

Fig 2.

*Fig 3.*

*Fig 4.*

# FAST FACTS

## GOBLIN

✶

I. FIRST FILM APPEARANCE: *Harry Potter and the Sorcerer's Stone*

II. ADDITIONAL FILM APPEARANCE:
*Harry Potter and the Deathly Hallows – Part 2*

III. LOCATION: Gringotts bank, Diagon Alley

IV. TECH TALK: The silicone material worn by the goblins in
*Deathly Hallows – Part 2* comes up to body temperature when applied.

V. DESCRIPTION FROM *HARRY POTTER AND THE
SORCERER'S STONE* BOOK, CHAPTER THREE:
*"The goblin was about a head shorter than Harry. He had a swarthy, clever
face, a pointed beard, and, Harry noticed, very long fingers and feet."*

"
*Clever as they come, goblins, but not
the most friendly of beasts."*
— RUBEUS HAGRID
*Harry Potter and the Sorcerer's Stone* film

Fig 1.

Fig 2.

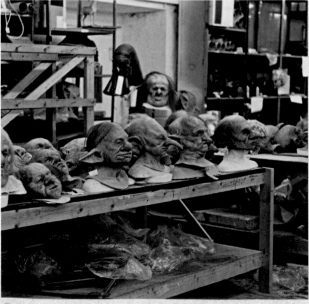

Fig 3.

# GRIPHOOK.

Griphook first meets Harry Potter in *Harry Potter and the Sorcerer's Stone* when the Gringotts worker guides him to the Potter family vault. They meet again in *Harry Potter and the Deathly Hallows – Parts 1* and *2,* when Griphook strikes a deal with Harry, who needs his help to break into the Lestranges' vault.

Griphook was played by veteran actor Warwick Davis, one of his many roles in the Harry Potter series. Transforming into Griphook for *Deathly Hallows – Parts 1* and *2* took four hours, which included wearing contact lenses and dentures with very sharp teeth that made it difficult to speak. It took another hour after shooting to remove the makeup. Davis also played the bank teller goblin who takes Harry Potter's vault key in *Harry Potter and the Sorcerer's Stone*, Hogwarts Professor Filius Flitwick, and the Hogwarts Choir Director in *Harry Potter and the Prisoner of Azkaban*. He also had a cameo in *Harry Potter and the Order of the Phoenix* as a goblin who lost Galleons trading on the potions market.

*Fig 4.*

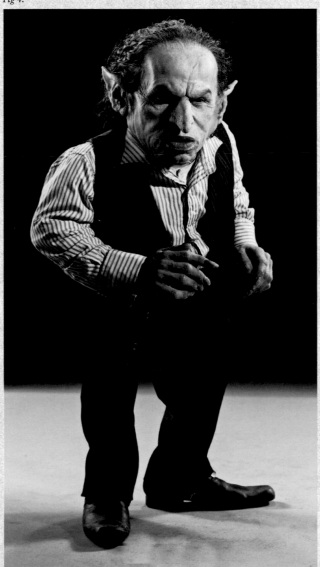

*Fig 5.*

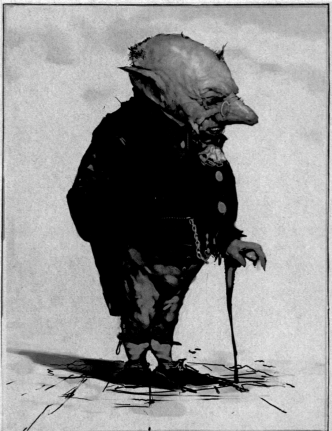

Fig 1. Gringotts goblins pose in a publicity shot for *Harry Potter and the Sorcerer's Stone*. Warwick Davis is at the center, playing a bank teller.
Fig 2. Prosthetic head piece model for the bank teller goblin.

Fig 3. The creature shop displays the goblin head prosthetics for *Sorcerer's Stone*.
Fig 4. Warwick Davis as Griphook in *Harry Potter and the Deathly Hallows – Part 2*.
Fig 5. Visual development artwork of Griphook by Paul Catling.

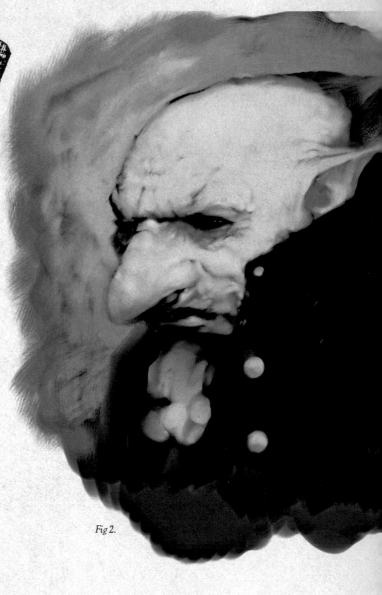

Fig 2.

# FAST FACTS

## GRIPHOOK

✶

I. FIRST FILM APPEARANCE: *Harry Potter and the Sorcerer's Stone*

II. ADDITIONAL FILM APPEARANCE:
*Harry Potter and the Deathly Hallows – Part 2*

III. LOCATIONS: Gringotts bank, Shell Cottage

IV. TECH TALK: The part of Griphook in *Harry Potter and the Sorcerer's Stone* was physically played by Verne Troyer; Warwick Davis provided only the voice.

V. DESCRIPTION FROM *HARRY POTTER AND THE DEATHLY HALLOWS* BOOK, CHAPTER TWENTY-FOUR:
*"Harry noted the goblin's sallow skin, his long thin fingers, his black eyes. . . . His domed head was much bigger than a human's."*

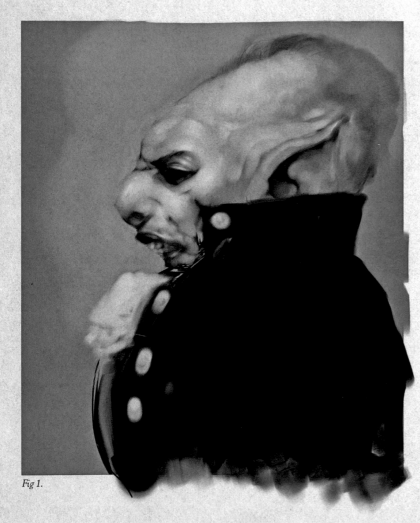

Fig 1.

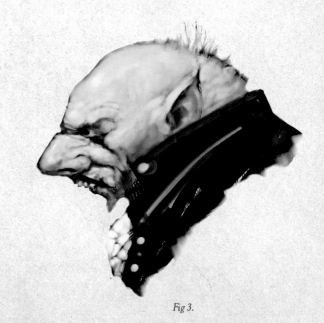

Fig 3.

Figs 1. — 6. Paul Catling's portrayals of Griphook for *Harry Potter and the Sorcerer's Stone* are clothed in Dickensian-style suits, which was the costume department's idea for the wardrobe for the first film.

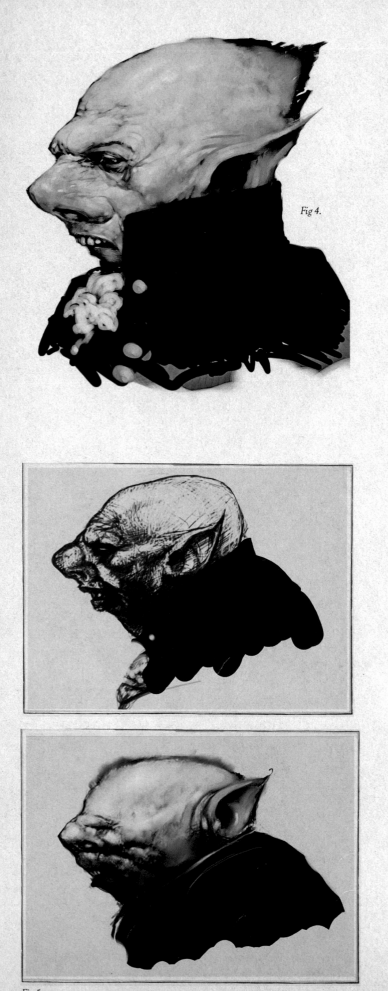

Fig 4.

"
*I said I'd get you in. I didn't say anything about getting you out."*

— GRIPHOOK

*Harry Potter and the Deathly Hallows — Part 2* film

Fig 5.

Fig 6.

# Fluffy.

To protect the Sorcerer's Stone in _Harry Potter and the Sorcerer's Stone_, several professors set up obstacles to thwart a potential theft. The first of these obstacles is Fluffy, a three-headed guard dog provided by Rubeus Hagrid.

An important challenge to the creature designers was always to make the unbelievable believable. So a three-headed dog in _Harry Potter and the Sorcerer's Stone_ needed to feel as if it were three individual dogs united in the same body. In order to accomplish this, the digital animators assigned a different personality to each of the heads: one was sleepy, one was smart, and one was very alert. This also provided an opportunity for comic interaction. Special attention was paid to having the heads act independently of each other, so none of their movements were ever made in sync.

When Harry Potter, Ron Weasley, and Hermione Granger attempt to get past the sleeping dog, they need to move one of its giant paws off the trap door, so a full-scale, weighted version of Fluffy's right paw was created for the actors to move. All of Fluffy's remaining actions were computer generated, except for one. The drool that lands on Ron's shoulder? An unpleasant practical effect.

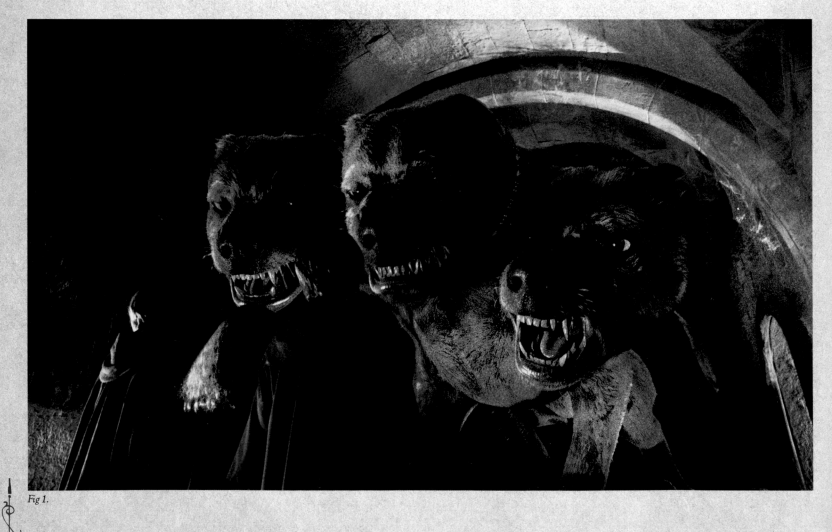

_Fig 1._

Fig 2.

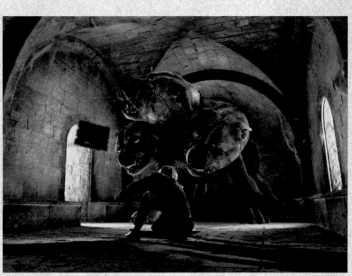
Fig 3.

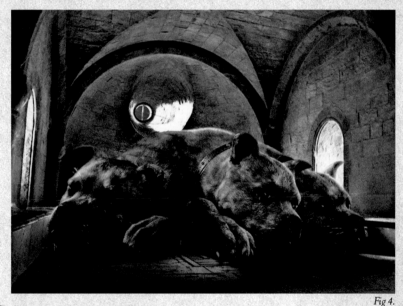
Fig 4.

Fig 1. Ron Weasley (Rupert Grint), Hermione Granger (Emma Watson), and Harry Potter (Daniel Radcliffe) encounter the three-headed guard dog, Fluffy, in a scene from *Harry Potter and the Sorcerer's Stone*; Figs 2. — 4. Screen stills of Fluffy include his two huge paws and his three huge heads.

# FAST FACTS

## FLUFFY

✳

I. FILM APPEARANCE: *Harry Potter and the Sorcerer's Stone*

II. LOCATION: Hogwarts castle, third floor corridor on the right-hand side

III. DESIGN NOTE: Fluffy's heads are based on that of a Staffordshire Bull Terrier

IV. DESCRIPTION FROM *HARRY POTTER AND THE SORCERER'S STONE* BOOK, CHAPTER NINE:

*"They were looking straight into the eyes of a monstrous dog, a dog that filled all the whole space between ceiling and floor. It had three heads. Three pairs of rolling, mad eyes; three noses, twitching and quivering in their direction; three drooling mouths . . ."*

"
*That's what Fluffy's guarding on the third floor. That's what's under the trapdoor . . . the Sorcerer's Stone!"*

—HERMIONE GRANGER
*Harry Potter and the Sorcerer's Stone* film

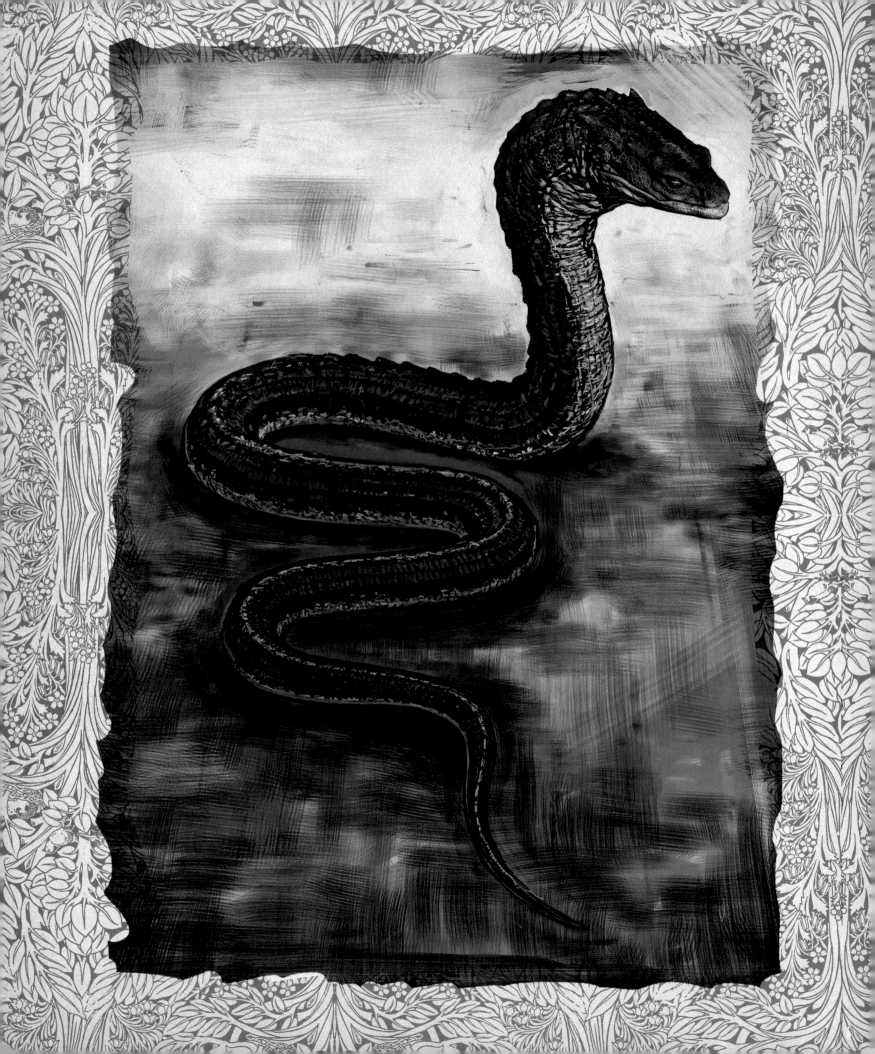

## CHAPTER VII

# DARK FORCES

*T*he wizarding world depicted in the Harry Potter films includes creatures that would haunt the most horrible of nightmares, many of them engaged by Lord Voldemort in his pursuit of power. Twice, Voldemort opens the Chamber of Secrets to release the Basilisk, whose stare can turn its victims to stone. The Dark Lord also enlists the Dementors during his second rise to power and uses the Inferi as part of his arsenal to guard his Horcrux locket.

# Basilisk.

The titular location of <u>Harry Potter and the Chamber of Secrets</u> contains a thousand-year-old snake—the Basilisk, originally under the control of Salazar Slytherin. In the years since the Basilisk's containment, only one student has been able to command it: Tom Riddle. When the Basilisk is released once more during the events of <u>Harry Potter and the Chamber of Secrets</u>, it is up to Harry to slay the beast and save the school.

Fig 1.

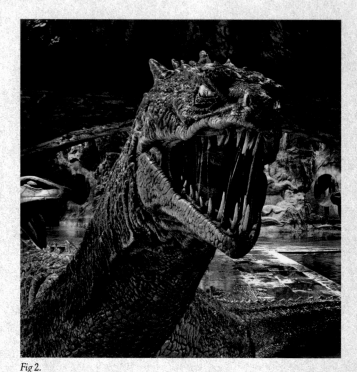

Fig 2.

Fig 3.

Previous: The deadly Basilisk, by Rob Bliss for *Harry Potter and the Chamber of Secrets*; Fig 1. Early concept art of the Basilisk by Rob Bliss for *Harry Potter and the Chamber of Secrets*; Fig 2. The Basilisk appears in the Chamber in a scene from the film; Fig 3. Pencil sketch of a long-horned Basilisk head by Rob Bliss; Fig 4. The Basilisk from above by an unknown artist. Fig 5. Study of a cobra by Rob Bliss to inform concepts of the Basilisk; Fig 6. The horns of the Basilisk reduced greatly in later artwork by Rob Bliss.

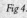
*Fig 4.*

*Fig 5.*

The Basilisk that lives deep below Hogwarts in *Harry Potter and the Chamber of Secrets* has a dragon-shaped head that literally heightens its exaggerated reptilian body. Bony, thorny, and a little slimy, the Basilisk was fully intended to be brought to life inside a computer. Visual development research included observation of live creatures, including an eight-foot-long Burmese python named Doris. A model was produced to be cyberscanned, but there was also a need for a prop of the Basilisk's shed skin to lie in the Chamber, which meant a model of the snake was needed at full scale, and so the creature shop constructed the Basilisk's first forty feet of discarded snakeskin in urethane rubber.

It then became logical that Daniel Radcliffe (Harry Potter) would need a full-size practical Basilisk mouth to fight against in the final battle scene in *Chamber of Secrets*. The creature shop was happy to comply, but realized that they should sculpt more than just the teeth and the inside of the mouth; they needed to sculpt the entire head, which would lessen the amount of CG shots needed. The filmmakers agreed, and then asked if the sculpt could extend to the neck. And if the jaw could be made to open and if the mouth could move up and down. And if the Basilisk's nose could move when it is stabbed. And if its eyes and eyelids could move even after it is blinded. And if its fangs could hinge backward, as any venomous snake's does, so that it could close its mouth. And so, in addition to the full-size model of the shed snakeskin, another full-size model became a practical Basilisk that took its place on the *Chamber of Secrets* set. The model used Aquatronics, employed to enhance the Basilisk's smooth glides and mouth movements; cable controls retracted its fangs.

*Fig 6.*

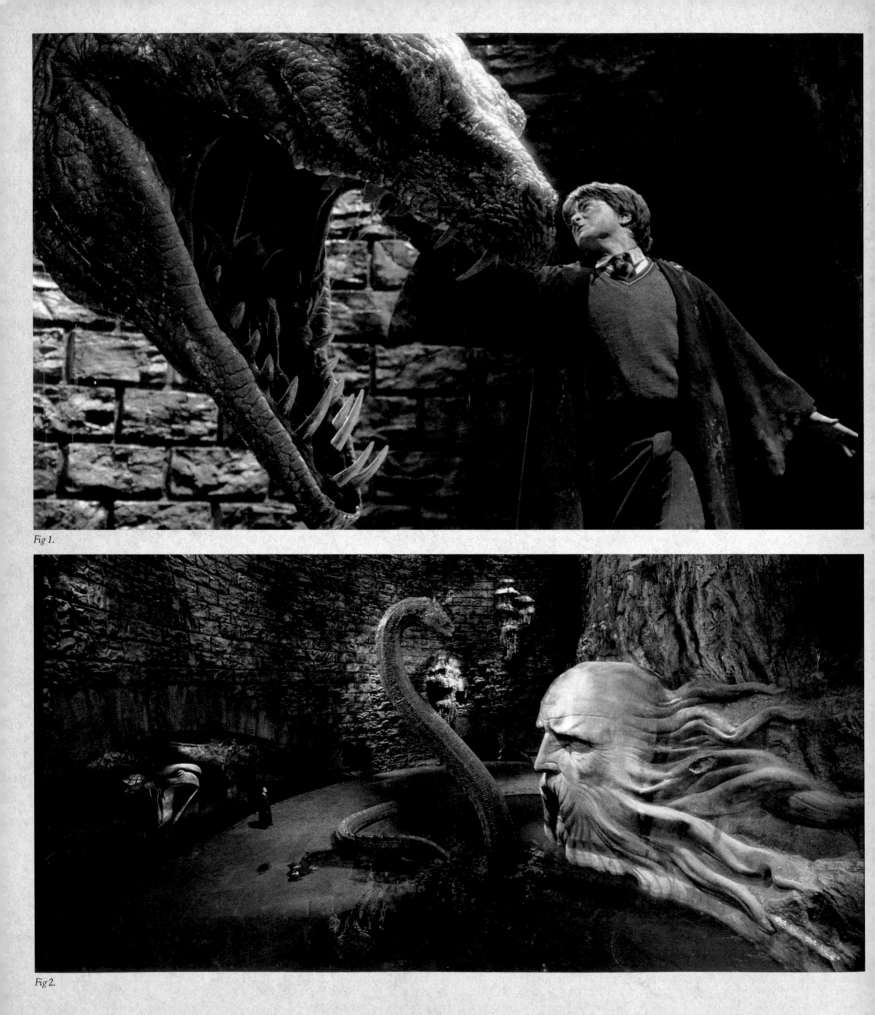

Fig 1.

Fig 2.

Fig 3.

Fig 4.

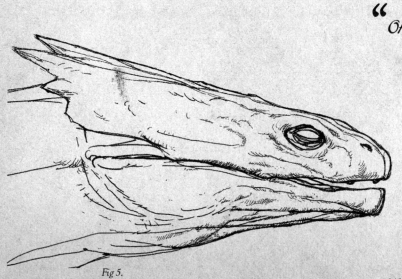

Fig 5.

"*Of the many fearsome beasts that roam our land, none is more deadly than the Basilisk. Capable of living for hundreds of years, instant death awaits any who meet this giant serpent's eye.*"

— HARRY POTTER, READING FROM
A TORN PAGE OF A LIBRARY BOOK
*Harry Potter and the Chamber of Secrets* film

Fig 1. Harry (Daniel Radcliffe) defeats the Basilisk in a scene from *Harry Potter and the Chamber of Secrets*; Fig 2. The death throes of the Basilisk; Fig 3. Development art of the Basilisk in death's repose by Rob Bliss; Fig 4. Studies of the Basilisk's eye by Rob Bliss; Fig 5. Early concept sketch by Rob Bliss.

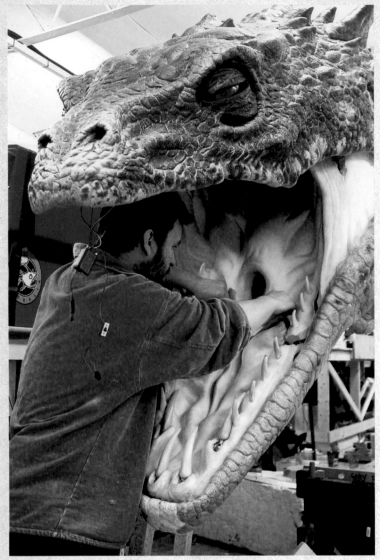

Fig 1.

Creating the neck and body of the practical Basilisk seemed less than practical at first. The creature's foam latex exterior skin would need to be laid over a tubular or hexagonal structure with long sides made of aluminum to ensure that the design didn't become too heavy or unwieldy. This could only be accomplished by machine work that would be complicated and laborious. Or so they thought. In a casual remark, one of the creature shop crew suggested using ladders, which became a fortuitous solution. The aluminum ladders were already strong, and were strengthened even more by modifications made to place them under the Basilisk skin. They were also light in weight, an important quality as the creature would be flailing about the set and battling with the series' titular hero.

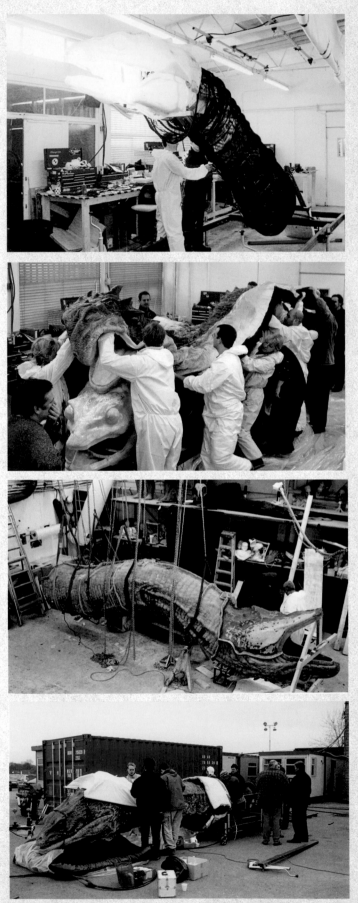

Figs 2.— 5.

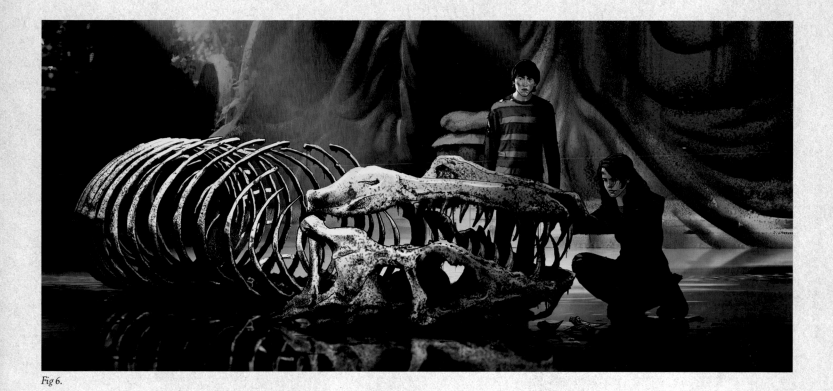

Fig 6.

Figs 1. — 5. Construction of the Basilisk in the creature shop included laying a forty-foot-long skin over a structure of aluminum ladders; Fig 6. Ron Weasley and Hermione Granger return to the Chamber of Secrets for a Basilisk's tooth in artwork by Adam Brockbank for *Harry Potter and the Deathly Hallows – Part 2*; Fig 7. The life-size Basilisk is sprayed down before a scene for *Harry Potter and the Chamber of Secrets*.

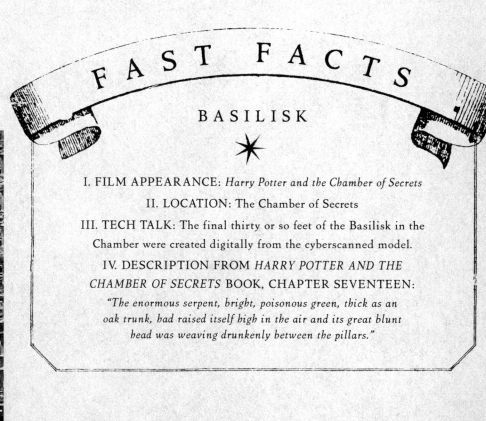

# FAST FACTS

## BASILISK

✳

I. FILM APPEARANCE: *Harry Potter and the Chamber of Secrets*

II. LOCATION: The Chamber of Secrets

III. TECH TALK: The final thirty or so feet of the Basilisk in the Chamber were created digitally from the cyberscanned model.

IV. DESCRIPTION FROM *HARRY POTTER AND THE CHAMBER OF SECRETS* BOOK, CHAPTER SEVENTEEN:

*"The enormous serpent, bright, poisonous green, thick as an oak trunk, had raised itself high in the air and its great blunt head was weaving drunkenly between the pillars."*

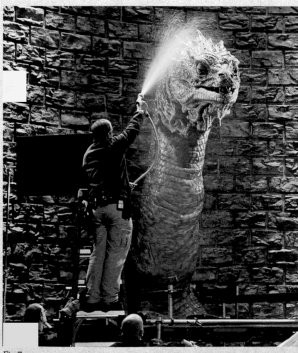

Fig 7.

# Dementor.

Dementors, spectral Dark creatures that guard Azkaban, are sent to Hogwarts to find and bring back Sirius Black in _Harry Potter and the Prisoner of Azkaban_. Harry is deeply affected by their soul-draining power, so Professor Lupin teaches him the Patronus charm to shield himself. In _Harry Potter and the Order of the Phoenix_, Dementors attack Harry and Dudley Dursley in Little Whinging, but Harry manages to drive them away. Dementors fight on Voldemort's side in _Harry Potter and the Deathly Hallows – Parts 1 and 2_.

Fig 1. (above) The skeletal structure of a Dementor disappears within its hooded and tattered cloak in artwork by Rob Bliss for _Harry Potter and the Prisoner of Azkaban_; Fig 2. (opposite) A concept sketch of Harry's encounter with the Dementors during a Quidditch game by Rob Bliss for _Prisoner of Azkaban_.

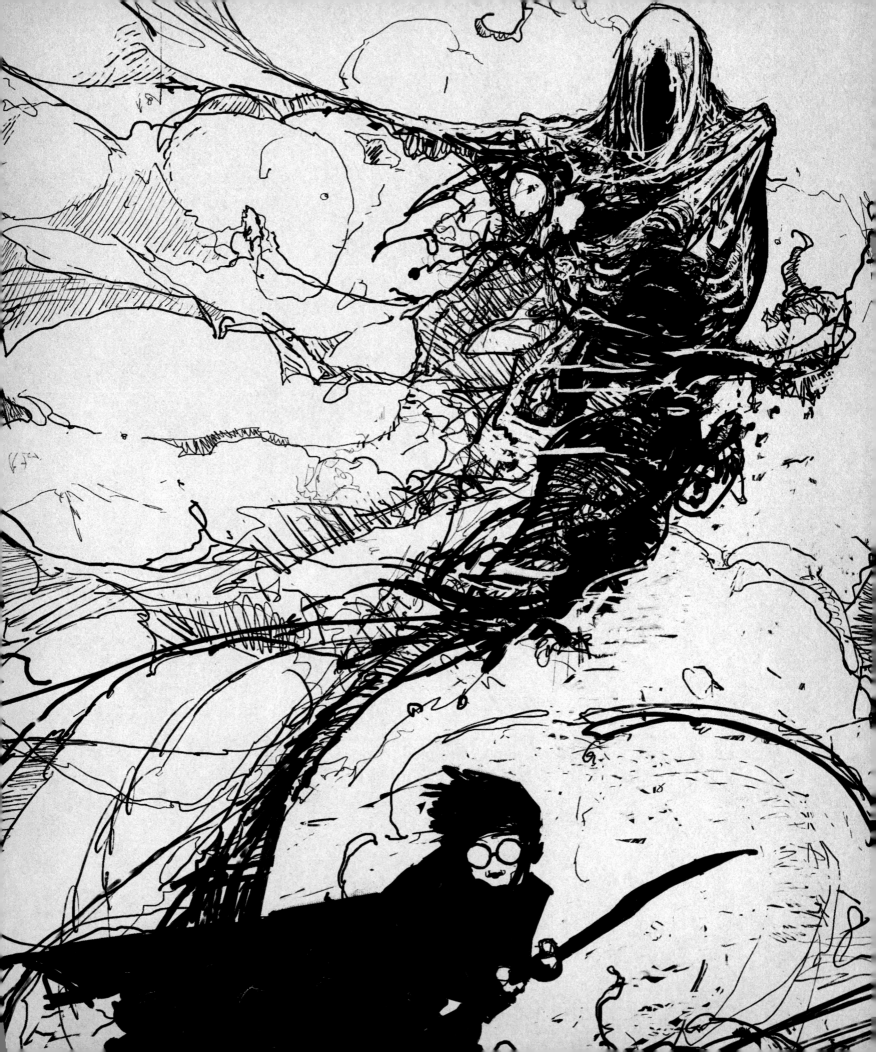

Figs 1. & 2. Dementor studies by Rob Bliss for *Harry Potter and the Prisoner of Azkaban*; Fig 3. Dementors float above the Hogwarts grounds in artwork by Andrew Williamson for *Prisoner of Azkaban*; Fig 4. Hooded Dementors envisioned by Olga Dugina and Andrej Dugin.

*Fig 1.*

*Fig 2.*

"*Dementors are amongst the foulest creatures to walk this earth. They feed on every good feeling, every happy memory, until a person is left with absolutely nothing but his worst experiences.*"

— REMUS LUPIN

*Harry Potter and the Prisoner of Azkaban* film

*Fig 3.*

Dementors are ethereal, insubstantial creatures with no perceptible structure. The visual development artists on *Harry Potter and the Prisoner of Azkaban* designed a veiled, skeletal shape that could suggest some anatomical frame when the Dementors glided or hovered in the air, and swathed them in shroud-like black robes that hung from their skulls. The creature designers worked closely with the costume department, who experimented with an assortment of fabrics that could convey a floating effect. Typically filmed in lowly lit scenes, the Dementors' coloration could not be solely black or else they would disappear into the background, so a combination of dark grays and blacks was used. The designers referenced embalmed bodies, whose wrappings were rotting and coming off, and added overlaid textures to the Dementors that gave the appearance of layers of decay.

The Dementors do not talk and only needed a mouth-like opening to drain happiness from their victims, so movement was the key to communicating these chilling, menacing characters. The filmmakers had hoped to bring the Dementors to life with a practical effect. They shot tests of fabric-covered Dementor models using different wind and lighting effects, and ran the film backward or in slow motion, but were not satisfied with the results. A puppeteer was brought in to test the same ideas, this time in an underwater environment, in hopes of portraying a slow and forceful creature. These tests captured what the filmmakers envisioned, but it was realized that using this process would make it difficult to repeat the same motion. It was decided that the Dementors needed to be computer-generated. The footage of the underwater tests was an important reference tool, and the digital artists expanded upon it with effects that gave the Dementors their own realistic gravity, making them stealthy and unearthly.

*Fig 4.*

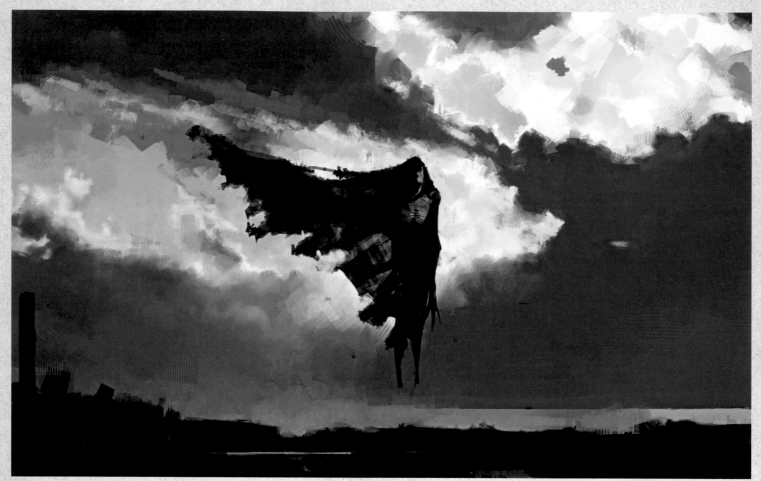

Fig 1.

Fig 1. Evocative artwork of a Dementor by Rob Bliss for *Harry Potter and the Prisoner of Azkaban*; Fig 2. Pencil sketch by Rob Bliss;
Figs 3. & 4. Rob Bliss explores Dementor textures and shades in detailed concept art; Fig 5. Harry Potter (Daniel Radcliffe) uses the
Patronus Charm to disperse the Dementors and protect Sirius Black (Gary Oldman) in a scene from *Prisoner of Azkaban*;
Fig 6. A shadowy view of the Quidditch match portrayed by Rob Bliss.

Fig 2.

## FAST FACTS

### DEMENTOR

✦

I. FIRST FILM APPEARANCE: *Harry Potter and the Prisoner of Azkaban*

II. ADDITIONAL FILM APPEARANCES: *Harry Potter and the Order
of the Phoenix, Harry Potter and the Deathly Hallows – Parts 1 and 2*

III. TECH TALK: The costume department based their
interpretation of the Dementors' robes on birds' wings.

IV. LOCATIONS: Hogwarts Express, Hogwarts castle, an
underpass adjacent to Privet Drive, Ministry of Magic

V. DESCRIPTION FROM *HARRY POTTER AND THE
PRISONER OF AZKABAN* BOOK, CHAPTER FIVE:

*"There was a hand protruding from the cloak and it was glistening, grayish,
slimy-looking, and scabbed, like something dead that had decayed in water."*

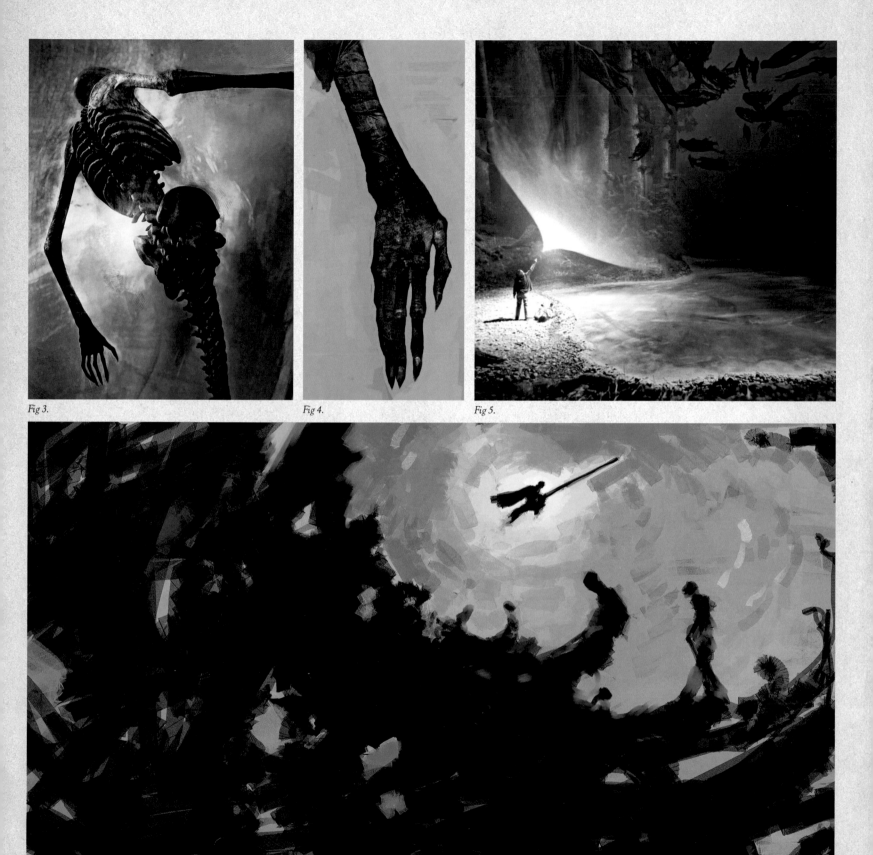

Fig 3.

Fig 4.

Fig 5.

Fig 6.

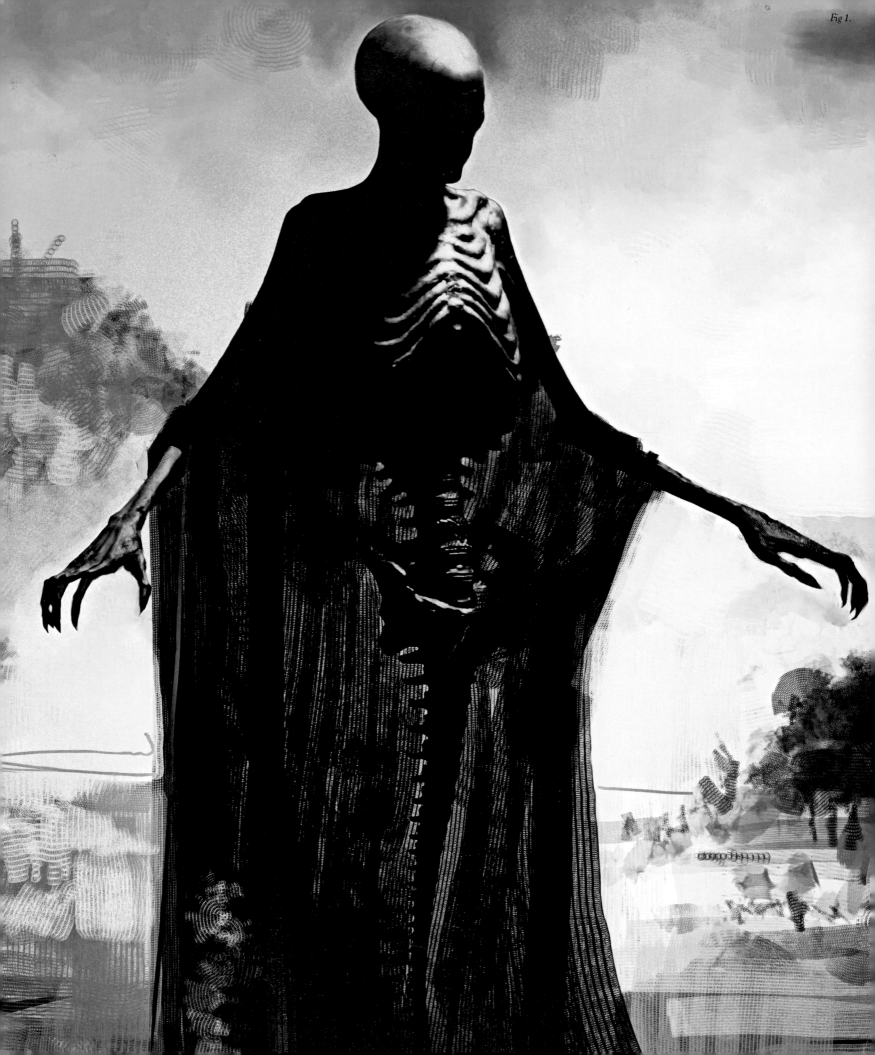

Fig 1.

"*Dementors are vicious creatures. They will not distinguish between the one they hunt and the one who gets in their way . . . It is not in the nature of a Dementor to be forgiving.*"

—ALBUS DUMBLEDORE

*Harry Potter and the Prisoner of Azkaban* film

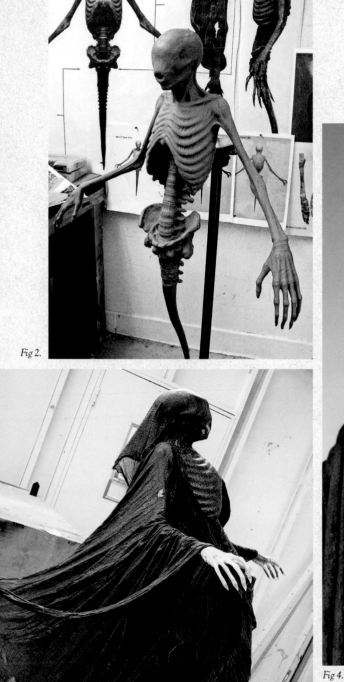

Fig 2.

Fig 3.

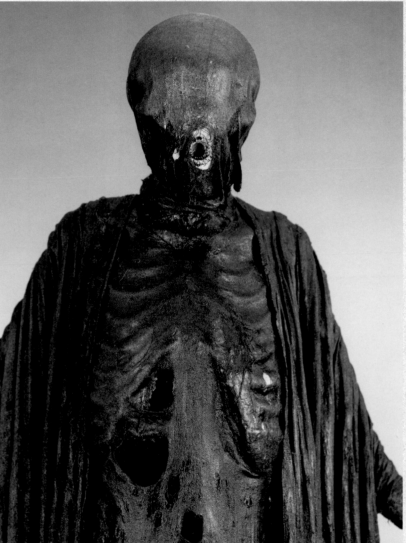

Fig 4.

For *Harry Potter and the Order of the Phoenix*, the Dementors were reconstructed, as the filmmakers wanted more of the Dementors to be seen. Their hoods were removed and their robes were drawn back in order to reveal their skulls and chests. They also needed substantial arms and articulated hands in order to hold Harry up against the underpass wall during their attack. Initially, the designers refashioned the hanging strips of their tattered shrouds to act as arms, akin to an octopus's, but found too many arms were distracting and so dropped the idea for two humanlike appendages.

Fig 1. Visual development art by Rob Bliss for *Harry Potter and the Prisoner of Azkaban* that is intended to give the creature shop ideas for paint colors and textures; Figs 2. – 4. Dementor construction in the creature shop for *Harry Potter and the Prisoner of Azkaban* included a collaboration with the costume department.

# Inferius.

The Inferi are another type of creature that is unique to the Harry Potter series. They are resurrected corpses, bewitched by any Dark wizard. In _Harry Potter and the Half-Blood Prince_, Harry Potter and Albus Dumbledore must gain entry into a sea cave to retrieve the Slytherin locket they believe to be a Horcrux. They achieve their task, but their way out is blocked by a reanimated mass of the gray, skeletal Inferi emerging from the lake, bewitched by Lord Voldemort. It takes a firestorm to destroy the Inferi and allow Harry and Dumbledore to escape.

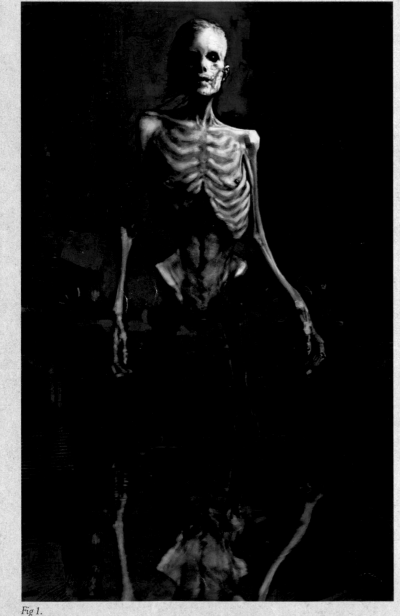

Fig 1.

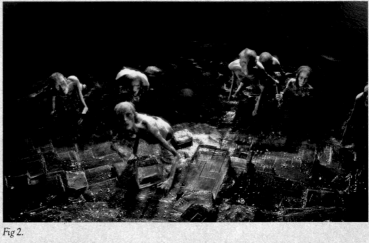

Fig 2.

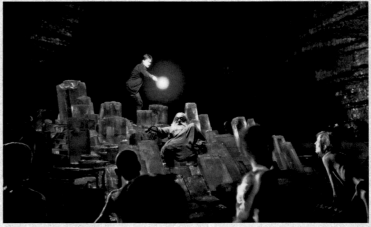

Fig 3.

Fig 1. Inferi concept art by Rob Bliss for _Harry Potter and the Half-Blood Prince_;
Figs 2. & 3. Digital composites of the Inferi invading the cave's crystal island;
Fig 4. (opposite) Harry attempts to stop the Inferi and protect Dumbledore in artwork by Adam Brockbank.

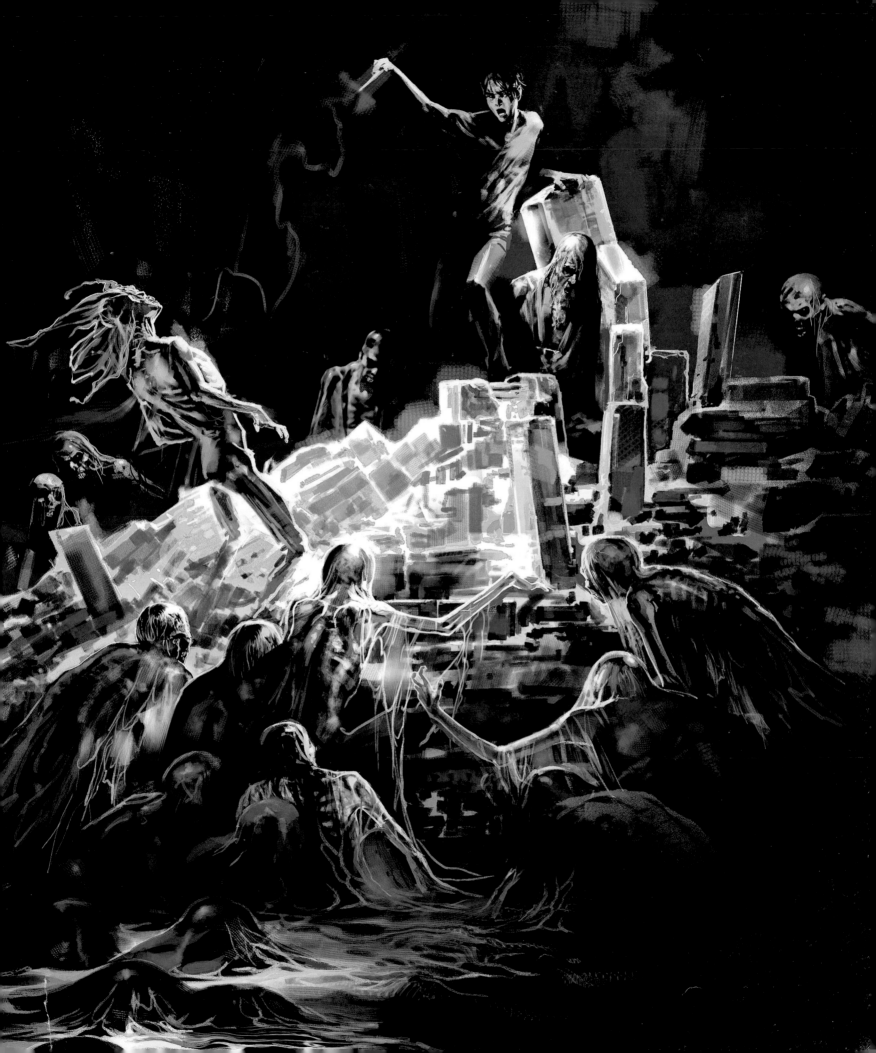

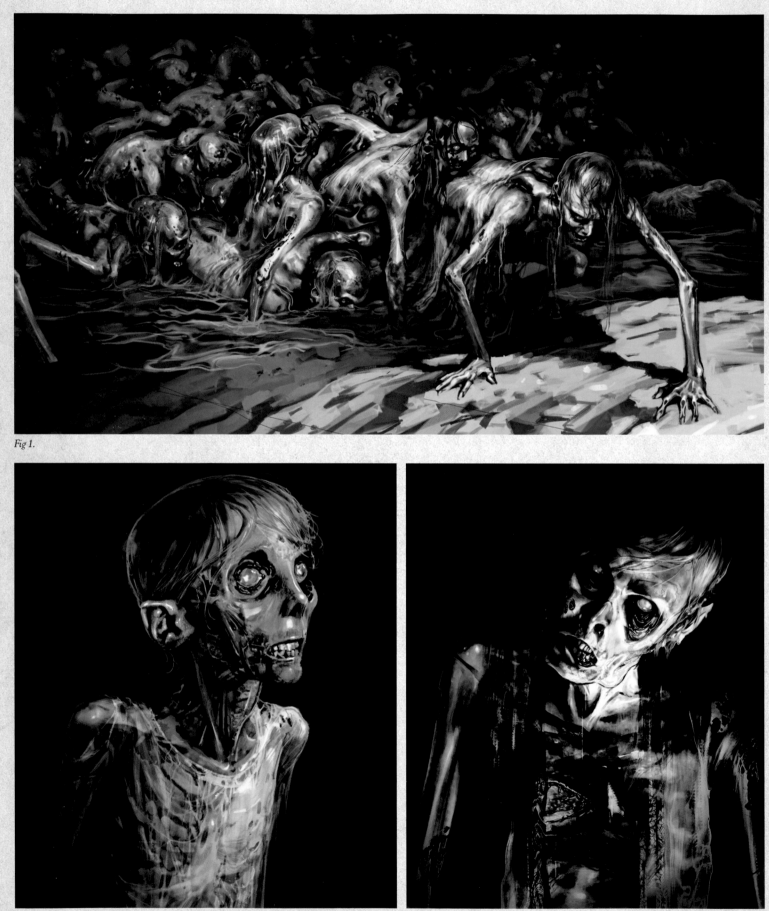

Fig 1.

Fig 2.

Fig 3.

The Inferi in the *Half-Blood Prince* film are grotesque and frightening, their sole task being to stop anyone from leaving the cave. However, though these "undead" beings are driven by Dark Forces, they are actually victims of Voldemort. The Harry Potter filmmakers wanted these creatures to be as threatening as they needed to be, and yet elicit sympathy from the audience. Visual development research included studying woodcuts from the Medieval Ages, with their images of misshapen and monstrous beings, and classic works such as *Dante's Inferno* and *Paradise Lost*. The artists even viewed photos of bodies that had been submerged in water to observe how that would affect the color and texture of their skin.

As the Inferi were to be another wholly computer-generated creatures, models of a male and a female version were sculpted at full size to be cyberscanned, but were not yet painted. Painting was done inside the computer, where tones of gray and black were layered on, and a texture was added that would give them the essence of having once been flesh-covered. Additionally, a digital skeleton was incorporated and tested for movement.

Another important mandate was that the Inferi not be mistaken for zombies. A cast of men and women were filmed in motion capture emerging from the lake and grabbing at Harry so that the Inferi's expressions and movements would realistically resemble that of anyone coming out of water. The digital Inferi, which included two children, were added to film footage shot in a water tank of Daniel Radcliffe (Harry Potter) being dragged underwater and then embraced by a female Inferi to ensure that the actor's hair and clothes floated naturally.

One of the most challenging effects for the scene was creating the firestorm that enables Harry and Dumbledore to escape. Lighting was a crucial consideration, and the digital artists needed to develop new software that would allow them to work with the large numbers of Inferi as well as the fire itself so that they combined seamlessly. This meant lighting the Inferi by the flames that encircled and destroyed them. The fire was designed to look fierce and combustive.

Fig 1. The Inferi climb out of the lake in artwork by Adam Brockbank for *Harry Potter and the Half-Blood Prince*; Figs 2. — 5. Studies for Inferi characters by Adam Brockbank.

*Fig 4.*

*Fig 5.*

Fig 1. Rob Bliss portrays Harry Potter imprisoned in the middle of a swarm of Inferi in *Harry Potter and the Half-Blood Prince*.

Fig 2.

Fig 3.

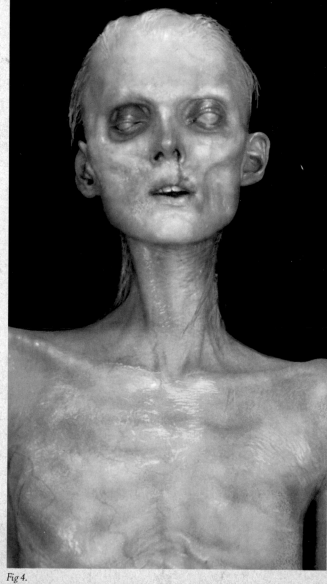

Fig 4.

## FAST FACTS

### INFERIUS

✳

I. FILM APPEARANCE: *Harry Potter and the Half-Blood Prince*

II. LOCATION: Undersea cave

III. TECH TALK: The final shots above and below the water
consist of thousands of Inferi entwined in a chaotic mass.

IV. DESCRIPTION FROM *HARRY POTTER AND THE HALF-
BLOOD PRINCE* BOOK, CHAPTER TWENTY-SIX:

*"[E]verywhere Harry looked, white heads and hands were emerging from the
dark water, men and women and children with sunken, sightless eyes were
moving toward the rock: an army of the dead rising from the black water."*

Figs 2. — 4. Inferi concepts by Rob Bliss.

## CHAPTER VIII

# COMPANIONS

*Following the acceptance letter to Hogwarts School of Witchcraft and Wizardry that Harry Potter receives in the first film is a list of supplies needed by first year students. Along with cauldrons and wands, they are allowed to bring, if they desire, an owl, a cat, or a toad. For many characters in the films, these companions become trusted friends.*

# Hedwig.

Hedwig is a snowy owl given to Harry Potter by Hagrid for his eleventh birthday, in *Harry Potter and the Sorcerer's Stone*. Hedwig often delivers messages for Harry and is able to find the addressee even if she is not given a specific address, as is the case with Sirius Black in *Harry Potter and the Goblet of Fire*.

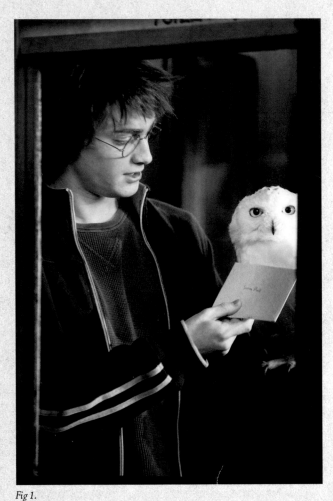

Fig 1.

The role of Hedwig was played by several male snowy owls throughout the Harry Potter series, most notably by a snowy owl named Gizmo. The other owls included Kasper, Ook, Swoops, Oh Oh, Elmo, and Bandit. Female owls are larger and have darker markings than male owls, so the lighter male was easier for Daniel Radcliffe (Harry Potter) to work with. Radcliffe's arm was protected by a thick leather arm guard, similar to the type used in falconry, when Gizmo perched upon it. Gizmo had stand-ins that would take his place when the lighting for scenes was being worked out, as well as for some flying sequences.

One of Hedwig's biggest scenes takes place in *Harry Potter and the Sorcerer's Stone*, when Professor McGonagall presents new Gryffindor Seeker Harry with a Nimbus 2000. It took roughly six months to train Gizmo with the needed behavior. For this, Gizmo carried a broom made from plastic tubing that was lighter in weight than most owls' prey. The broom was held by a temporary attachment to his talons, but like the other Owl Post deliveries, it was tied to a harness mechanism that the trainer released in the right spot for Harry (Daniel Radcliffe) to catch.

Previous: Harry Potter at Hogwarts with his companion, Hedwig, at his side in a scene envisioned for *Harry Potter and the Sorcerer's Stone* by Dermot Power; Fig 1. Harry (Daniel Radcliffe) and Hedwig (Gizmo) in a scene from *Harry Potter and the Goblet of Fire*; Fig 2. Harry (Daniel Radcliffe) and Hedwig (Gizmo) in *Harry Potter and the Sorcerer's Stone*. Beneath Radcliffe's robe's sleeve is a protective leather sheath; Fig 3. A publicity photo of Hedwig (Gizmo) flying; Fig 4. Hedwig (Gizmo) and trainer; Fig 5. Hedwig (Gizmo) sits patiently in the Gryffindor Common Room in *Harry Potter and the Half-Blood Prince*.

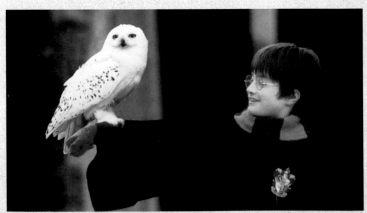

Fig 2.

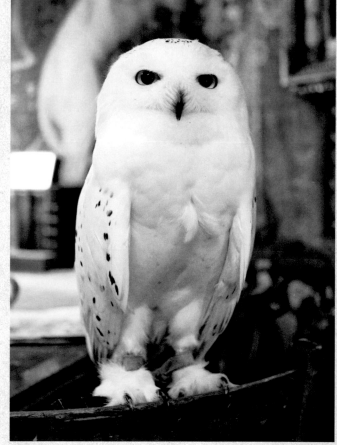

Fig 3.

## FAST FACTS

### HEDWIG

✴

I. FIRST FILM APPEARANCE: *Harry Potter and the Sorcerer's Stone*

II. ADDITIONAL FILM APPEARANCES: *Harry Potter and the Chamber of Secrets, Harry Potter and the Prisoner of Azkaban, Harry Potter and the Goblet of Fire, Harry Potter and the Order of the Phoenix, Harry Potter and the Half-Blood Prince, Harry Potter and the Deathly Hallows – Part 1*

III. LOCATION: number 4, Privet Drive, Hogwarts, The Owlery, Diagon Alley, The Burrow, The Leaky Cauldron

IV. OWNER: Harry Potter

V. ANIMAL ACTORS: Gizmo, plus Kasper, Ook, Swoops, Oh Oh, Elmo, and Bandit

VI: DESCRIPTION FROM *HARRY POTTER AND THE SORCERER'S STONE* BOOK, CHAPTER FIVE:

*"Harry now carried a large cage that held a beautiful snowy owl . . ."*

Fig 5.

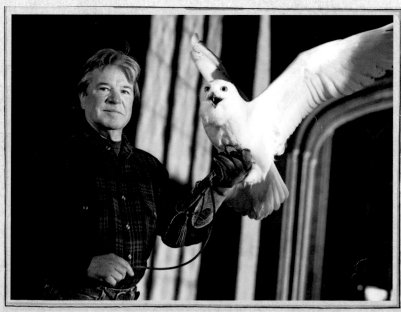

Fig 4.

"*Right smart bird you've got there, Mr. Potter. It arrived here just five minutes before yourself.*"

— TOM, INNKEEPER
AT THE LEAKY CAULDRON
*Harry Potter and the Prisoner of Azkaban* film

# Errol.

Fig 1.

**E**rrol belongs to the Weasley family and is not the most graceful of owls, as observed by Harry Potter on his first visit to The Burrow, in _Harry Potter and the Chamber of Secrets_, when Errol slams into the window. Errol also manages to upset a bowl of potato chips when he delivers a Howler to Ron Weasley in the Great Hall of Hogwarts. Errol is a bit old and a bit slow, so the filmmakers had fun with this character as a comic contrast to Hedwig.

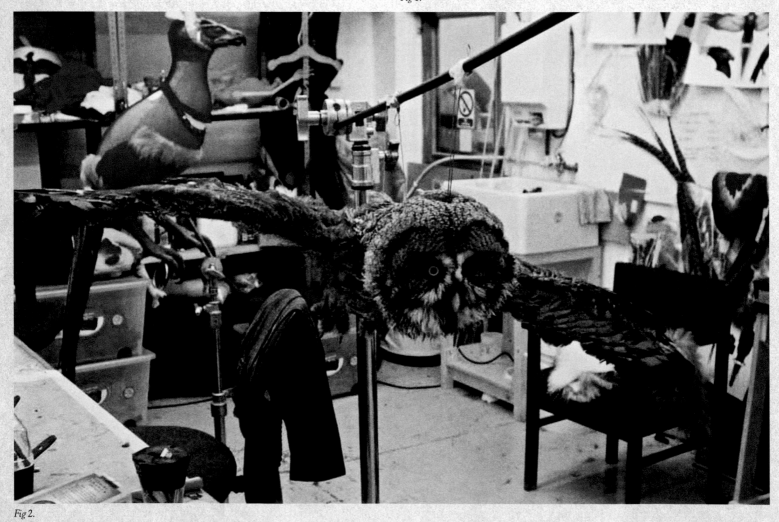

Fig 2.

*" Sorry I'm late. The owl that delivered my release
papers got all lost and confused. Some ruddy
bird called Errol."*

— RUBEUS HAGRID

*Harry Potter and the Chamber of Secrets* film

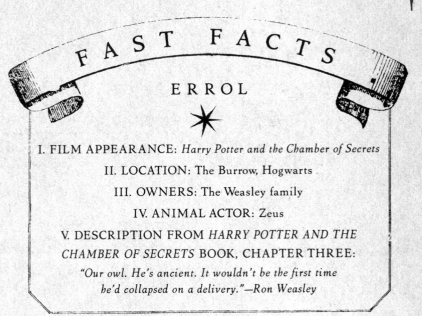

FAST FACTS

ERROL

✴

I. FILM APPEARANCE: *Harry Potter and the Chamber of Secrets*

II. LOCATION: The Burrow, Hogwarts

III. OWNERS: The Weasley family

IV. ANIMAL ACTOR: Zeus

V. DESCRIPTION FROM *HARRY POTTER AND THE
CHAMBER OF SECRETS* BOOK, CHAPTER THREE:
*"Our owl. He's ancient. It wouldn't be the first time
he'd collapsed on a delivery."—Ron Weasley*

Errol was played by Zeus, a great gray owl, which is considered the largest species of owl worldwide. Zeus received training for all of his character's actions in *Harry Potter and the Chamber of Secrets*, except one. He could fly with an envelope in his mouth, and was taught to lie down and then get back up. Owls have hollow bones; consequently they cannot be trained to crash into anything solid. So Zeus was filmed flying gracefully through the kitchen window of The Burrow, and then filmed "getting up" from the counter. This footage was combined with that of a digital Errol colliding with the window.

Fig 1. Animal trainer Gary Gero and Zeus, who played the Weasley's clumsy owl, Errol, in *Harry Potter and the Chamber of Secrets*; Fig 2. The animatronic version of Errol in the creature shop; Fig 3. Percy Weasley helps the aged, ungainly owl into The Burrow in a scene from *Chamber of Secrets*.

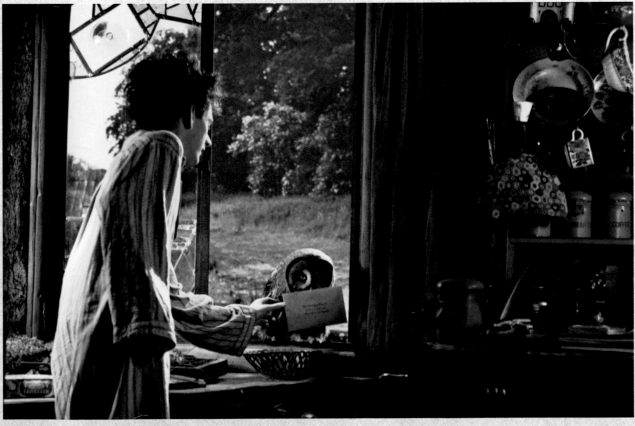

*Fig 3.*

# Pigwidgeon.

In the book _Harry Potter and the Goblet of Fire_, Pigwidgeon, an extremely small owl, is given to Ron by his family to replace Scabbers. However, while Pigwidgeon appeared in a promotional photograph for the film of the same book, and was filmed at Platform 9¾ for a scene that did not appear in the final film cut of _Harry Potter and the Order of the Phoenix_, his on-screen debut came in _Harry Potter and the Half-Blood Prince_, where he can be seen perched on a chair in the Gryffindor common room. Pigwidgeon was played by Mars, a scops owl, which is one of the smallest species of owls.

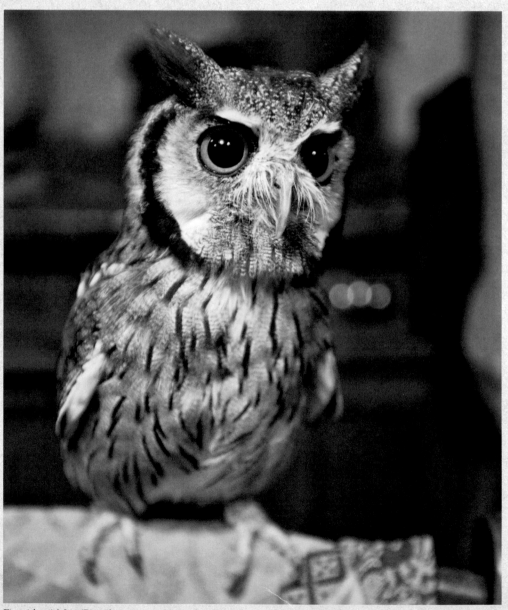

Fig 1. (above) Mars (Pigwidgeon) in a publicity shot; Fig 2. Rupert Grint (Ron Weasley) holds Mars (Pigwidgeon) in a publicity shot for _Harry Potter and the Goblet of Fire_, though Mars did not actually appear in the film; Fig 3. Pigwidgeon (Mars) near Ron's bed in a rare outtake from _Goblet of Fire_. Mars' film debut came in _Harry Potter and the Half-Blood Prince_.

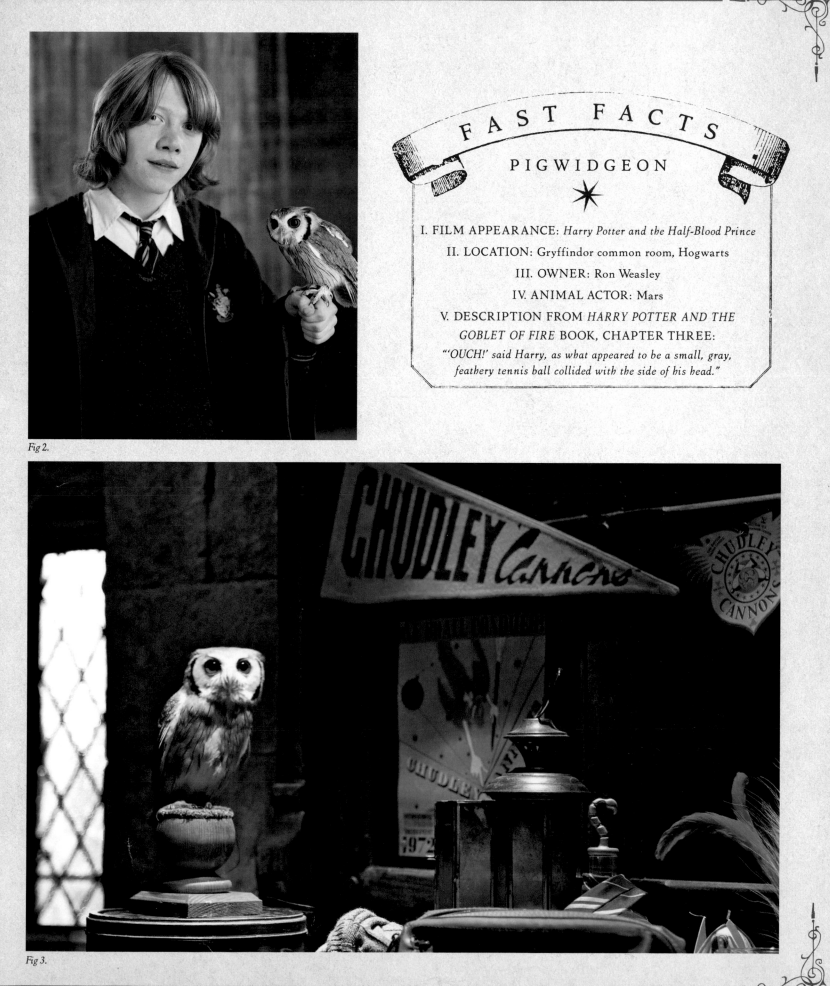

Fig 2.

# FAST FACTS

## PIGWIDGEON

✳

I. FILM APPEARANCE: *Harry Potter and the Half-Blood Prince*

II. LOCATION: Gryffindor common room, Hogwarts

III. OWNER: Ron Weasley

IV. ANIMAL ACTOR: Mars

V. DESCRIPTION FROM *HARRY POTTER AND THE GOBLET OF FIRE* BOOK, CHAPTER THREE:

*"'OUCH!' said Harry, as what appeared to be a small, gray, feathery tennis ball collided with the side of his head."*

Fig 3.

# Scabbers.

Scabbers is Ron Weasley's pet rat, handed down from his brother Percy. Ron brings Scabbers to Hogwarts in his first year, in <u>Harry Potter and the Sorcerer's Stone</u>. The rat is temporarily turned into a goblet during Transfiguration class in <u>Harry Potter and the Chamber of Secrets</u> by Ron's broken wand. It is in <u>Harry Potter and the Prisoner of Azkaban</u> that Scabbers is discovered to be the Animagus form of Peter Pettigrew, who escapes the Hogwarts grounds, losing Ron his rat.

The various incarnations of Scabbers over the course of the Harry Potter series were played by twelve real and several animatronic rats. The animal actor who primarily played the part was named Dex, who, with the other rats, was trained to run to and stay on a mark. Rats are very intelligent creatures and easy to train. In *Harry Potter and the Sorcerer's Stone*, Scabbers's big set piece is having his head caught in a candy box and being forced out when Ron tries a spell on him. An animatronic rat was used for the majority of the scene, but Dex was used at the last moment of the spell, "backing out" of the candy box to end up sitting on Ron's (Rupert Grint) lap. A trainer placed a candy box that was attached to a wire over Dex's head and then gently pulled it off on cue.

It took roughly four months to train Dex and Crackerjack, the cat that played Crookshanks, to run down the hallway in their opening scene of *Harry Potter and the Prisoner of Azkaban*. The animals had already become used to each other, so training them was simply a matter of teaching them to run in the same direction. Training methods included having the animals run next to each other in parallel runways created by soft netting, in the direction of a food reward. The only challenge for this scene was that Crackerjack would often overtake Dex, who was so used to the cat that he wasn't running as fast as any rat normally should have.

"*Sunshine, daisies, butter mellow, turn this stupid fat rat yellow.*"

— RON WEASLEY
*Harry Potter and the Sorcerer's Stone* film

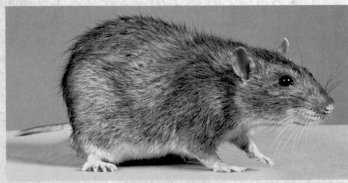

*Fig 1.*

*Fig 2.*

Fig 3.

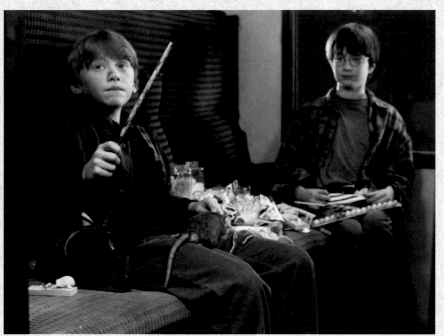
Fig 4.

*"This is Scabbers, by the way. Pathetic, isn't he?"*
— RON WEASLEY
*Harry Potter and the Sorcerer's Stone* film

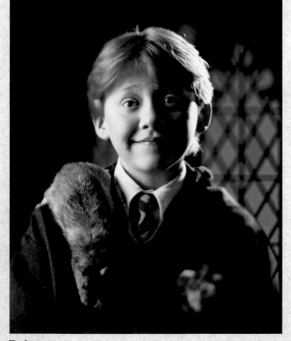
Fig 5.

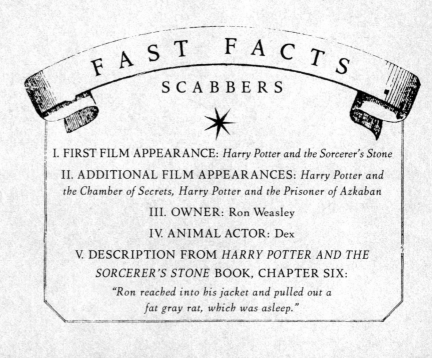

## FAST FACTS
### SCABBERS

✦

I. FIRST FILM APPEARANCE: *Harry Potter and the Sorcerer's Stone*

II. ADDITIONAL FILM APPEARANCES: *Harry Potter and the Chamber of Secrets, Harry Potter and the Prisoner of Azkaban*

III. OWNER: Ron Weasley

IV. ANIMAL ACTOR: Dex

V. DESCRIPTION FROM *HARRY POTTER AND THE SORCERER'S STONE* BOOK, CHAPTER SIX:

*"Ron reached into his jacket and pulled out a fat gray rat, which was asleep."*

Figs 1. & 2. Dex, the rat who played the dual role of Scabbers/Wormtail; Fig 3. Hermione Granger (Emma Watson) and Harry Potter (Daniel Radcliffe) with Ron Weasley (Rupert Grint) holding Scabbers (Dex) in a scene from *Harry Potter and the Prisoner of Azkaban*; Fig 4. Scabbers (Dex) goes after the candy on Ron's lap as Harry looks on in a scene from *Harry Potter and the Sorcerer's Stone*; Fig 5. A publicity shot of Rupert Grint (Ron Weasley) with Dex (Scabbers) for *Sorcerer's Stone*.

# Crookshanks.

Hermione Granger acquires Crookshanks, a large ginger cat, in her third year at Hogwarts, in the film *Harry Potter and the Prisoner of Azkaban*. Our first view of Crookshanks is as a streak of orange careening after Scabbers, Ron's rat, in the hallways of the Leaky Cauldron. Crookshanks exhibits his playful nature in *Harry Potter and the Order of the Phoenix* when Fred and George dangle an Extendable Ear over the staircase at number 12, Grimmauld Place.

Crookshanks was most frequently played by Crackerjack, a red Persian cat, who made his screen debut in *Harry Potter and the Prisoner of Azkaban*. Crookshanks' matted coat was created with what could be called "fur extensions." Each time Crackerjack was groomed, his trainers would keep the brushed-out undercoat fur and ball it into little blobs that could be clipped onto the cat's fur. A clear, sting-free jellylike substance gave him runny eyes, and an animal-safe brown "eye shadow" was streaked around his eyes and mouth to create a cross look on the well-dispositioned cat.

Crackerjack, who can stop on a mark on cue, learned a retrieving skill for the Extendable Ear scene in *Harry Potter and the Order of the Phoenix*. Crookshanks bats at the Ear, wrestles with it, and then manages to yank it down and carry it away to the dismay of the young Weasleys and friends. The trainers spent the better part of three months teaching the team of cats—which included Prince and Pumpkin—to play with and then grab the Ear, take it away, and drop it in a bowl off camera, where they would be rewarded with a kitty treat.

Fig 1. Crackerjack (Crookshanks) in a publicity photo for *Harry Potter and the Prisoner of Azkaban*.

> "*A cat! Is that what they told you? Looks more like a pig with hair if you ask me.*"
> —Ron Weasley
> *Harry Potter and the Prisoner of Azkaban* film

## FAST FACTS

### CROOKSHANKS

I. FIRST FILM APPEARANCE: *Harry Potter and the Prisoner of Azkaban*

II. ADDITIONAL FILM APPEARANCES: *Harry Potter and the Goblet of Fire, Harry Potter and the Order of the Phoenix, Harry Potter and the Half-Blood Prince*

III. OWNER: Hermione Granger

IV. ANIMAL ACTOR: Crackerjack, plus Prince and Pumpkin

V. DESCRIPTION FROM *HARRY POTTER AND THE PRISONER OF AZKABAN* BOOK, CHAPTER FOUR:

*"The cat's ginger fur was thick and fluffy, but it was definitely a bit bowlegged and its face looked grumpy and oddly squashed, as though it had run headlong into a brick wall."*

# Mrs. Norris.

Mrs. Norris is the companion of Hogwarts caretaker Argus Filch. She seems to have an uncanny sense for happening upon misbehaving students that aids in her patrol of the corridors, and an almost supernatural connection to Filch, who benefits from her vigilance. Mrs. Norris's closeness to Filch is apparent from her first appearance in *Harry Potter and the Sorcerer's Stone*. In *Harry Potter and the Goblet of Fire*, Filch and Mrs. Norris enjoy a dance at the Yule Ball.

Through the entire course of the eight *Harry Potter* films, Mrs. Norris was played by three Maine Coon cats named Maximus (Max), Alanis, and Tommy, and occasionally an animatronic cat. Each cat had a specialty according to David Bradley, the actor who played Argus Filch. Max was good at running to or alongside him, and could even jump on his back and sit on his shoulder on cue, as seen in *Harry Potter and the Order of the Phoenix*. Alanis was so good at resting in Bradley's arms during shooting that she fell asleep several times. A bona fide cat lover, Bradley needed only to rub her gently on her head and she would wake up and play her part. As the stone floors in Hogwarts were often chilly, all the cats, including those that played Professor McGonagall's Animagus and Hermione's cat, Crookshanks, were provided heated floors to keep their bodies, and especially their paws, warm.

The Petrified Mrs. Norris in *Harry Potter and the Chamber of Secrets* was an animatronic cat, though little movement was required. Though Mrs. Norris is described in the books as having yellow lamp-like eyes, the filmmakers chose to give her red eyes in the early films, which was achieved digitally in post-production. Mrs. Norris's spiky fur was enhanced by having the already fluffy-coated cat species wear a collar camouflaged with matching fake fur and by using a nontoxic gel product to obtain an even wilder look.

Fig 2. Argus Filch (David Bradley) and the ubiquitous Mrs. Norris confront Ron Weasley (Rupert Grint) and Harry Potter (Daniel Radcliffe) in *Harry Potter and the Chamber of Secrets*; Fig 3. Filch (David Bradley) takes Mrs. Norris to the Yule Ball in *Harry Potter and the Goblet of Fire*.

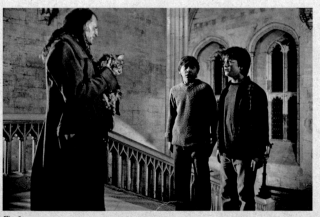

Fig 3.

## FAST FACTS

### MRS. NORRIS

✳

I. FIRST FILM APPEARANCE: *Harry Potter and the Sorcerer's Stone*

II. ADDITIONAL FILM APPEARANCES: *Harry Potter and the Chamber of Secrets, Harry Potter and the Prisoner of Azkaban, Harry Potter and the Goblet of Fire, Harry Potter and the Order of the Phoenix, Harry Potter and the Half-Blood Prince,* and *Harry Potter and the Deathly Hallows – Part 2.*

III. LOCATION: Hogwarts castle • IV. OWNER: Argus Filch

V. ANIMAL ACTORS: Maximus, Alanis, and Tommy

VI. DESCRIPTION FROM *HARRY POTTER AND THE SORCERER'S STONE* BOOK, CHAPTER EIGHT:

*"Filch owned a cat called Mrs. Norris, a scrawny, dust-colored creature with bulging, lamplike eyes just like Filch's."*

# Fang.

It is no surprise in the *Harry Potter* films that Fang, the companion to a half giant such as Rubeus Hagrid, would be a dog equally gigantic when compared to most other breeds. Though Fang is large, he isn't necessarily as brave as expected, as discovered in *Harry Potter and the Sorcerer's Stone*. To accomodate these facets of the character therefore, Fang was played by a series of Neapolitan Mastiffs, a dog known for its massive head and body, but one that has a very peaceful nature.

From *Harry Potter and the Sorcerer's Stone* through *Harry Potter and the Prisoner of Azkaban*, Fang was played by a Mastiff named Hugo. Monkey took the role in *Harry Potter and the Goblet of Fire* and *Harry Potter and the Order of the Phoenix*, and Uno in *Harry Potter and the Half-Blood Prince*. Other dogs that worked in the role were Bella, Vito, and Bully, a rescue success story: Bully was adopted by one of the animal trainers after the film finished shooting.

For *Harry Potter and the Chamber of Secrets*, an animatronic version of Fang was used when the Ford Anglia car raced out of the Forbidden Forest. The animatronic Fang was radio-controlled to move and even to drool. For *Order of the Phoenix*, Monkey was required to catch a piece of steak and chew on it. The trainers limited the number of takes for this scene, although they kidded that this might be the only time an actor would ask to do more takes. All the dogs were cued by trainers that were off camera to Sit, Stay, Speak, and Come, but no trainer yet has been able teach a Neapolitan Mastiff to learn the Don't Drool behavior.

Fig 1.

Fig 2.

Fig 3.

Fig 4.

"*Just so's yeh know, he's a bloody coward.*"
— RUBEUS HAGRID
*Harry Potter and the Sorcerer's Stone* film

Fig 1. Harry, Ron, and Fang in a scene for *Harry Potter and the Sorcerer's Stone*. Fig 2. A publicity shot of Hugo, one of the many Neapolitan Mastiffs who played Fang for *Harry Potter and the Sorcerer's Stone*. Fig 3. Fang poses for a publicity shot, along with fellow animal actors. Fig 4. Publicity shot of Hagrid and Fang.

# FAST FACTS
## FANG
✴

I. FIRST FILM APPEARANCE: *Harry Potter and the Sorcerer's Stone*

II. ADDITIONAL FILM APPEARANCES: *Harry Potter and the Chamber of Secrets, Harry Potter and the Prisoner of Azkaban, Harry Potter and the Order of the Phoenix, Harry Potter and the Half-Blood Prince.*

III. LOCATION: Hagrid's hut, Forbidden Forest

IV. OWNER: Hagrid

V. ANIMAL ACTORS: Hugo, Monkey, Uno, Vito, Bella, and Bully

VI. DESCRIPTION FROM *HARRY POTTER AND THE SORCERER'S STONE* BOOK, CHAPTER EIGHT:
"*[Hagrid] let them in, struggling to keep a hold on the collar of an enormous black boarhound.*"

# Trevor.

Neville Longbottom brings a toad with him to his first year at Hogwarts and promptly loses it in *Harry Potter and the Sorcerer's Stone.*

Four toads performed Neville's companion, Trevor, through the course of the *Harry Potter* series. The toads were kept in a heated, moss-based terrarium. When Trevor was needed for a scene, a trainer would place the toad in Matthew Lewis's (Neville Longbottom) hands, on the floor, or on the arm of a chair. As soon as the scene was finished, the trainer would return the toad to the terrarium.

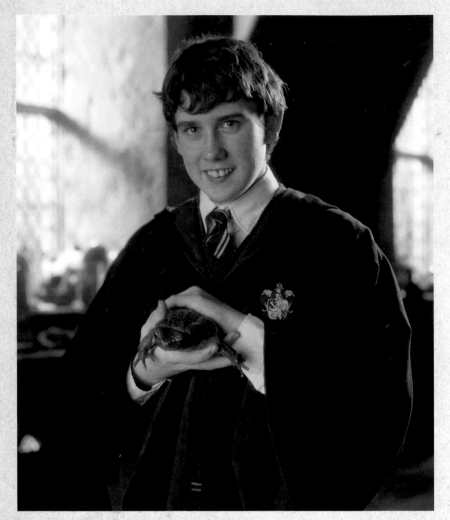

Fig 1. Matthew Lewis (Neville Longbottom) and one of the toads who played Trevor in a publicity shot for *Harry Potter and the Prisoner of Azkaban.*

> *"Has anyone seen a toad?*
> *A boy named Neville's lost one."*
> —HERMIONE GRANGER
> *Harry Potter and the Sorcerer's Stone* film

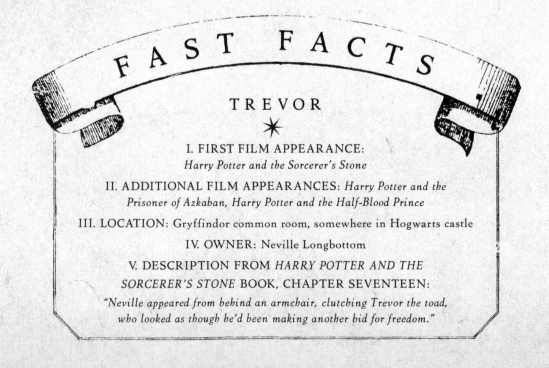

## FAST FACTS

### TREVOR

✳

**I. FIRST FILM APPEARANCE:**
*Harry Potter and the Sorcerer's Stone*

**II. ADDITIONAL FILM APPEARANCES:** *Harry Potter and the Prisoner of Azkaban, Harry Potter and the Half-Blood Prince*

**III. LOCATION:** Gryffindor common room, somewhere in Hogwarts castle

**IV. OWNER:** Neville Longbottom

**V. DESCRIPTION FROM *HARRY POTTER AND THE SORCERER'S STONE* BOOK, CHAPTER SEVENTEEN:**
*"Neville appeared from behind an armchair, clutching Trevor the toad, who looked as though he'd been making another bid for freedom."*

# Arnold.

Ginny Weasley finally got her own pet, a Pygmy Puff, in *Harry Potter and the Half-Blood Prince*. Purchased at her twin brothers' shop, Weasleys' Wizard Wheezes, the large-eyed creature happily sits on her shoulder as she shows the round pink puffball to Dean Thomas on the Hogwarts Express. Visual development art offered an opportunity to investigate what might be under all that fur, although inevitably the creature's digital designers chose to portray Arnold with the maximum hair allowed.

"*He's lovely.*"

—LUNA LOVEGOOD
*Harry Potter and the Half-Blood Prince* film

## FAST FACTS

### ARNOLD

✷

I. FILM APPEARANCE: *Harry Potter and the Half-Blood Prince*

II. LOCATION: Available at Weasleys' Wizard Wheezes

III. OWNER: Ginny Weasley

IV. DESCRIPTION FROM *HARRY POTTER AND THE HALF-BLOOD PRINCE* BOOK, CHAPTER SIX:

"*[Ginny] was pointing at a number of round balls of fluff in shades of pink and purple, all rolling around the bottom of a café and emitting high-pitched squeals.*"

Fig 1. Ginny Weasley's Pygmy Puff Arnold in unpuffed and puffed forms by Rob Bliss for *Harry Potter and the Half-Blood Prince*.

# Fawkes.

Phoenixes are powerful magical birds that are immortal, as they regenerate in an infinite series of life cycles. A phoenix's powers include tears that have the ability to heal, and the strength to carry extremely heavy loads. Harry Potter meets Fawkes in Dumbledore's office in <u>Harry Potter and the Chamber of Secrets</u>, just as the decrepit-looking bird bursts into flames. Dumbledore explains that this is natural for a phoenix, and they admire the new chick that rises through the pile of ash. Fawkes helps in the Chamber of Secrets by flying in the Sorting Hat, which holds the sword of Gryffindor. Fawkes also cures Harry of the Basilisk's wound with his tears, and flies Harry, Ron Weasley, and Gilderoy Lockhart out of the Chamber.

Fawkes appears in three stages of his life: as an aged, frail bird that bursts into flames, as the chick born out of the ashes, and as the fully developed, powerful bird that assists Harry in defeating the Basilisk at the end of *Harry Potter and the Chamber of Secrets*. The visual development artist researched real birds in addition to artwork of the mythic phoenix for the design. Fawkes is a fusion of several powerful birds, most notably a sea eagle and a vulture. The exaggerated crest on his head has feathers sitting backward, which gave him a noble mien. His sharp beak and claws imposed an air of danger. In both his senior phase and as a newborn chick, Fawkes was given more of the vulture aesthetic, with a stretched-out neck and layered wrinkles. The designer was provided with a selection of tail feathers from pheasants and other game birds that he grouped together and manipulated to test feather composition and layering effects.

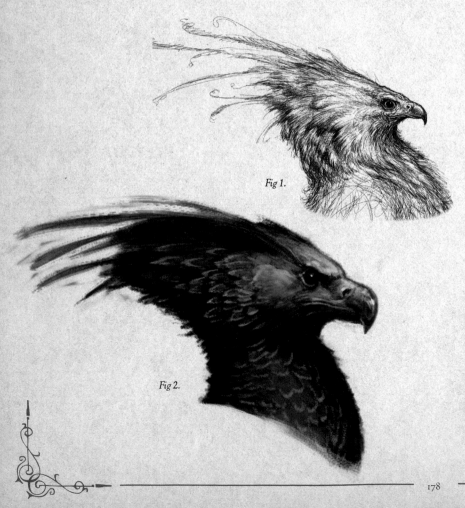

Fig 1.

Fig 2.

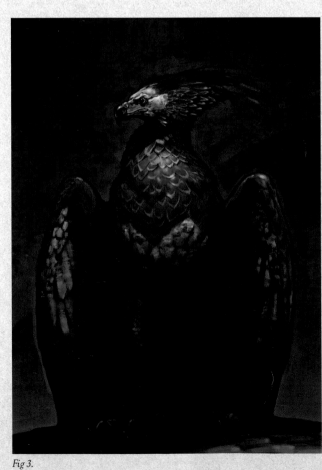

Fig 3.

Figs 1. — 6. Studies of Fawkes the phoenix for *Harry Potter and the Chamber of Secrets* by Adam Brockbank, exploring the creature's colors and possible crest and wing styles.

Fig 4.

Fig 5.

Fig 6.

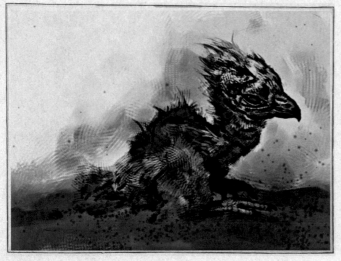

Fig 1.

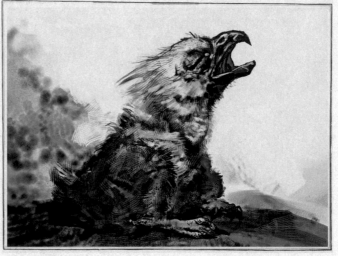

Fig 2.

Fig 3.

Figs 1. & 2. Adam Brockbank portrays Fawkes rising from the ashes into his fledgling form for *Harry Potter and the Chamber of Secrets*;
Fig 3. Albus Dumbledore (Richard Harris) explains the life cycle of the phoenix to Harry Potter (Daniel Radcliffe) in a scene from
*Chamber of Secrets*; Adam Brockbank's art portrays Professor Dumbledore gently blowing the ashes from his beloved companion as
Harry Potter looks on (Fig 4.), and Harry's first encounter with Fawkes, unfortunately on a Burning Day (Fig 5).

Fawkes' coloring had to be fiery, with a palette of burnt oranges and dark reds. His underside is in shades of gold, as most birds have darker colorations on their tops and undersides. The phoenix's neck and throat are variegated oranges, with a golden trim, and was likened to the coloring of a burnt-out match by concept artist Adam Brockbank. Baby Fawkes is a combination of a washed-out pinkish-red and the gray of the ashes from which he emerges.

Fawkes was fully created in both animatronic and digital forms. The animatronic Fawkes could slide on his perch, react to other characters, and stretch his wings out to their full length. This Fawkes was also able to cry the tears that needed to fall onto Harry Potter's (Daniel Radcliffe) arm to heal him from the Basilisk's venom. Richard Harris (Dumbledore) paid the creature designers the highest compliment when he was surprised to find out that Fawkes was anything other than a live, trained bird.

*Fig 4.*

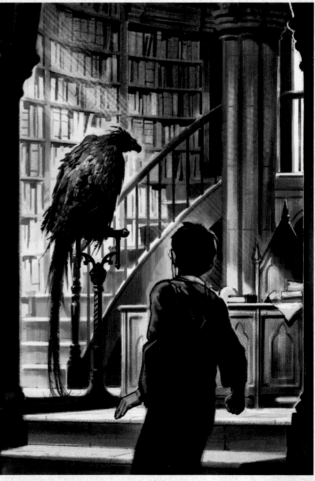

*Fig 5.*

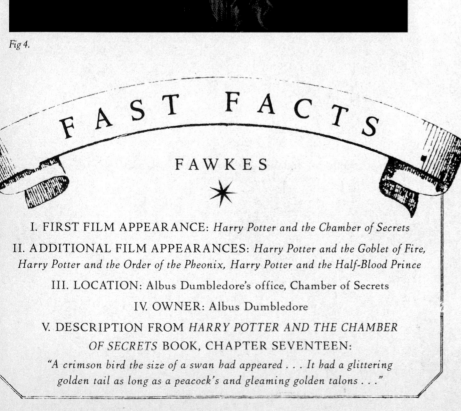

# FAST FACTS

## FAWKES

✦

I. FIRST FILM APPEARANCE: *Harry Potter and the Chamber of Secrets*

II. ADDITIONAL FILM APPEARANCES: *Harry Potter and the Goblet of Fire, Harry Potter and the Order of the Pheonix, Harry Potter and the Half-Blood Prince*

III. LOCATION: Albus Dumbledore's office, Chamber of Secrets

IV. OWNER: Albus Dumbledore

V. DESCRIPTION FROM *HARRY POTTER AND THE CHAMBER OF SECRETS* BOOK, CHAPTER SEVENTEEN:

*"A crimson bird the size of a swan had appeared . . . It had a glittering golden tail as long as a peacock's and gleaming golden talons . . ."*

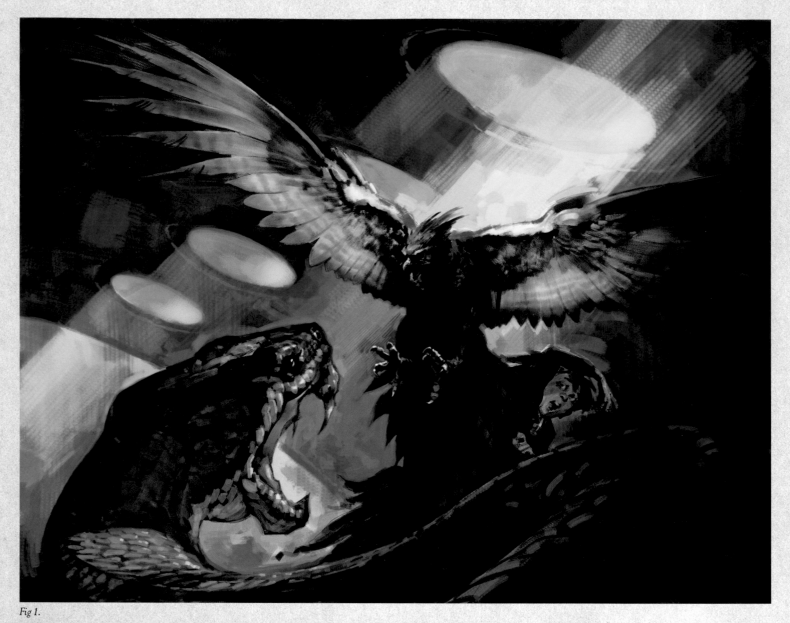

Fig 1.

Fawkes attacks the Basilisk in the
Chamber of Secrets (Fig 1.), and
rescues Harry, Ron and Ginny
Weasley, and Professor Lockhart from
the Chamber (Fig 2.), both by Adam
Brockbank for *Harry Potter and the
Chamber of Secrets*; Fig 3. The internal
animatronic structure of Fawkes sits
in the creature shop; Fig 4. Val Jones
(left) and Josh Lee (right) work on the
animatronic Fawkes in the creature
shop; Fig 5. Fawkes's mechanical
wing construct; Fig 6. The completed
animatronic Fawkes set upon his
perch.

Fig 2.

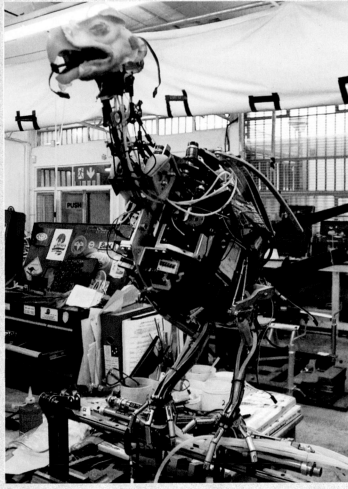

Fig 3.

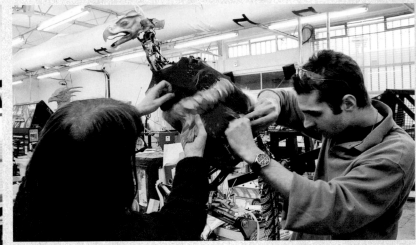

Fig 4.

Fig 5.

> " *Fawkes is a phoenix, Harry. They burst into flame
> when it is time for them to die, and then they
> are reborn from the ashes.*"
>
> — ALBUS DUMBLEDORE
> *Harry Potter and the Chamber of Secrets* film

The computer-generated version of Fawkes was not a cyberscanned model, as were most creatures created for the Harry Potter series. The digital design team worked with the visual development artwork, and observed and filmed real birds as reference, specifically a turkey vulture and a Blue Macaw. At the time, accomplishing believable digital feathers was still tricky, and if not created properly, the distinct reds and golds of Fawkes would clump into a muddled orange layer. The team realized that different softwares were needed to have the practical and CGI Fawkes analogous. Fawkes was modeled and animated in one software, then "feathered" in another. This version returned to the first software for lighting, and was then rendered for the screen in a third software. Fawkes's appearances in his other Harry Potter movies, designed as a slimmed-down, "midlife" Fawkes, were all CGI versions.

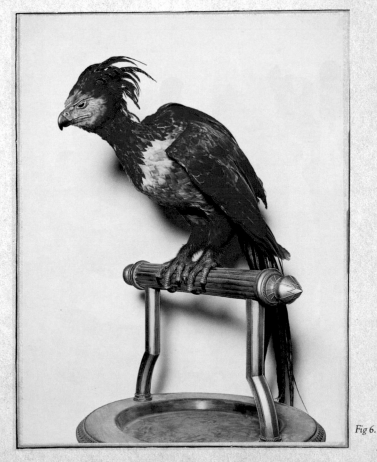

Fig 6.

# Nagini.

Nagini the snake is Lord Voldemort's companion, and a Horcrux. Nagini tries to kill Arthur Weasley at the Ministry of Magic in _Harry Potter and the Order of the Phoenix_, but fails. The snake appears in a terrifying scene at Godric's Hollow in _Harry Potter and the Deathly Hallows – Part 1_ as she attempts to kill Harry, but narrowly fails again. In order for Voldemort to be destroyed, Nagini needs to be killed, a task that is accomplished by Neville Longbottom wielding the sword of Gryffindor in _Harry Potter and the Deathly Hallows – Part 2_.

*Fig 1.*

Fig 1. Nagini, the faithful companion of Lord Voldemort by Paul Catling for _Harry Potter and the Goblet of Fire_; Fig 2. An early concept of Nagini by Paul Catling; Fig 3. Nagini peers over the chair as Bartemius Crouch Jr., (David Tennant) is given instructions by an unseen Lord Voldemort in a scene from _Harry Potter and the Goblet of Fire_.

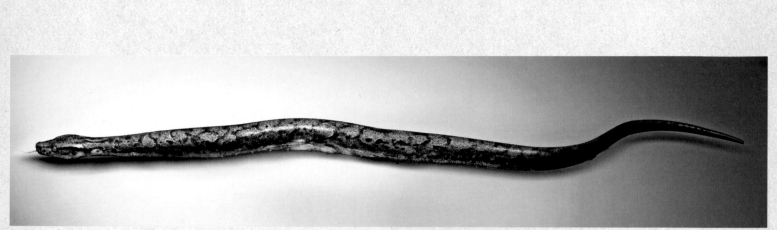

Fig 2.

> *"Kill the snake. Kill the snake and then it's just him."*
> —HARRY POTTER
> *Harry Potter and the Deathly Hallows — Part 2* film

Fig 3.

> *"Nagini...dinner."*
> —LORD VOLDEMORT
> *Harry Potter and the*
> *Deathly Hallows — Part 1* film

The Nagini that Harry sees in his disturbing visions throughout *Harry Potter and the Goblet of Fire* was a mash-up of python and anaconda breeds, and was roughly twenty feet long. The creature shop created a to-scale model that was painted and then cyberscanned, and the same model was used for *Harry Potter and the Order of the Phoenix*. Nagini's role was considerably larger in *Harry Potter and the Deathly Hallows — Parts 1* and *2*, and so the designer revamped her to be an even more threatening presence. A live python was studied by the digital crew, who not only sketched and filmed the snake, but took high resolution images of individual scales. These images were used to create new textures and colors that added iridescence and a snakeskin's reflective properties. Nagini was still primarily python, but with added cobra- and viper-like movements. Viper characteristics were introduced into her face for more animation of her brows and eyes, and sharper fangs protruded from her mouth.

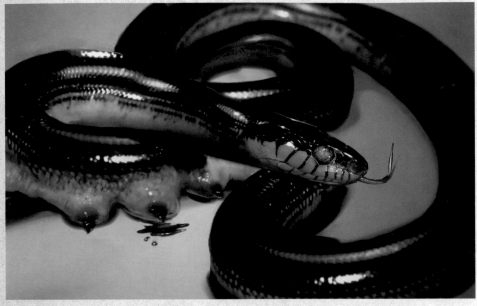

For the sequence of Nagini bursting through the body of Bathilda Bagshot to attack Harry, in *Deathly Hallows—Part 1*, an amalgamation of digital versions of Bathilda (Hazel Douglas) and Harry (Daniel Radcliffe) and live-action shots was employed. Nagini slithers up through Bathilda's head in a CGI construction that was composited onto a live-action shot of the actress. Harry's battle with the snake was a composite of a 3-D digital model of Daniel Radcliffe and live shots of Radcliffe "fighting" against a team of crew members, wearing green-screen gloves, holding him down. The crew was removed digitally, and the snake was added for the final shot.

Fig 1. In *Harry Potter and the Goblet of Fire*, Nagini was intended to suckle the embryonic form of Lord Voldemort. Concept art by Paul Catling; Fig 2. Paul Catling artwork of Nagini bursting through the mouth of Bathilda Bagshot in *Harry Potter and the Deathly Hallows – Part 1*; Fig 3. Digital template of Nagini in the graveyard at the end of *Goblet of Fire*; Fig 4. the finished concept as seen on-screen; Fig 5. Another view of Nagini's surprising entrance by Paul Catling for *Deathly Hallows – Part 1*.

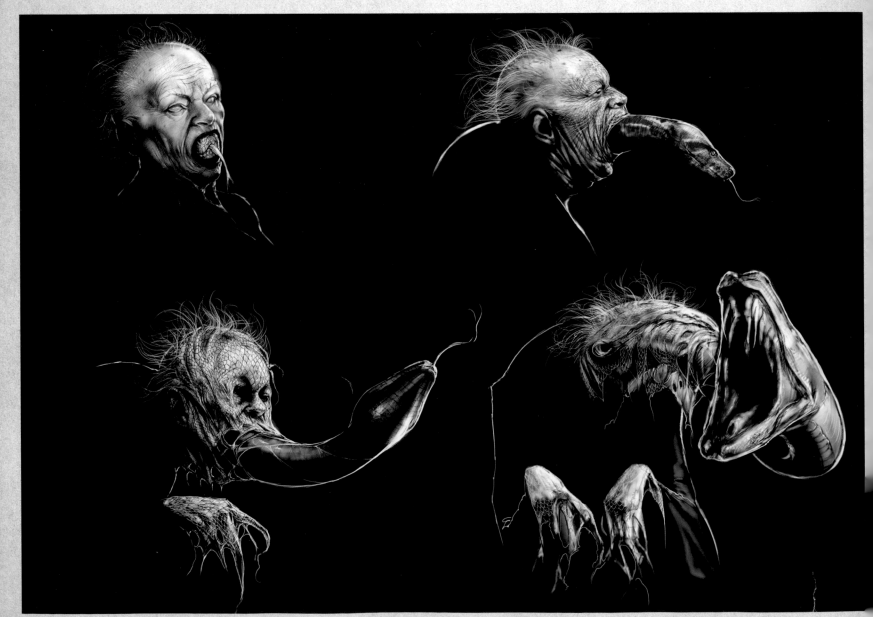

*Fig 2.*

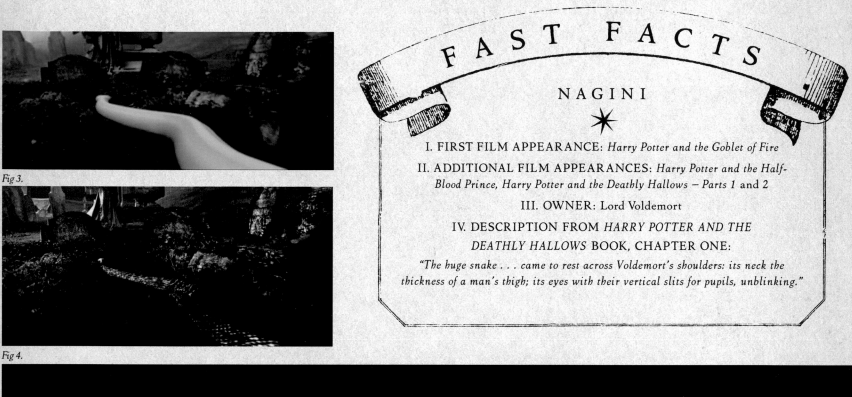

Fig 3.

Fig 4.

# FAST FACTS

## NAGINI

✳

I. FIRST FILM APPEARANCE: *Harry Potter and the Goblet of Fire*

II. ADDITIONAL FILM APPEARANCES: *Harry Potter and the Half-Blood Prince, Harry Potter and the Deathly Hallows – Parts 1 and 2*

III. OWNER: Lord Voldemort

IV. DESCRIPTION FROM *HARRY POTTER AND THE DEATHLY HALLOWS* BOOK, CHAPTER ONE:

*"The huge snake . . . came to rest across Voldemort's shoulders: its neck the thickness of a man's thigh; its eyes with their vertical slits for pupils, unblinking."*

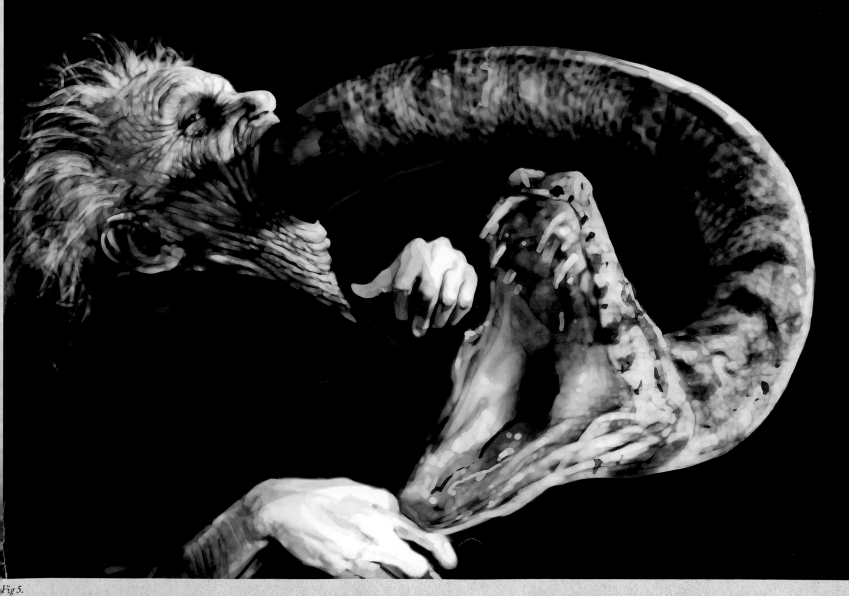

Fig 5.

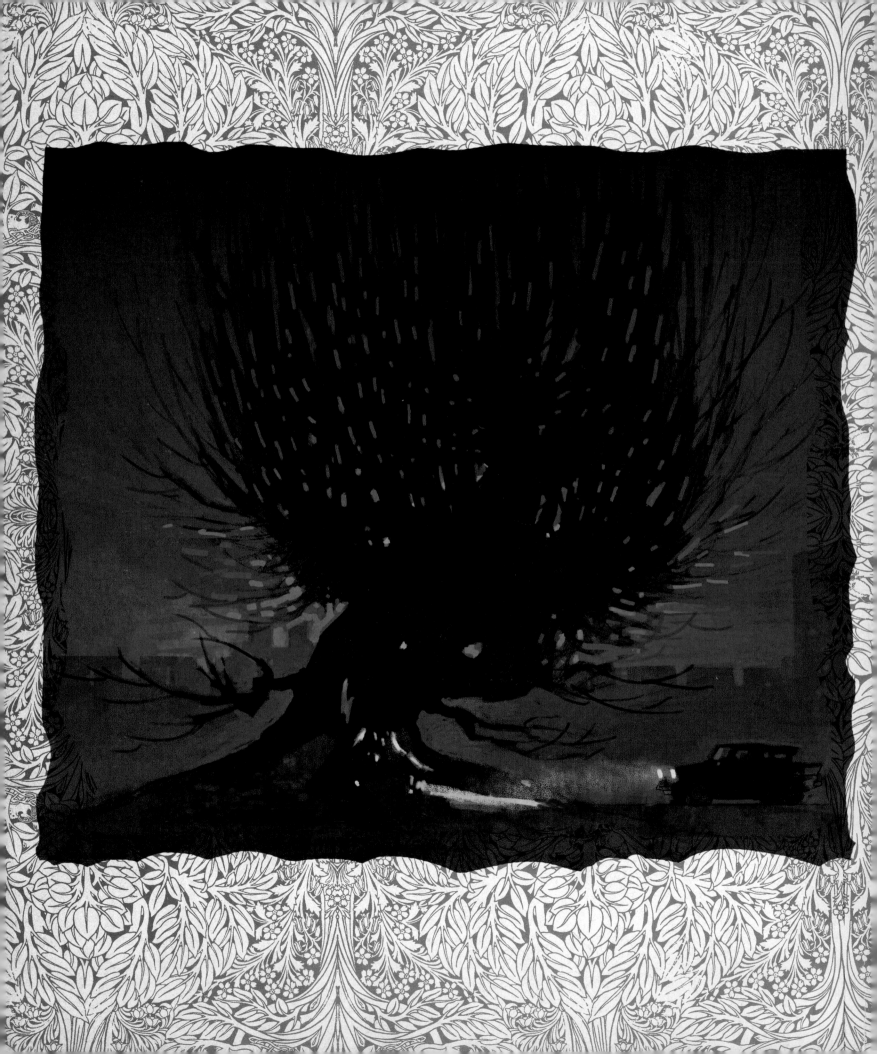

CHAPTER IX

# THE GREENHOUSE

Creatures do not always walk, fly, or swim in the *Harry Potter* films. Plants, whether rooted in the ground or in a greenhouse, can have their own personalities and idiosyncrasies. Some can be useful, like Mandrakes, or dangerous, like the Whomping Willow. Some plants are prickly, like the <u>Mimbulus mimbletonia</u>, and others are soft and enveloping—perhaps too enveloping in the case of the Devil's Snare.

# Devil's Snare.

Devil's Snare is a fleshy, rubbery plant with long shoots and creepers that prefers dark, dank environments. The plant is used as the second obstacle that Harry Potter, Ron Weasley, and Hermione Granger need to overcome in *Harry Potter and the Sorcerer's Stone* on their way to find the titular object. Devil's Snare kills its victims by wrapping itself around anything or anyone that treads or falls upon it. While trapped in the plant in *The Sorcerer's Stone*, Hermione recalls that you can be released by Devil's Snare only by letting your limbs go limp or shining a bright light on it, preferably sunlight.

The filmmakers assumed that the Devil's Snare sequence in *Harry Potter and the Sorcerer's Stone* would be created digitally, but then discovered that the production cost would be prohibitive. Presented with this challenge, the filmmakers realized they could employ a practical effect inspired by early cinema. The scene of the Devil's Snare vines encircling the three actors was actually shot in reverse. The giant vines were wrapped around the actors first. Hidden underneath the mass of vegetation were puppeteers who slowly pulled the tentacles off and away as the actors "struggled." By playing the film backward, it would appear as if the actors were being enveloped by the plant. The only visual effect was the *Lumos Solem* spell from the wand.

*Fig 1.*

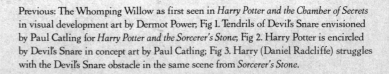

Previous: The Whomping Willow as first seen in *Harry Potter and the Chamber of Secrets* in visual development art by Dermot Power; Fig 1. Tendrils of Devil's Snare envisioned by Paul Catling for *Harry Potter and the Sorcerer's Stone*; Fig 2. Harry Potter is encircled by Devil's Snare in concept art by Paul Catling; Fig 3. Harry (Daniel Radcliffe) struggles with the Devil's Snare obstacle in the same scene from *Sorcerer's Stone*.

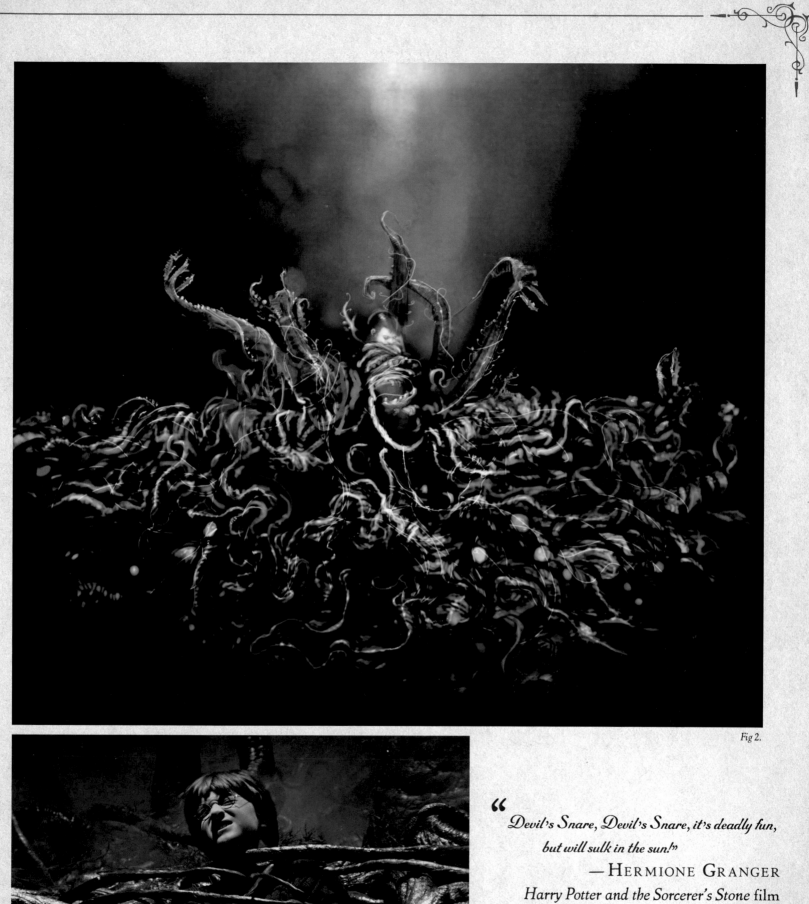

Fig 2.

Fig 3.

"Devil's Snare, Devil's Snare, it's deadly fun,
but will sulk in the sun!"
— HERMIONE GRANGER
*Harry Potter and the Sorcerer's Stone* film

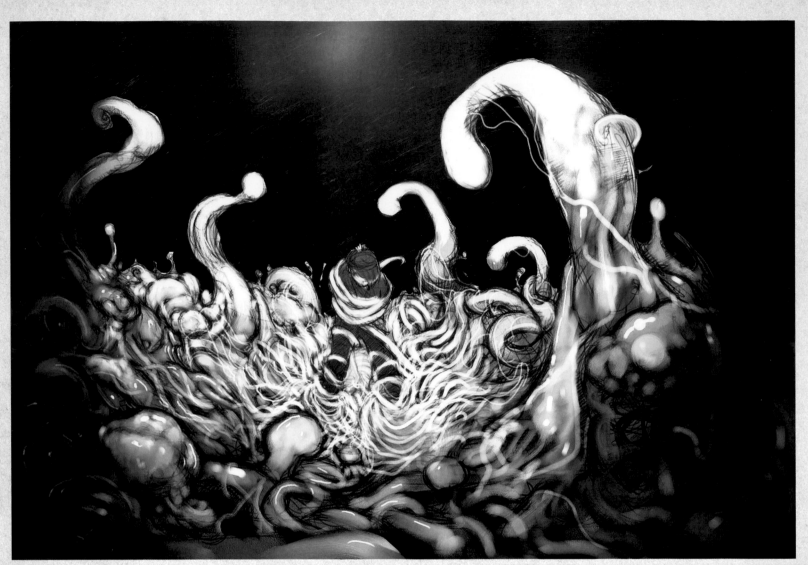

Fig 1.

Fig 2.

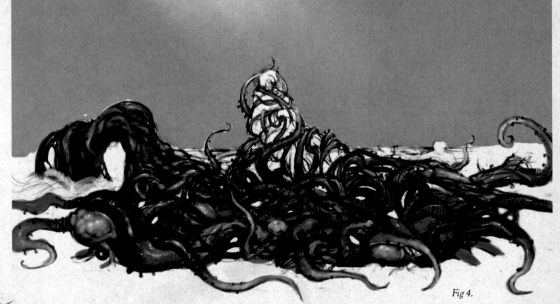

Fig 4.

Figs 1. — 5. For *Harry Potter and the Sorcerer's Stone*, Paul Catling explored Devil's Snare in scene studies and individual pieces; Fig 6. Hermione, Harry, and Ron entrapped in a cutaway sketch of Devil's Snare by Paul Catling.

Fig 3.

# FAST FACTS

## DEVIL'S SNARE

✶

I. FILM APPEARANCE: *Harry Potter and the Sorcerer's Stone*

II. LOCATION: Hogwarts

III. DESCRIPTION FROM *HARRY POTTER AND THE SORCERER'S STONE* BOOK, CHAPTER SIXTEEN:

*"The moment [Hermione] had landed, the plant had started to twist snakelike tendrils around her ankles. As for Harry and Ron, their legs had already been bound tightly in long creepers without their noticing."*

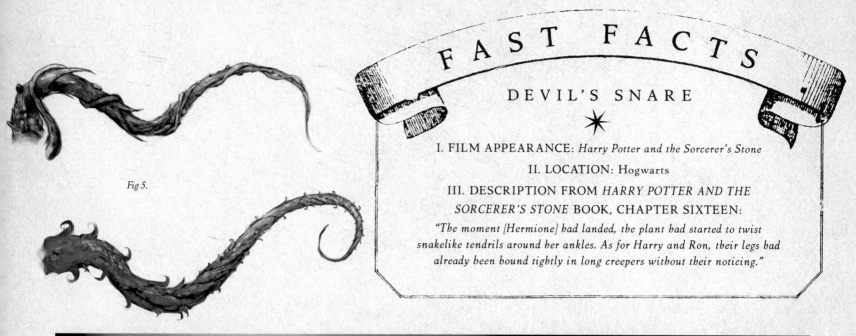

Fig 5.

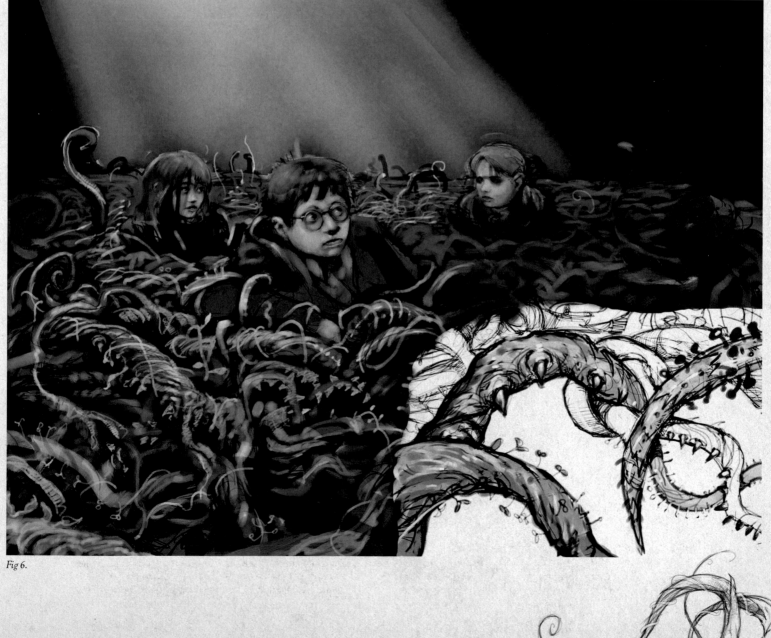

Fig 6.

# Mandrake.

The root of the mandrake, or mandragora, can be used to revive those who have been Petrified. In *Harry Potter and the Chamber of Secrets*, Herbology professor Pomona Sprout assigns Mandrakes to her second year students, and she instructs them to wear earmuffs, as their cries can kill a person.

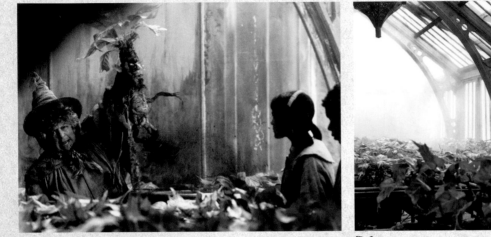

Fig 1.

Fig 2.

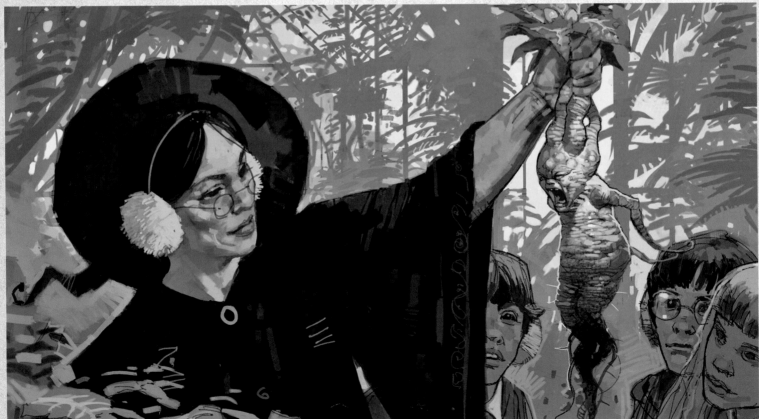

Fig 3.

Fig 1. Professor Pomona Sprout (Miriam Margoyles) demonstrates the repotting of Mandrakes in her Herbology class in a scene from *Harry Potter and the Chamber of Secrets*; Fig 2. Rows of Mandrakes grow in the Greenhouse; Fig 3. Visual development art by Dermot Power of Professor Sprout's class; Figs 4. & 5. A crying and a quiet Mandrake, with and without leaves, by Dermot Power.

*Fig 4.*

*Now, as our Mandrakes are still only seedlings,*
*their cries won't kill you yet, but they could*
*knock you out for several hours."*

—PROFESSOR SPROUT
*Harry Potter and the Chamber of Secrets* film

*Fig 5.*

Visual development of the Mandrake's leaves for *Harry Potter and the Chamber of Secrets* was based on the real Mandrake plant, so named because it appears to have a trunk and limbs. For the body of the plant, the creature shop designers realized that the look of the baby Mandrakes couldn't be too cute or cuddly as their purpose was to be destroyed in order to make the Petrification cure. So they tried to make them as horrible and unlovable as possible, with wrinkled, screeching faces. More than fifty completely mechanical Mandrakes were created that made up the top halves of their flowerpots, with their movement achieved by one of the most basic special effects techniques—animatronic puppetry. The machinery for the Mandrakes was inside the pots, operated underneath the Greenhouse table by controllers. Once their animatronic action was turned on, the Mandrake would cycle through a series of writhing, wriggling motions that could be sped up or slowed down.

For Professor Sprout, Draco Malfoy, and a few others, Mandrakes were constructed that had similar movement but could be removed from their pots and still move their mouths and appendages, accomplished through radio transmitters.

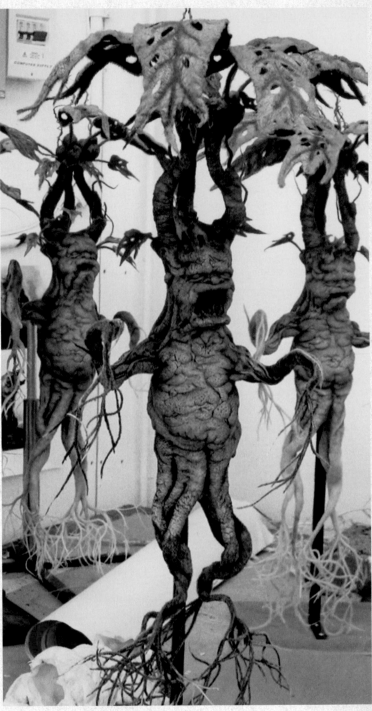

Fig 2.

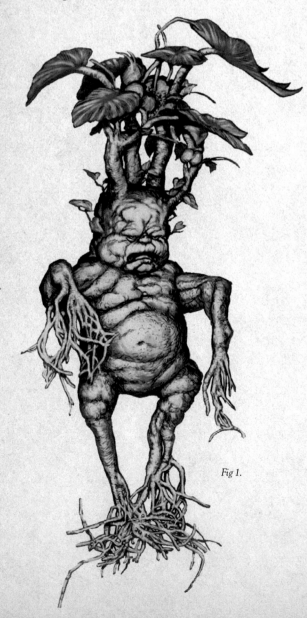

*Fig 1.*

Figs 1. & 5. Dermot Power studied real Mandrakes to inspire his visual development art for *Harry Potter and the Chamber of Secrets*; Fig 2. The animatronic Mandrakes out of their pots and aloft in the creature shop; Fig 3. Hermione Granger (Emma Watson, center) pulls her Mandrake up and out for repotting in a scene from *Chamber of Secrets*; Fig 4. Close-up of a not-so-adorable animatronic baby Mandrake.

# FAST FACTS

## MANDRAKE

✳

I. FILM APPEARANCE: *Harry Potter and the Chamber of Secrets*

II. LOCATION: Greenhouses, Hogwarts

III. DESCRIPTION FROM *HARRY POTTER AND THE CHAMBER OF SECRETS* BOOK, CHAPTER SIX

*"Instead of roots, a small, muddy, and extremely ugly baby popped out of the earth. The leaves were growing right out of his head. He had pale green, mottled skin, and was clearly bawling at the top of his lungs."*

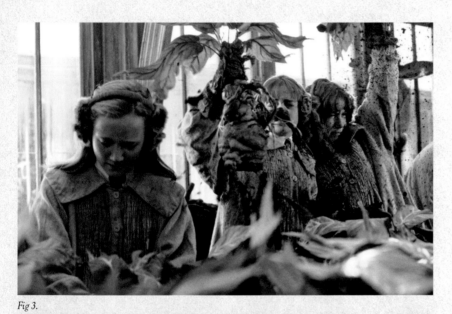

Fig 3.

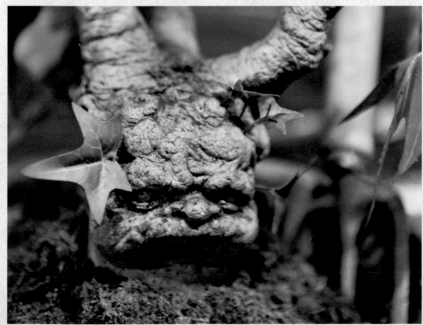

Fig 4.

Fig 5.

# Whomping Willow.

The Whomping Willow, which grows on the grounds of Hogwarts in the Harry Potter films, is a dangerous, spiteful tree, with branches that can swing, grab, and pound. The tree is rather indestructible—when Ron Weasley and Harry Potter crash the Weasley's flying Ford Anglia into its branches in *Harry Potter and the Chamber of Secrets*, they do more damage to the car than the tree. There is a secret entrance in the Whomping Willow that leads to the Shrieking Shack, as discovered in *Harry Potter and the Prisoner of Azkaban*.

Fig 1. Concept art of the flying Ford Anglia about to crash into the Whomping Willow by Dermot Power for *Harry Potter and the Chamber of Secrets*; Fig 2. The Weasley family's flying car, carrying Harry Potter (Daniel Radcliffe) and Ron Weasley (Rupert Grint), crashes into the Whomping Willow on the Hogwarts grounds in a scene from *Chamber of Secrets*; Fig 3. A foggy nighttime silhouette of the Whomping Willow by Dermot Power.

> " *Not to mention the damage you inflicted on a Whomping Willow that's been on these grounds since before you were born.*"
>
> —SEVERUS SNAPE
> *Harry Potter and the Chamber of Secrets* film

*Fig 1.*

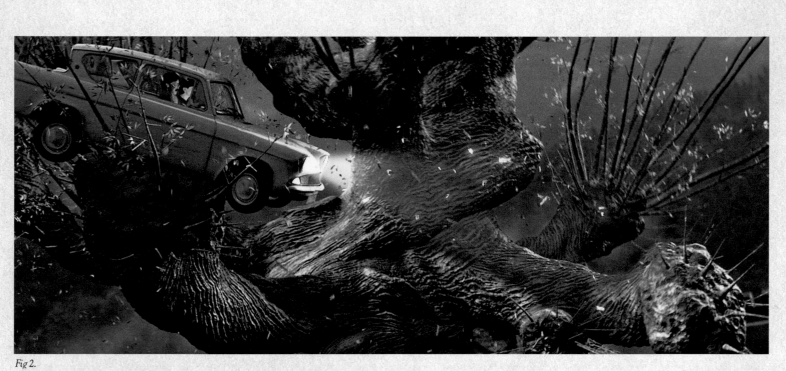

Fig 2.

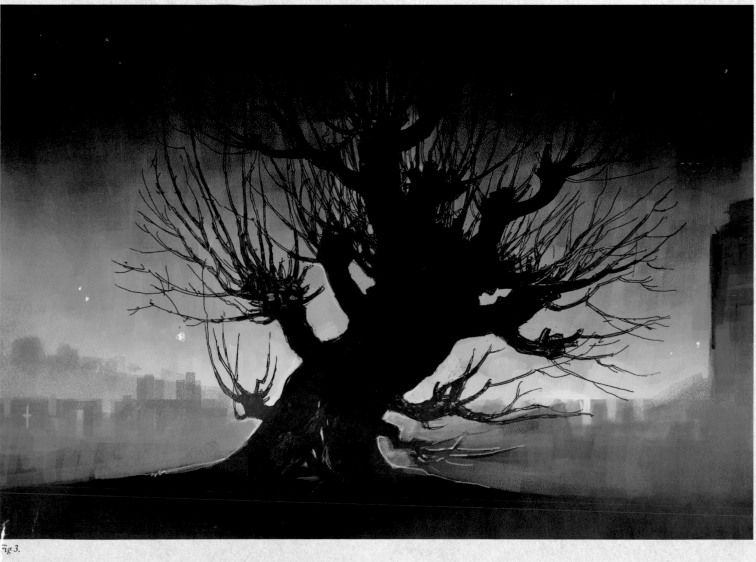

Fig 3.

Considering what the Whomping Willow needed to do in *Harry Potter and the Chamber of Secrets*—swallow a car and spit it out—the designers realized the tree had to be big. Very big. As often happened during the Harry Potter films, the idea that the Willow needed to be computer-generated was tabled when the special effects, visual effects, and art departments put their heads and skills together and constructed a tree that grew in pieces to the height of eighty-five feet. First, a hydraulic-motion base was built, and then it was hidden by the rubber-covered trunk of the tree. The car fit into this and could be waved around. Then hydraulically operated branches were added to twist and grasp around the car. The trunk and branches were controlled by a miniature version of the tree that was a waldo device. The waldo contained actuators that sent an electric signal through a computer to corresponding actuators in the full-size Willow, which then imitated the waldo's movement.

For *Harry Potter and the Prisoner of Azkaban*, the tree was moved from its location near the Training Grounds to an area closer to the castle. It was also downsized, as the sequence of the black dog grabbing Ron and dragging him inside took place at the base of the tree. The Whomping Willow was no less dangerous, though, grabbing Harry and Hermione Granger with whiplike branches and flying them around through the air. Motion-controlled rigs swung Daniel Radcliffe (Harry) and Emma Watson (Hermione) around in a sequence that had been previsualized in an animatic, which is a digitally created storyboard. The rigs' movements were imported into a computer, which converted that movement into flailing, grabbing branches. For any action deemed too dangerous, 3-D digital models of Radcliffe and Watson stood in for the actors.

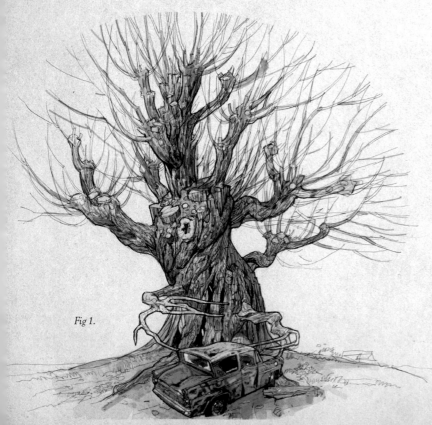

Fig 1.

Fig 2.

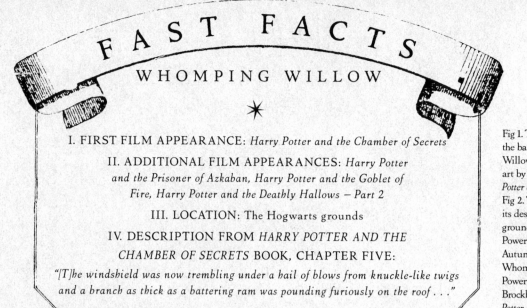

# FAST FACTS
## WHOMPING WILLOW

✳

I. FIRST FILM APPEARANCE: *Harry Potter and the Chamber of Secrets*

II. ADDITIONAL FILM APPEARANCES: *Harry Potter and the Prisoner of Azkaban, Harry Potter and the Goblet of Fire, Harry Potter and the Deathly Hallows – Part 2*

III. LOCATION: The Hogwarts grounds

IV. DESCRIPTION FROM *HARRY POTTER AND THE CHAMBER OF SECRETS* BOOK, CHAPTER FIVE:

*"[T]he windshield was now trembling under a hail of blows from knuckle-like twigs and a branch as thick as a battering ram was pounding furiously on the roof . . ."*

Fig 1. The Ford Anglia sits at the base of the Whomping Willow, post-crash, in concept art by Dermot Power for *Harry Potter and the Chamber of Secrets*; Fig 2. The Ford Anglia begins its descent onto the Hogwarts grounds in artwork by Dermot Power for *Chamber of Secrets*; Autumn and winter views of the Whomping Willow by Dermot Power (Fig 3.) and Adam Brockbank (Fig. 4) for *Harry Potter and the Prisoner of Azkaban*.

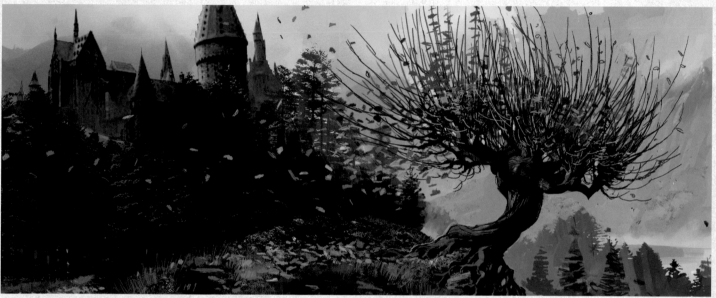

Fig 3.

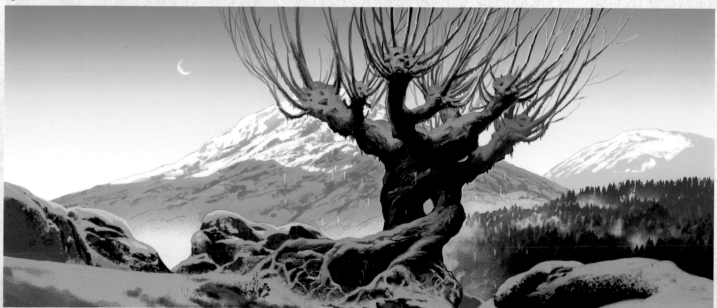

Fig 4.

# Mimbulus Mimbletonia.

In *Harry Potter and the Order of the Phoenix*, Neville Longbottom brings a *Mimbulus mimbletonia* to school. This lumpy gray plant wriggles and pulsates, and squirts out Stinksap when irritated. Neville obviously takes good care of it; the plant is still present during a scene in *Harry Potter and the Deathly Hallows – Part 2*, in the Room of Requirement, where it sits near the wireless transmitter.

The movement of the *Mimbulus mimbletonia* was animated in a similar way to the Mandrakes. A metal skeletal structure inside of the prop would twist and scrunch via radio-controlled transmitters. For simple motions such as these, the transmitter would be manually controlled. Creatures with more intricate, complicated movements would be activated via a computer program.

In a scene in the Gryffindor common room deleted from *Harry Potter and the Order of the Phoenix*, Neville probes and prods at the plant. At one point he pokes the wrong place, and the plant spurts green sludge all over him. Director David Yates wanted Matthew Lewis (Neville Longbottom) to not react as he was drenched, to remain motionless. The actor admitted it got harder and harder not to flinch, as he knew what was about to happen. Lewis had to change his wardrobe and wash up between each take.

*Fig 1.*

## FAST FACTS

### MIMBULUS MIMBLETONIA

✳

I. FIRST FILM APPEARANCE: *Harry Potter and the Order of the Phoenix*

II. ADDITIONAL FILM APPEARANCES:
*Harry Potter and the Deathly Hallows – Part 2*

III. LOCATION: Gryffindor common room, Room of Requirement

IV. DESCRIPTION FROM *HARRY POTTER AND THE ORDER OF THE PHOENIX* BOOK, CHAPTER TEN:

*"[Neville] . . . pulled out what appeared to be a small gray cactus in a pot except that it was covered with what looked like boils rather than spines."*

Fig 1. Neville Longbottom (Matthew Lewis) attends his *Mimbulus mimbletonia* in the Gryffindor common room in a deleted scene from *Harry Potter and the Order of the Phoenix*; Fig 2. Plant portrait by Rob Bliss.

*Fig 2*

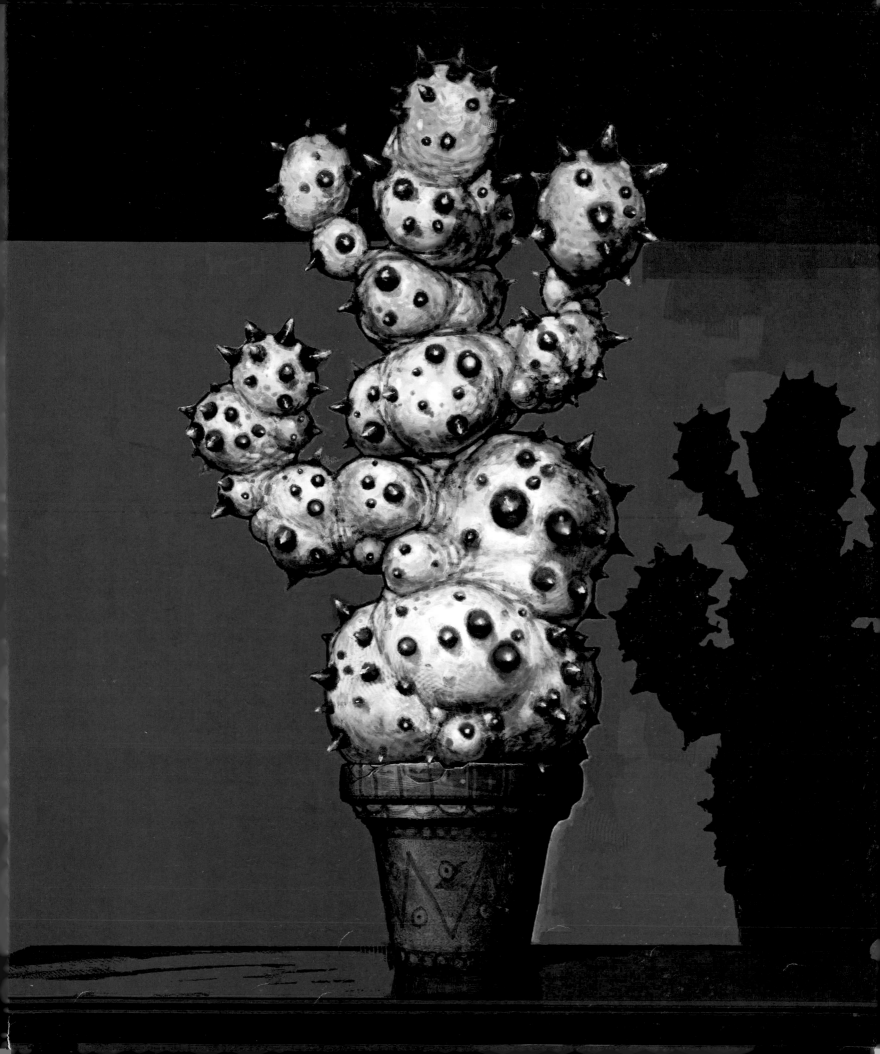

# Venomous Tentacula.

After drinking the *Felix Felicis* potion, Harry Potter comes upon Professor Horace Slughorn as he passes by the greenhouse in *Harry Potter and the Half-Blood Prince*. In a scene unique to the film, Slughorn is snipping off leaves from the Venomous Tentacula, a bushy plant with tendrils—tentacula—that contain the venom in venomous. The sinuous, grasping movement of the Tentacula's tendrils was computer-generated.

Fig 1.

Fig 2.

"
*Are those Tentacula leaves, sir?*
*They're very valuable, aren't they?"*
— HARRY POTTER
*Harry Potter and the Half-Blood Prince* film

Fig 3.

Fig 1. Samples of the grasping tentacles of the Venomous Tentacula, and (Fig 2.) the plant itself, by Adam Brockbank for *Harry Potter and the Half-Blood Prince*; Fig 3. Director David Yates demonstrates to actor Jim Broadbent (Horace Slughorn) how the Venomous Tentacula will appear in the Greenhouse; Fig 4. Harry Potter (Daniel Radcliffe, background) comes upon Slughorn (Jim Broadbent) surreptitiously cutting off Tentacula leaves in a scene from *Half-Blood Prince*.

# FAST FACTS

## VENOMOUS TENTACULA

✳

I. FILM APPEARANCE: *Harry Potter and the Half-Blood Prince*

II. LOCATION: Herbology Greenhouse

III. DESCRIPTION FROM *HARRY POTTER AND THE CHAMBER OF SECRETS* BOOK, CHAPTER SIX:

*"[Professor Sprout] gave a sharp slap to a spiky, dark red plant as she spoke, making it draw in the long feelers that had been inching sneakily over her shoulder."*

"*My own interests are . . . purely academic, of course.*"
— HORACE SLUGHORN
*Harry Potter and the Half-Blood Prince* film

Fig 4.

# Dirigible Plum.

In the film <u>Harry Potter and the Deathly Hallows – Part 1</u>, Dirigible Plums are depicted growing upside down amid the dark shiny leaves of its bushy tree, as observed by Harry Potter, Hermione Granger, and Ron Weasley when they see the plant beside Xenophilius Lovegood's house in <u>Deathly Hallows – Part 1</u>. Orange-colored, they are shaped more like a radish than a plum. They are also capable of floating away like a tiny helium-filled blimp. In <u>Harry Potter and the Order of the Phoenix</u>, Luna Lovegood wears a pair of Dirigible Plum–shaped earrings. Evanna Lynch, who played Luna, crafted the radish-shaped earrings, among other jewelry she created for her character throughout the films.

"*Keep off the Dirigible Plums?*"
—RON WEASLEY, READING
A SIGN OUTSIDE OF THE
LOVEGOODS' HOUSE
*Harry Potter and the Deathly
Hallows – Part 1* film

Fig 2.

Fig 3.

Fig 1.

Figs 1. & 3. Specimen studies of the Dirigible Plum by Adam Brockbank for *Harry Potter and the Deathly Hallows – Part 1*; Fig 2. The Dirigible Plum bush in front of the Lovegoods' house on the set of *Deathly Hallows – Part 1*; Fig 4. The same view, with Harry and Ron, envisioned in concept art by Adam Brockbank.

## FAST FACTS

### DIRIGIBLE PLUM

✶

I. FIRST FILM APPEARANCE AS JEWELRY:
*Harry Potter and the Order of the Phoenix*

II. FIRST FILM APPEARANCE AS PLANT:
*Harry Potter and the Deathly Hallows – Part 1*

III. LOCATION: Xenophilius Lovegood's House

IV. DESCRIPTION FROM *HARRY POTTER AND THE DEATHLY HALLOWS* BOOK, CHAPTER TWENTY:
*"The zigzagging path leading to the front door was overgrown with a variety of odd plants, including a bush covered in an orange radishlike fruit Luna sometimes wore as earrings."*

Fig 4

First published in the United States and Canada in 2014 by:
Harper Design
*An Imprint of* HarperCollins *Publishers*
Tel: (212) 207-7000
Fax: (212) 207-7654
harperdesign@harpercollins.com
www.harpercollins.com

Distributed throughout the United States and Canada by:
HarperCollins Publishers
195 Broadway
New York, NY 10007
Fax (212) 207-7654

Library of Congress Control Number: 2014942363

ISBN: 978-0-06-237423-3

*Produced by*
INSIGHT EDITIONS
PO Box 3088
San Rafael, CA 94912
www.insighteditions.com

INSIGHT EDITIONS:
Publisher: Raoul Goff
Art Director: Chrissy Kwasnik
Executive Editor: Vanessa Lopez
Project Editor: Talia Platz
Production Editor: Rachel Anderson
Book Design & Layout: Chrissy Kwasnik
Production Manager: Anna Wan

INSIGHT EDITIONS would like to thank Jody Revenson, Lauren Sina Bondi Donohue,
Jenelle Wagner, Malea Clark-Nicholson, and Elaine Ou.

ROOTS of PEACE    REPLANTED PAPER

Insight Editions, in association with Roots of Peace, will plant two trees for each tree used in the
manufacturing of this book. Roots of Peace is an internationally renowned humanitarian organization
dedicated to eradicating land mines worldwide and converting war-torn lands into productive farms
and wildlife habitats. Roots of Peace will plant two million fruit and nut trees in Afghanistan and
provide farmers there with the skills and support necessary for sustainable land use.

Manufactured in China by Insight Editions

10 9 8 7 6 5 4 3 2 1

P. 1: Norbert, the Norwegian Ridgeback, by visual development artist Paul Catling for *Harry Potter and the Sorcerer's Stone*; P. 2: Harry and Ron gaze at the hollow
that houses Aragog and his descendants in artwork by Dermot Power for *Harry Potter and the Chamber of Secrets*; P. 3: Hippogriff sketch by Dermot Power for *Harry
Potter and the Prisoner of Azkaban*; P. 4: Visual development art of the skeletal, mysterious Thestrals first seen in *Harry Potter and the Order of the Phoenix*;
P. 5: A study of the Cornish pixie's wings by Rob Bliss for *Harry Potter and the Chamber of Secrets*; Pp. 6–7: Concept art by Andrew Williamson of the Dementors
hovering around Hogwarts castle for *Harry Potter and the Order of the Phoenix*; P. 8: A Gringotts goblin illustrated by Paul Catling for *Harry Potter and the Sorcerer's
Stone*; P. 10: A Ukrainian Ironbelly drops Harry, Ron, and Hermione near Hogwarts after their escape from Gringotts Bank. Visual development art by Adam
Brockbank for *Harry Potter and the Deathly Hallows – Part 2*; P. 11: Bioluminescent Grindylow illustrated by artist Paul Catling for *Harry Potter and the Goblet of Fire*.